THE CANADIAN ROCKIES

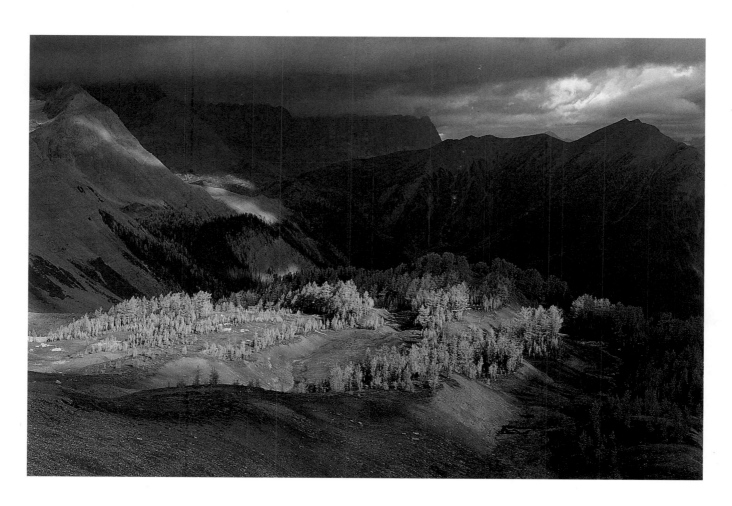

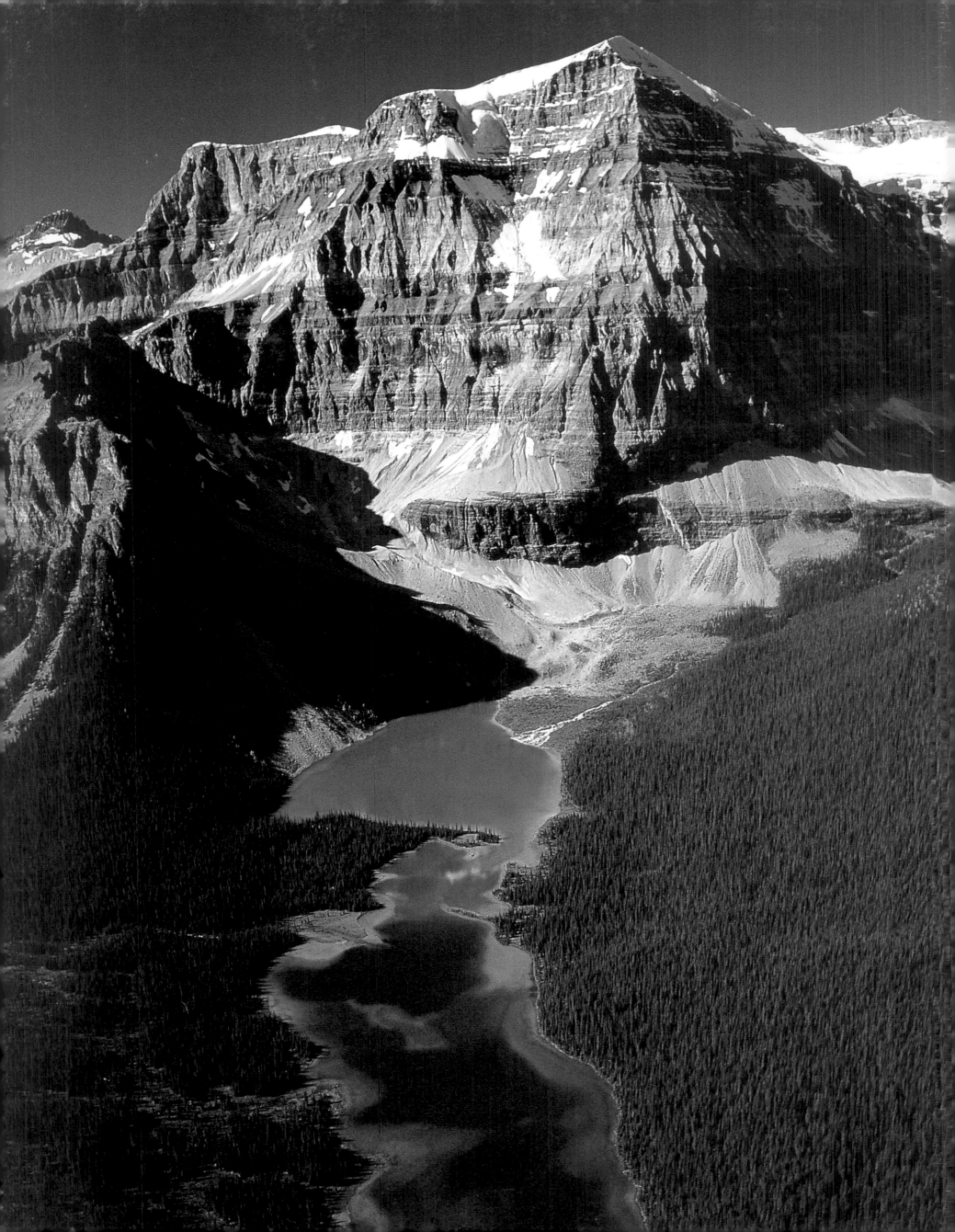

THE CANADIAN ROCKIES

A Spectacular Collection of Photographs
by Douglas Leighton

Altitude Publishing

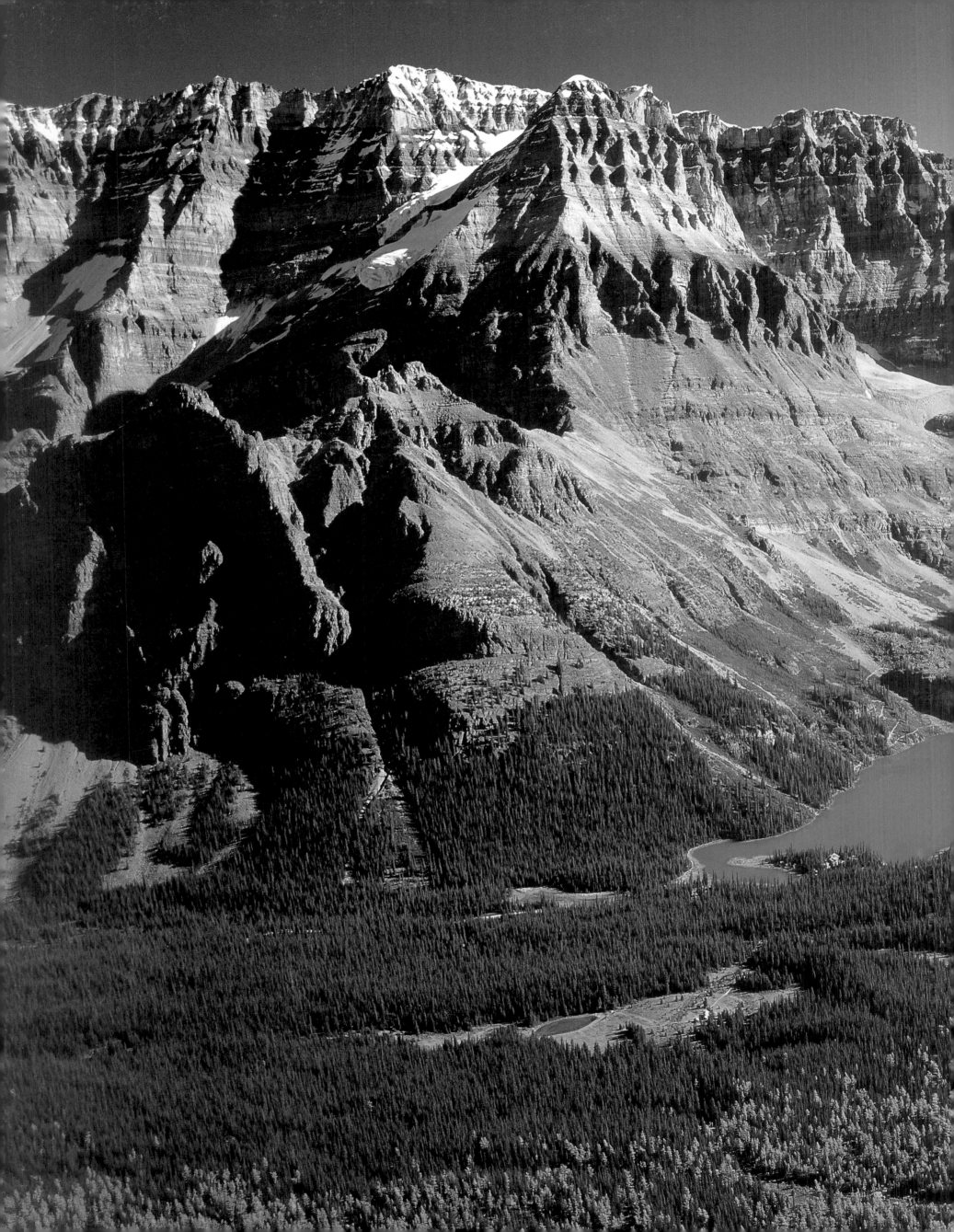

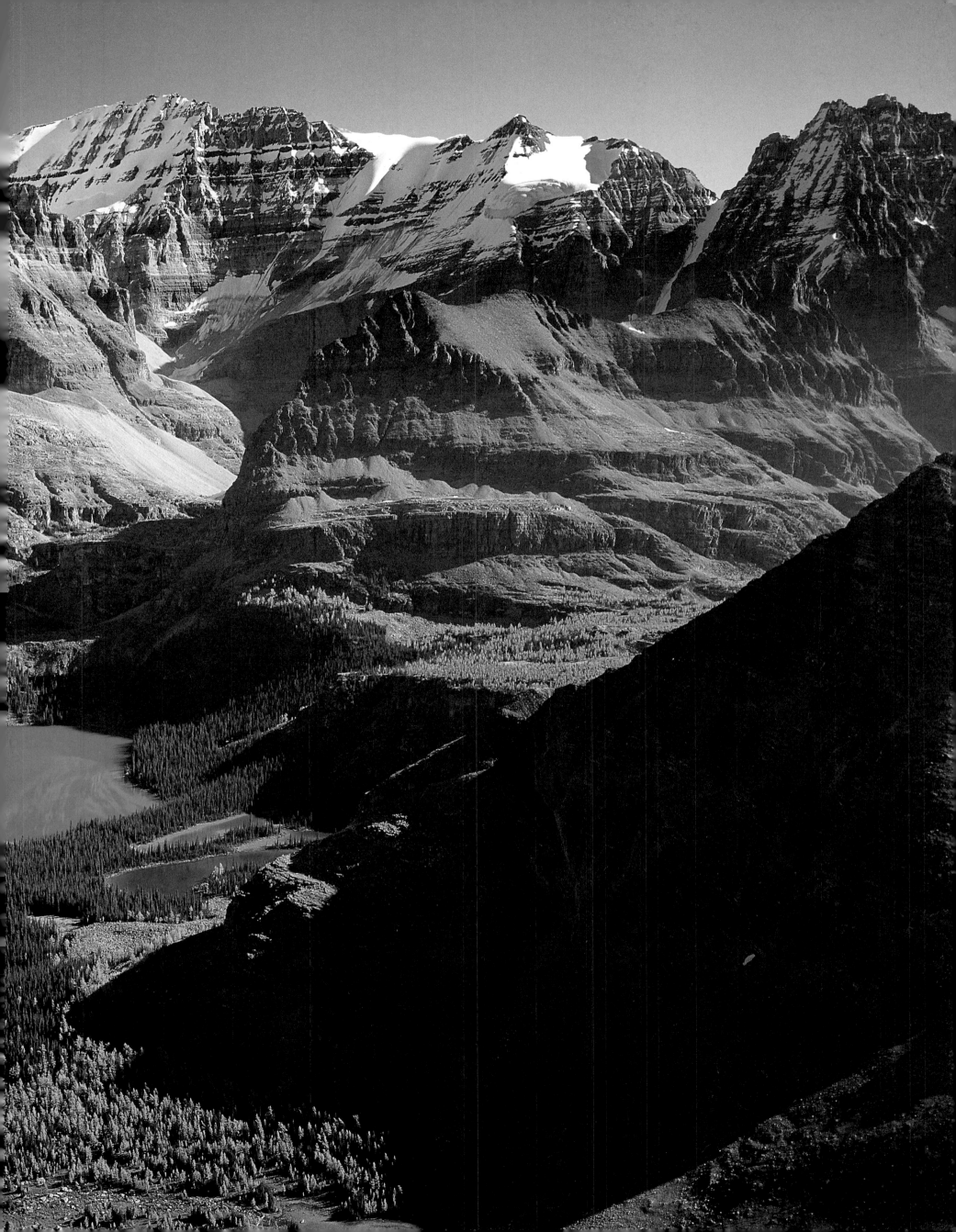

PUBLICATION INFORMATION

Canadian Cataloguing in Publication Data
Leighton, Douglas, 1953-
The Canadian Rockies

ISBN 1-55153-176-3

1. Rocky Mountains, Canadian (B.C. and Alta.)—Pictorial works.*
2. Rocky Mountains, Canadian (B.C. and Alta.)* I Title.
FC219.L45 2001 917.1'0022'2 C2001-910249-6
F1090.L45 2001

We acknowledge the financial support of the Government of Canada
through the Book Publishing Industry Development Program (BPIDP)
for our publishing activities.

 Altitude GreenTree Program
Altitude Publishing will plant twice as many trees
as were used in the manufacturing of this book.

The photographs in this book have not been digitally enhanced or altered.

Production

Concept and design	Stephen Hutchings
Design assistants	Andy Stanton
	Scott Manktelow
Copy editing	Andrea Murphy
Financial management	Laurie Smith

Printed and bound in Canada by Friesen Printers, Altona, Manitoba

Front cover and page 3: Shadow Lake and Mt. Ball, Banff National Park
Back cover: Subalpine larches, Mt. Fay, Consolation Valley, Banff National Park
Title page: Numa Pass and the Rockwall, Banff National Park
Page 2: Mt. Ball and Shadow Lake, Banff National Park
Page 4-5: Lake O'Hara Basin, Yoho National Park

Altitude Publishing
The Canadian Rockies • Vancouver
1500 Railway Ave.
Canmore, Alberta T1W 1P6
(403) 678-6888

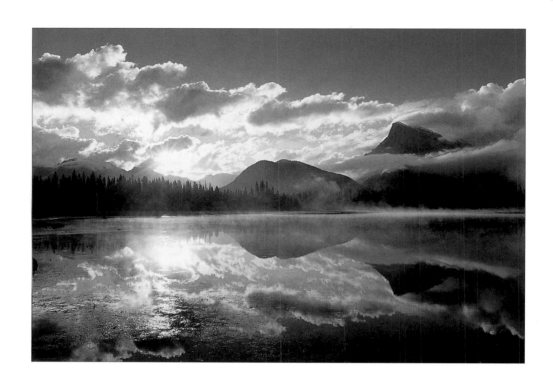

CONTENTS

above: **Morning mists on the Vermilion Lakes**
Banff National Park

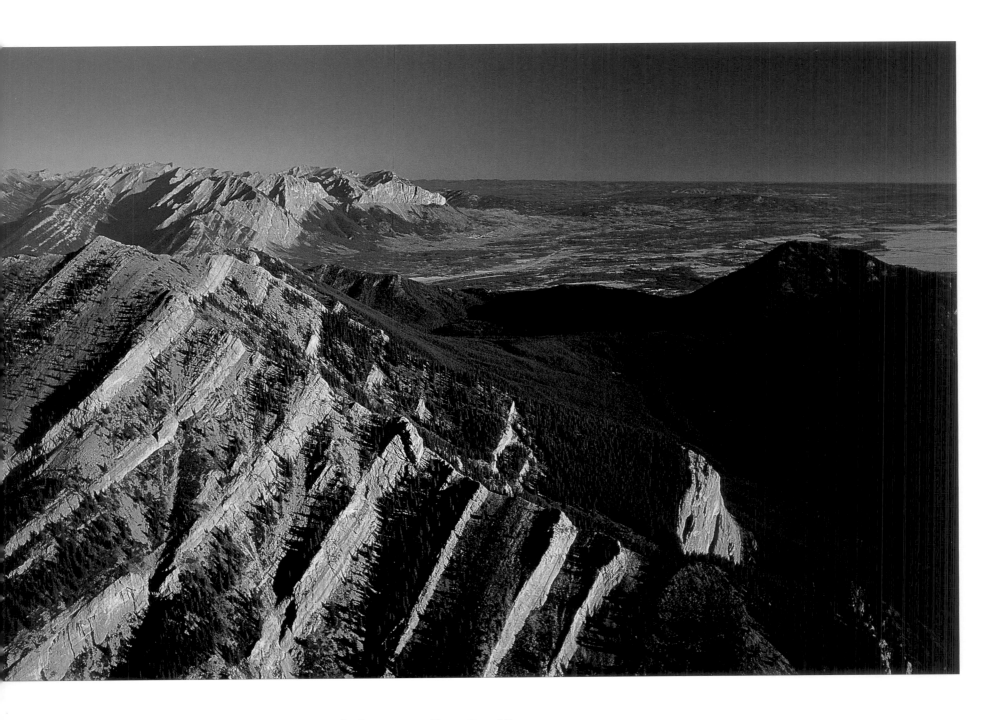

above: **East edge of the Canadian Rockies**
view north from Kananaskis Country

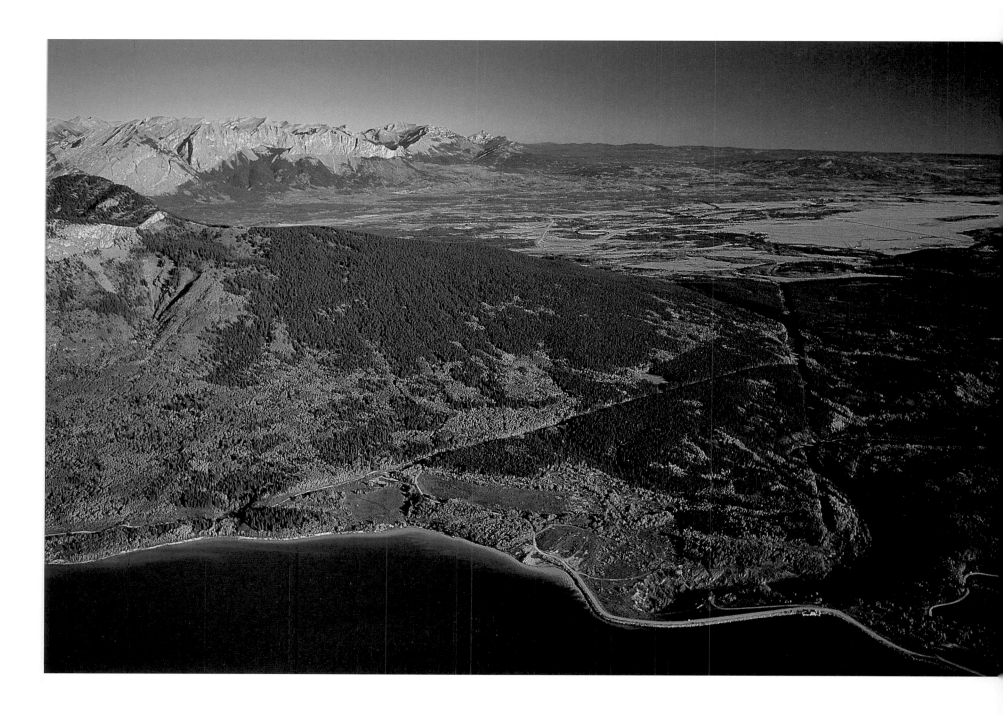

above: **East edge of the Canadian Rockies**
Barrier Lake in Kananaskis Country

next pages: **Goat Range, Upper Spray Valley**
Banff National Park (view south to Peter Lougheed Provincial Park)

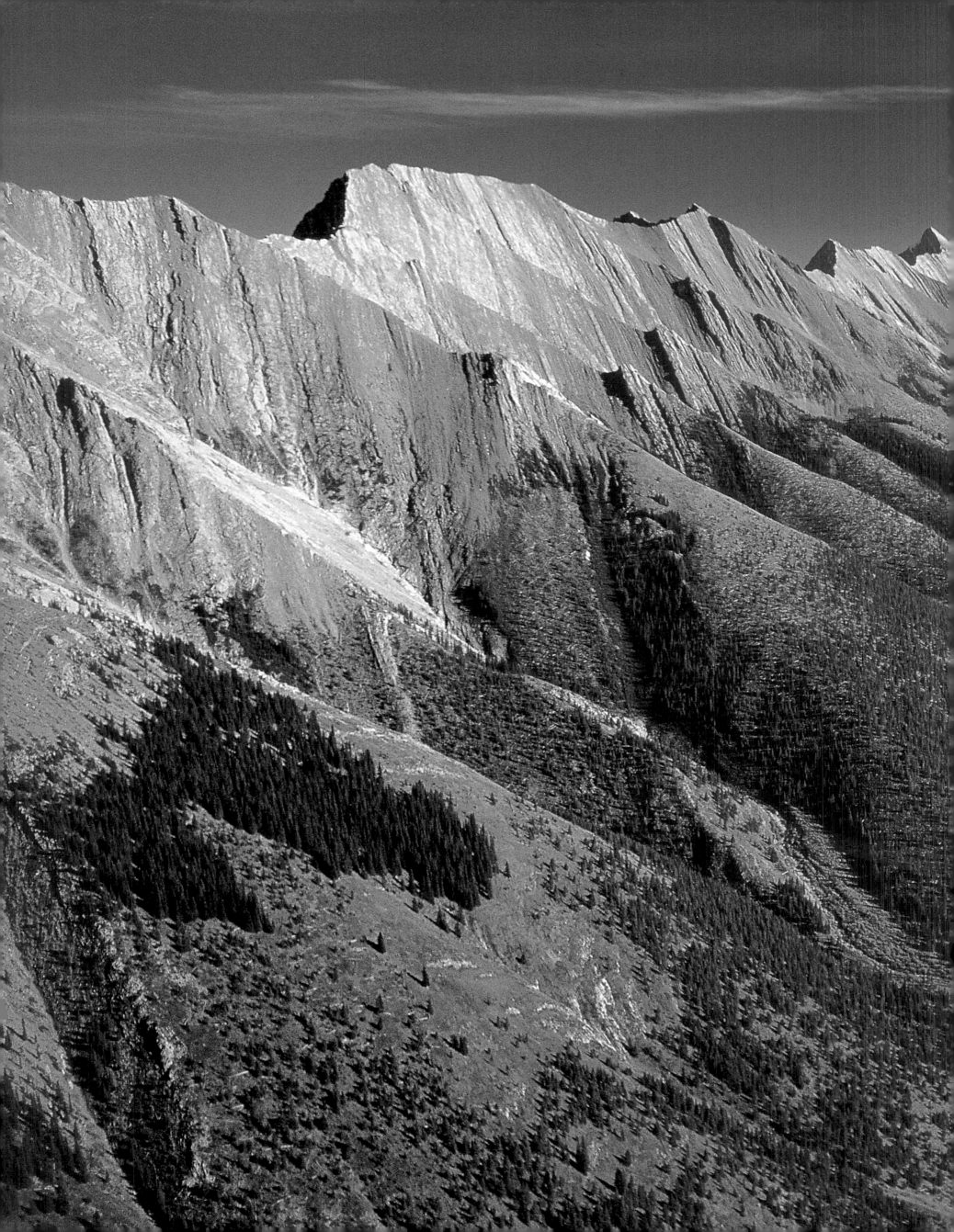

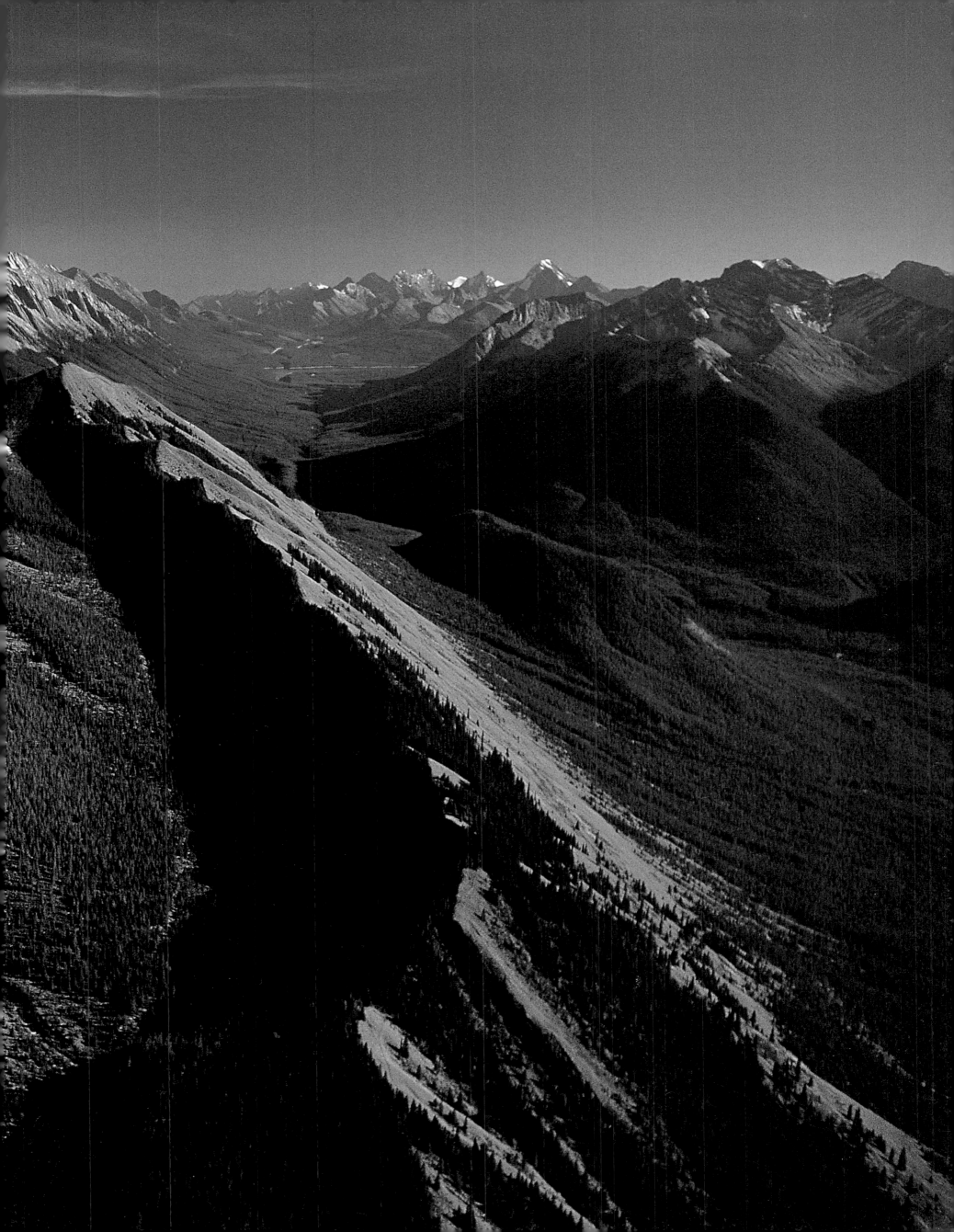

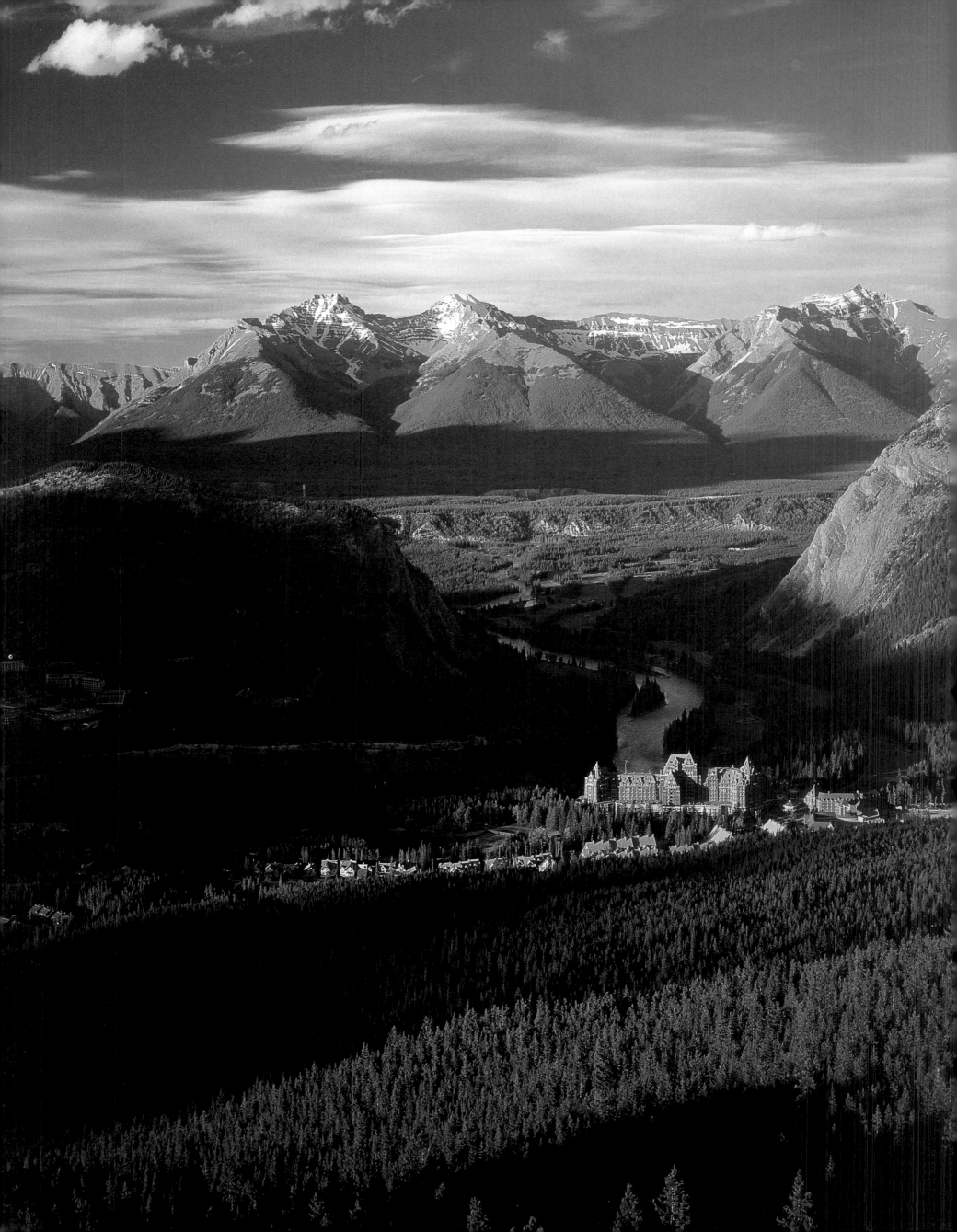

INTRODUCTION

he helicopter jolts suddenly as we lift off from the tarmac near Canmore, Alberta. Our ascent is quick and steep. The mountains below us swell gradually upwards like giant waves that break eastward towards the shore of the flat prairies. The way the shapes of these mountains so graphically illustrate the forces that created them is amazing. Tens of millions of years ago, as the mountains were being actively created, this easternmost sheet of limestone pushed up and over the plains. The steep mountain cliffs now beckon—and perhaps even challenge—those who approach the mountains from the east.

The helicopter swings towards the north. We follow the river as it snakes along the valley floor. The montane vegetation on either side is deep green with coniferous growth. In patches, this green is broken by unexpected bursts of yellow aspens. Soon the winter cold will force the leaves to fall and the colour of the whole forest to become muted and quiet, but as we fly over it now, the valley is decorated with the full kaleidoscope of autumn.

We pass over a stretch of water that lies smooth and blue. Just below it, the water seems to break apart into a shimmer of silver as it tumbles over shallow rocks that

opposite: **Banff Springs Hotel, Bow Valley and the Fairholme Range**
Banff National Park

≈ 13 ≈

lie across the riverbed. Further on, the river edges into eddies of pale green and deep turquoise. As with the water of the lakes, river water in the Canadian Rockies defies easy description.

As we continue, I observe the constantly shifting patterns made by the changing

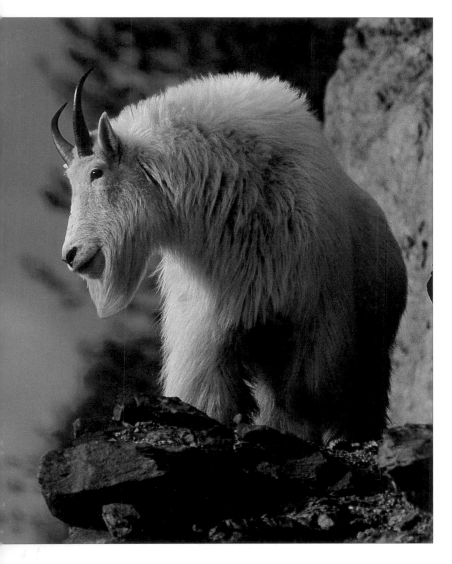

textures, colours and shapes below us. I marvel at the ability of raptors such as eagles, who so keenly spot and identify their prey from similar heights, amidst all the detail and distracting abstractions that are the very fabric of an aerial perspective. With binoculars, I try pick out some of the features that flash past below me. I spot a stand of fir trees, a single golden aspen, and then the river appears and disappears from the frame of the binoculars. I find an elk in the grasses beside the river, then another and then many more—a whole herd grazing below me, their brown backs clumped together like giant oblong rocks.

In front of us the valley opens up into the distinctive U-shape that is characteristic of massive glacial activity. I try to imagine what this area must have looked like 18,000 years ago during the Wisconsin Glaciation when all the valleys were filled with ice and the enormous peaks appeared as small islands of rock in that enormous frozen ocean. As if to give form to that image, we

above: **Mountain goat**
Yoho National Park

now fly up to and over the Columbia Icefield, the largest body of ice surviving from that period. As we make our way across the vast expanse of ice, I see to the north some craggy rocks breaking the surface of the ice: the apex of a 3,500-metre mountain. We skirt around them and quickly swoop down a tongue of ice into a valley of rich colour. The glacier ends abruptly at a lake of the most shockingly vivid greens and blues that I have ever seen.

The Canadian Rockies is a world defined by abrupt transitions and startling juxtapositions. It seems that every instance of shape, colour, light or temperature in the mountain world is made up of opposites: the gleaming surface of an icy glacier co-existing beside the dark tones of limestone and dolomite; delicate and fragile plants nestling in the shadows of giant peaks. Opposites abound. But so do harmonies.

In this book I hope to share some of the compelling sights, shapes, colours and patterns that have excited me for the past few decades. Although I was born in Banff and have lived in the Canadian Rockies most of my life, every day continues to bring new combinations of elements—from a flash of sun on a distant, shadowed peak, to the sudden appearance of a yellow crocus breaking through a crust of snow—that make me appreciate, all over again, just how beautiful and enduring this mountain world truly is.

above: **Alpine Silky Phacelia (*phacelia sericea*)**
Waterton Lakes National Park

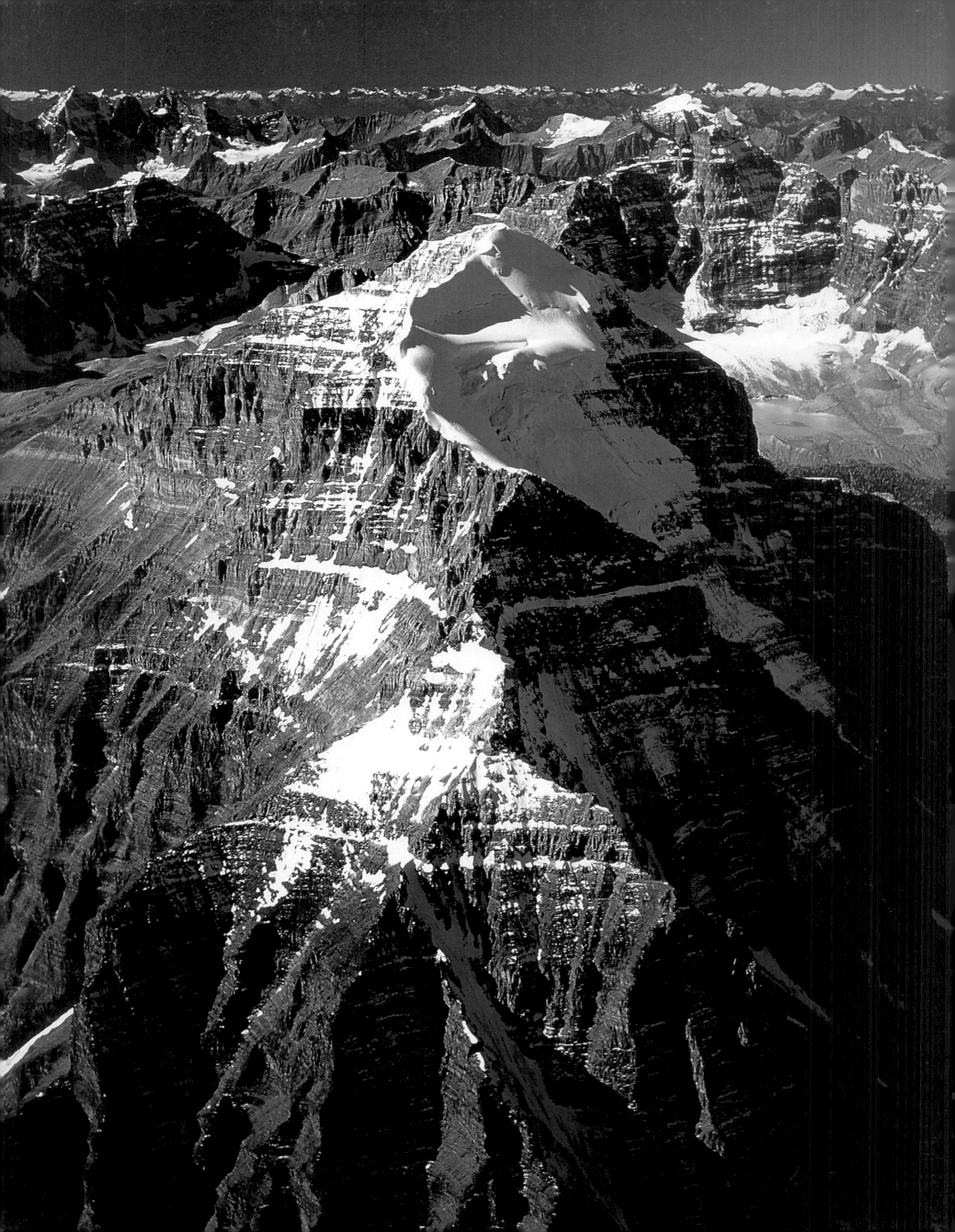

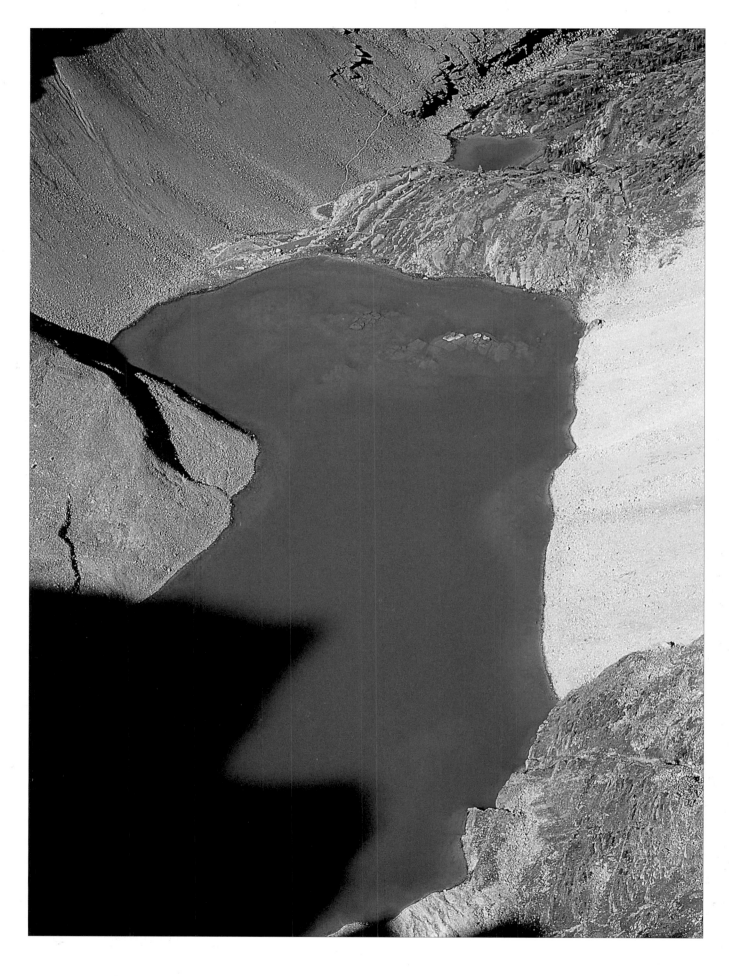

opposite: **Mt. Temple above Lake Louise**
Banff National Park

above: **Lake Oesa**
Yoho National Park

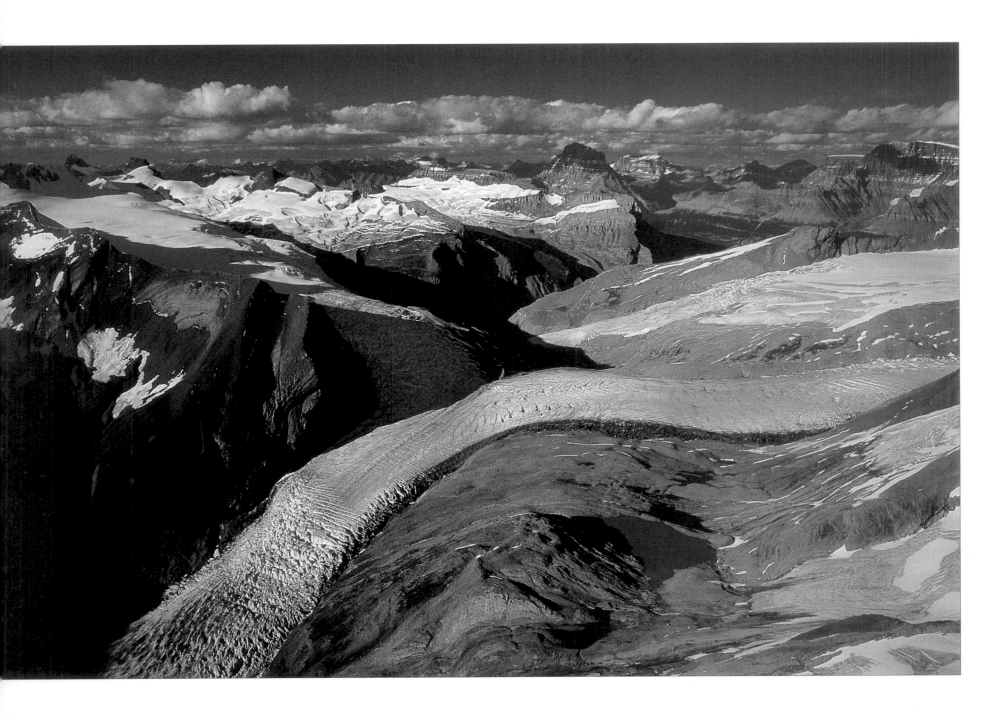

above: **Glacier, Clemenceau Icefield**
British Columbia

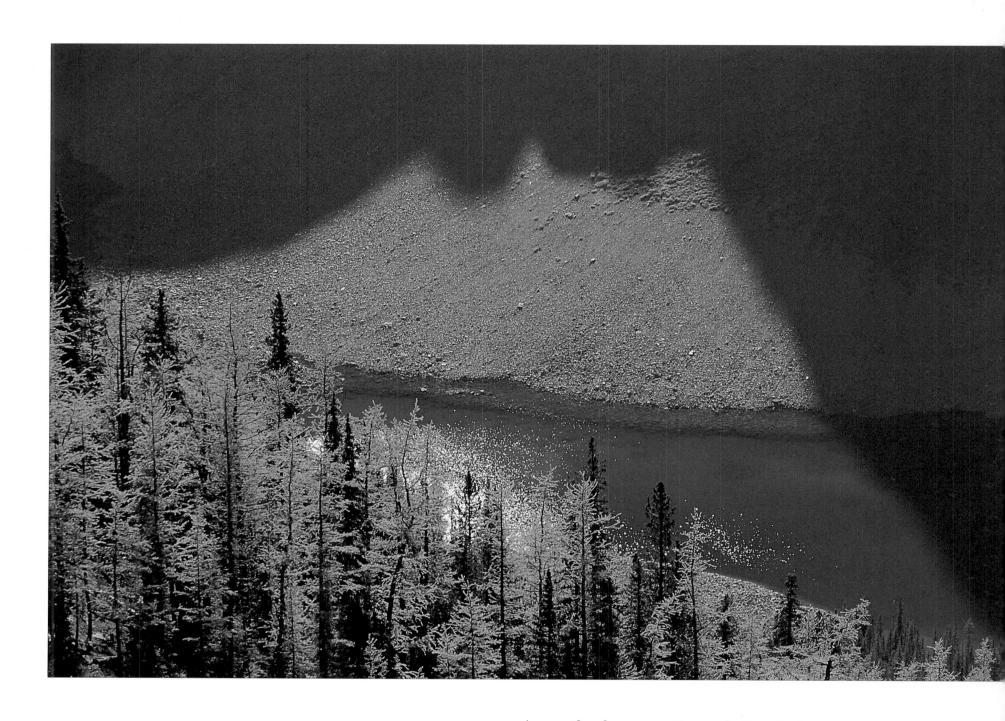

above: **Shadows on Consolation Lake**
Banff National Park

next pages: **Great grey owl carrying prey**
Banff National Park

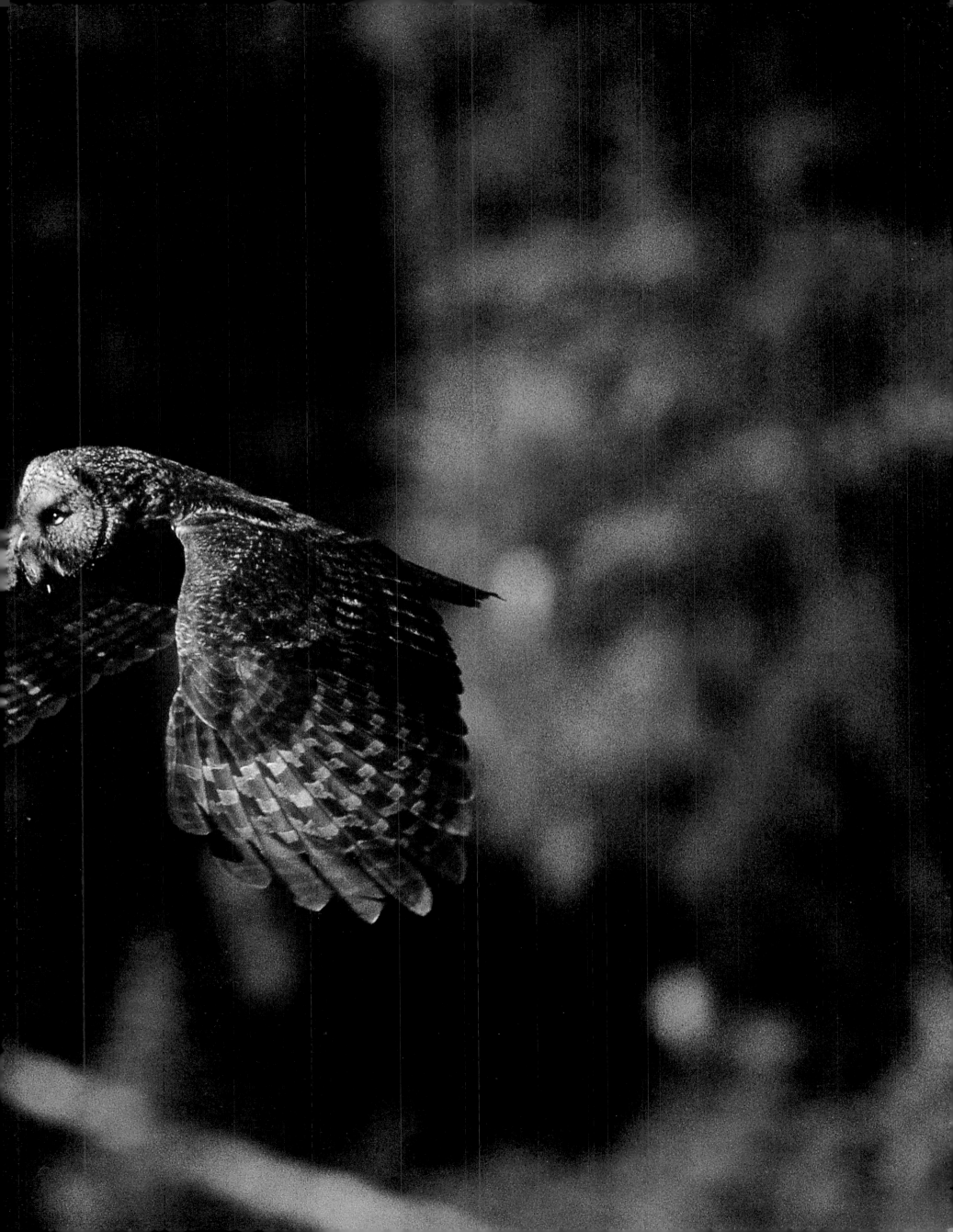

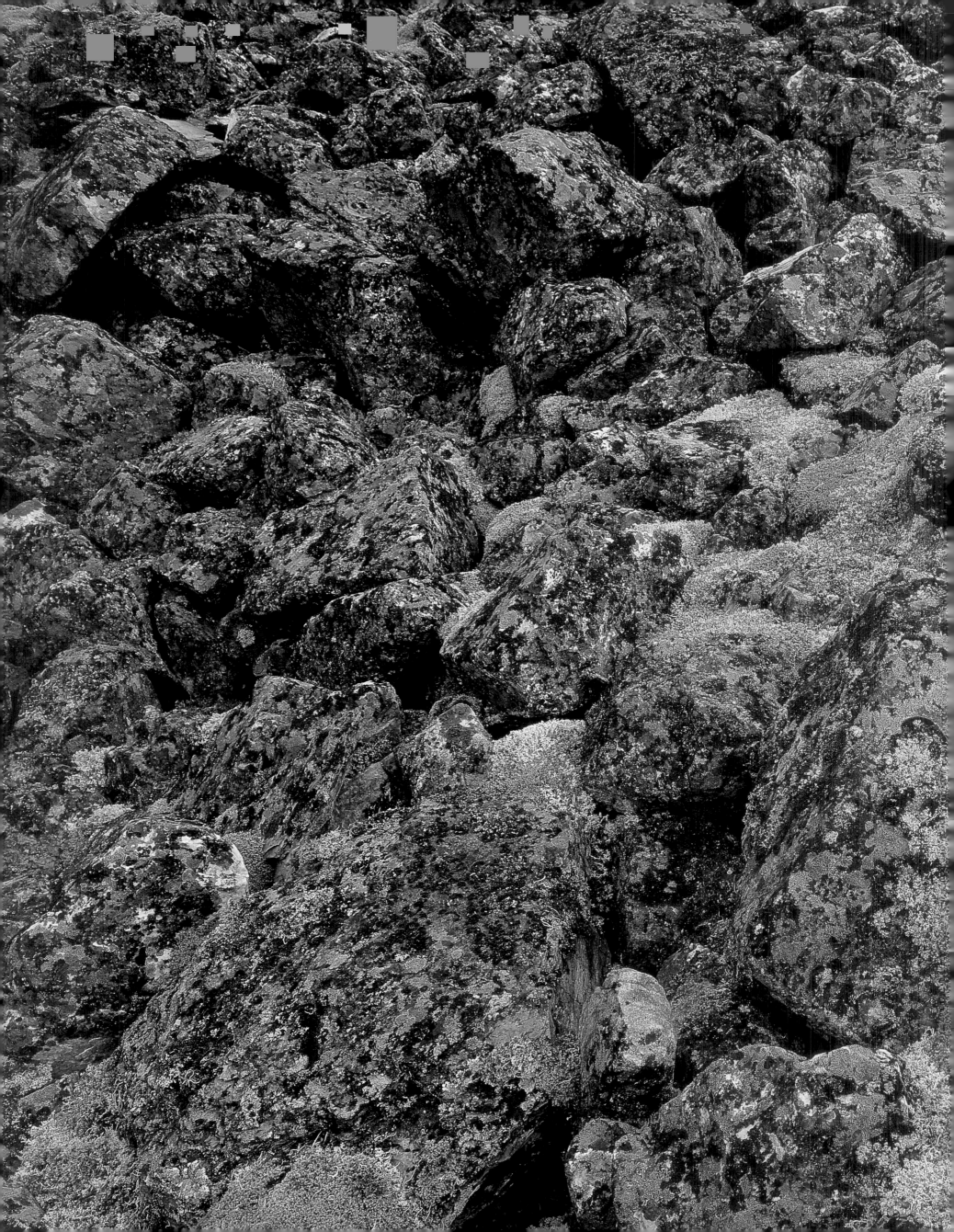

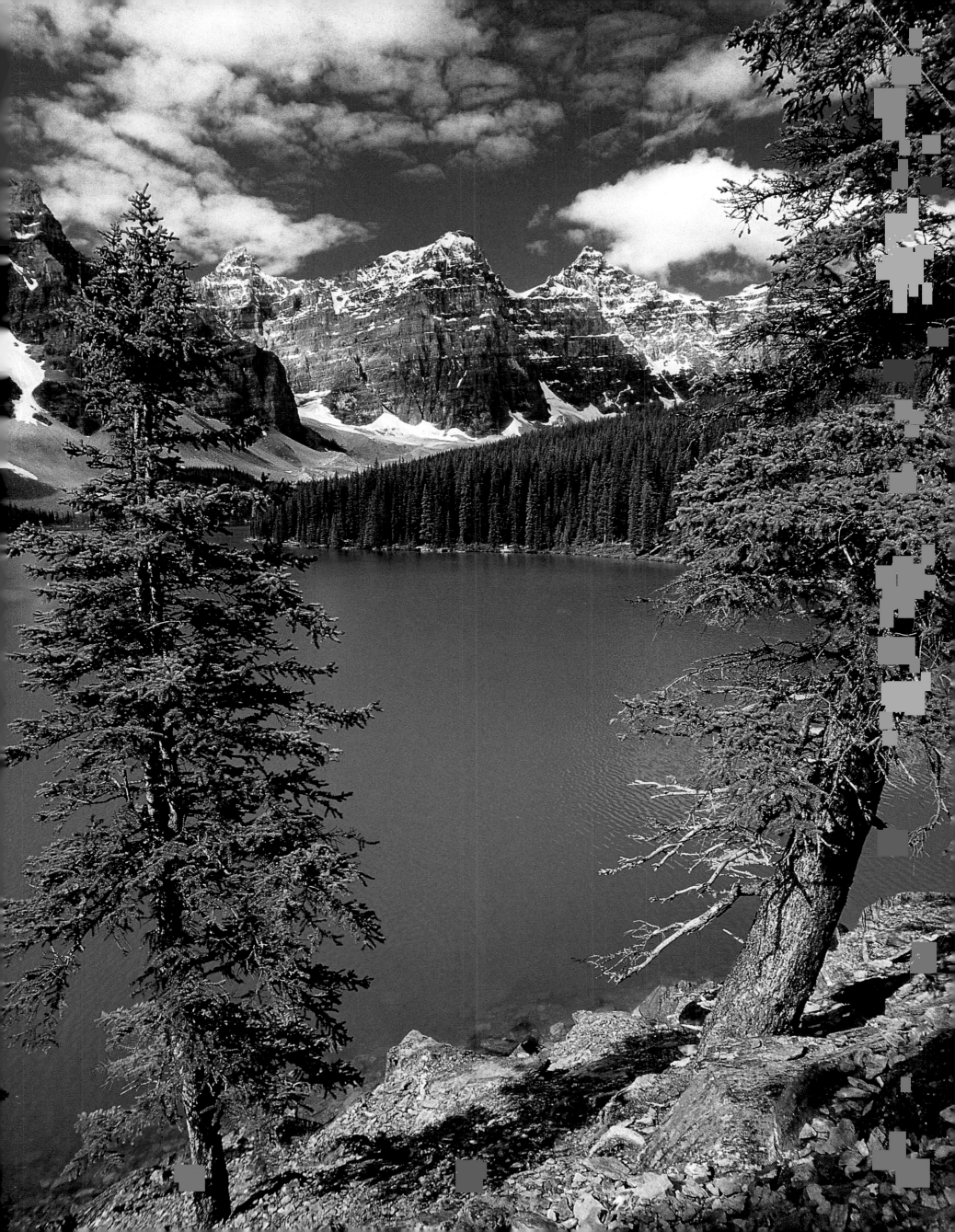

above: **Olive Lake**
Kootenay National Park

above: **Last autumn leaves, Olive Lake**
Kootenay National Park

next pages: **Spirit Island, Maligne Lake**
Jasper National Park

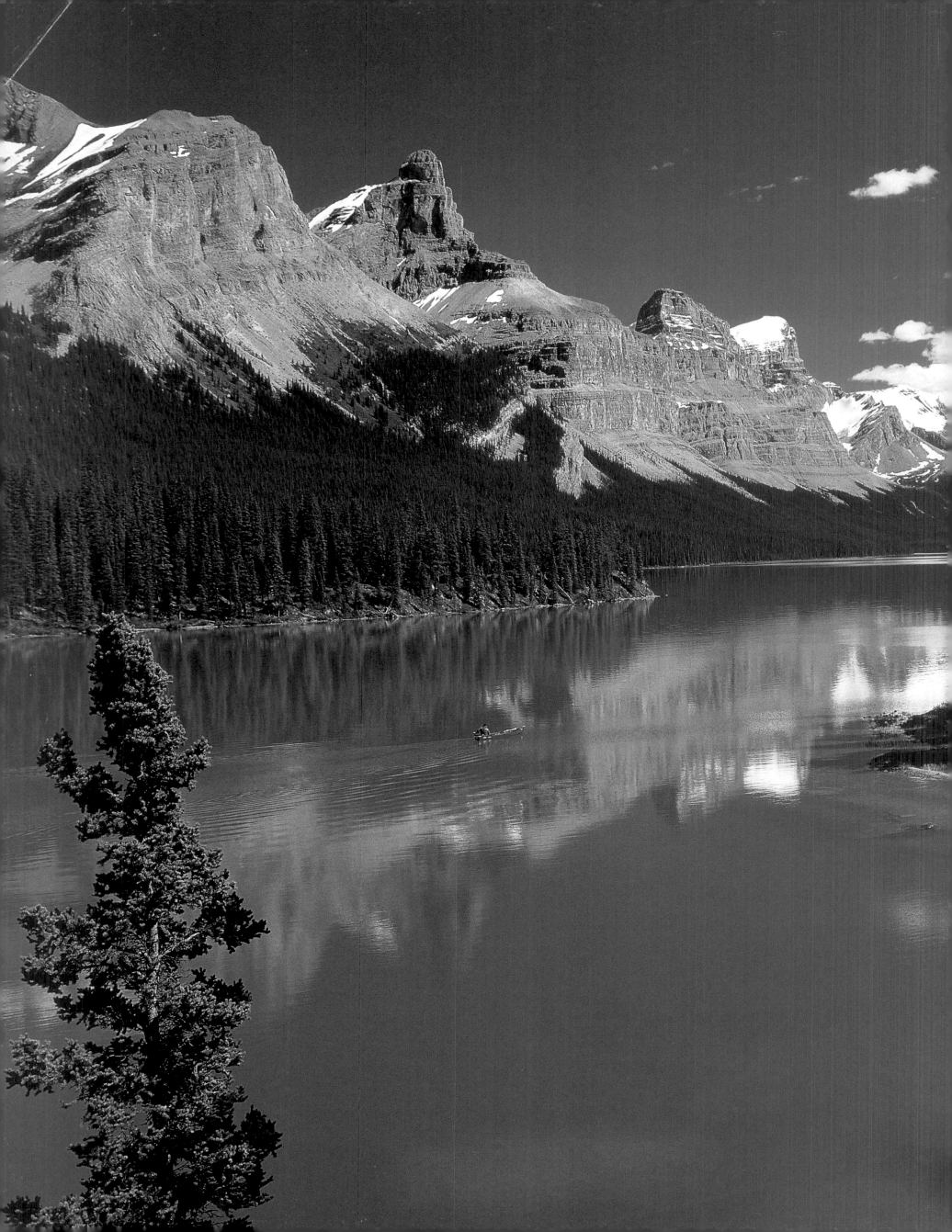

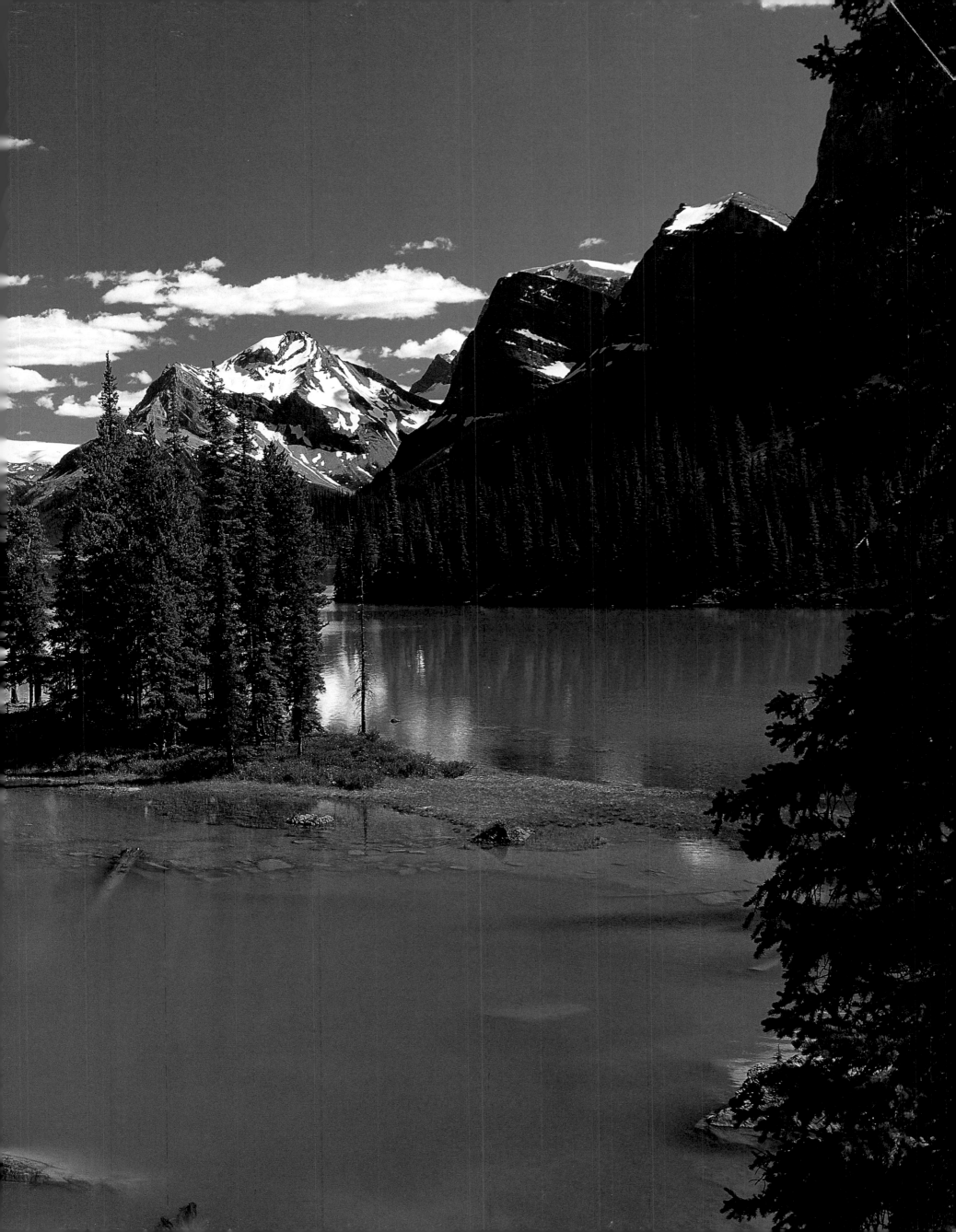

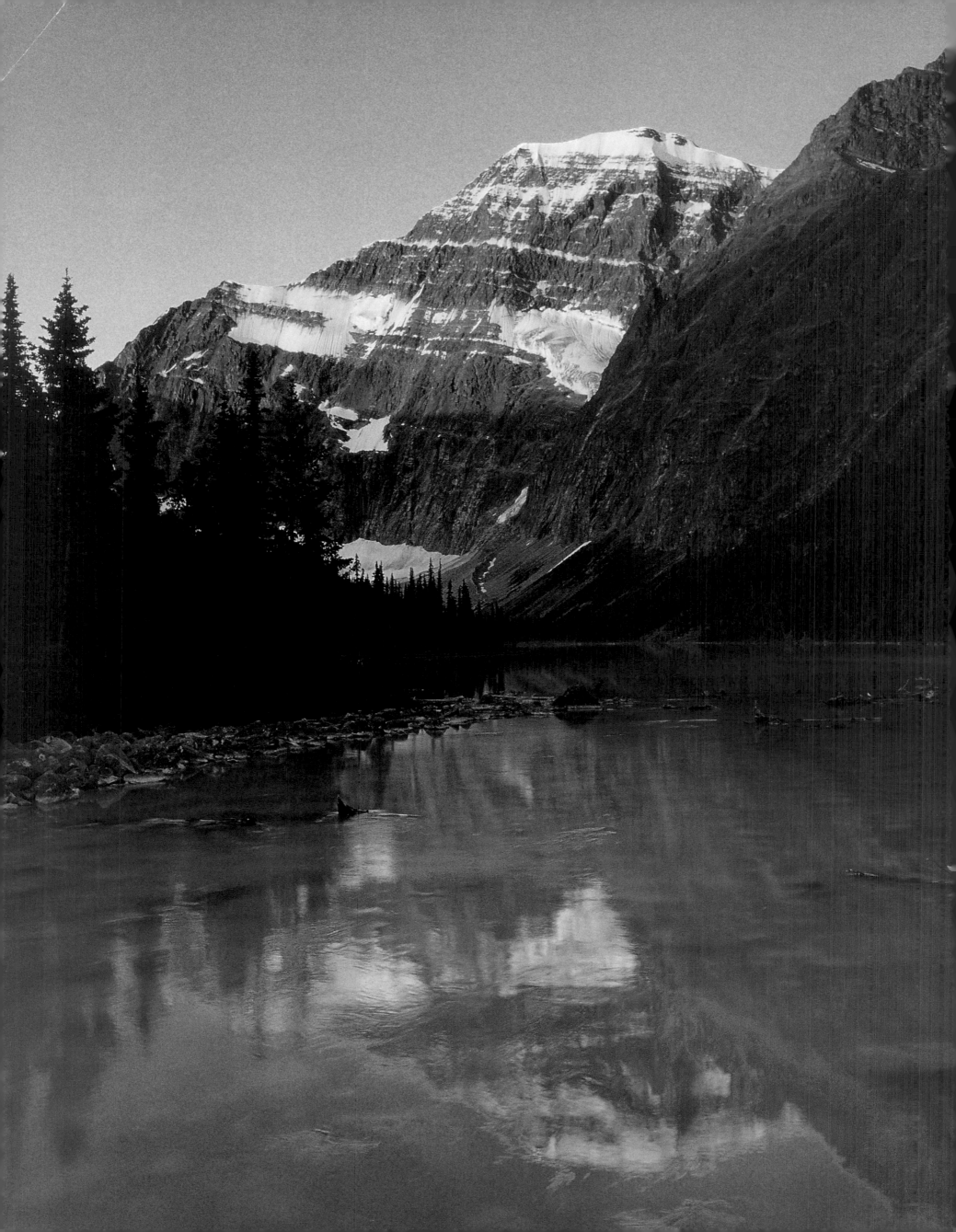

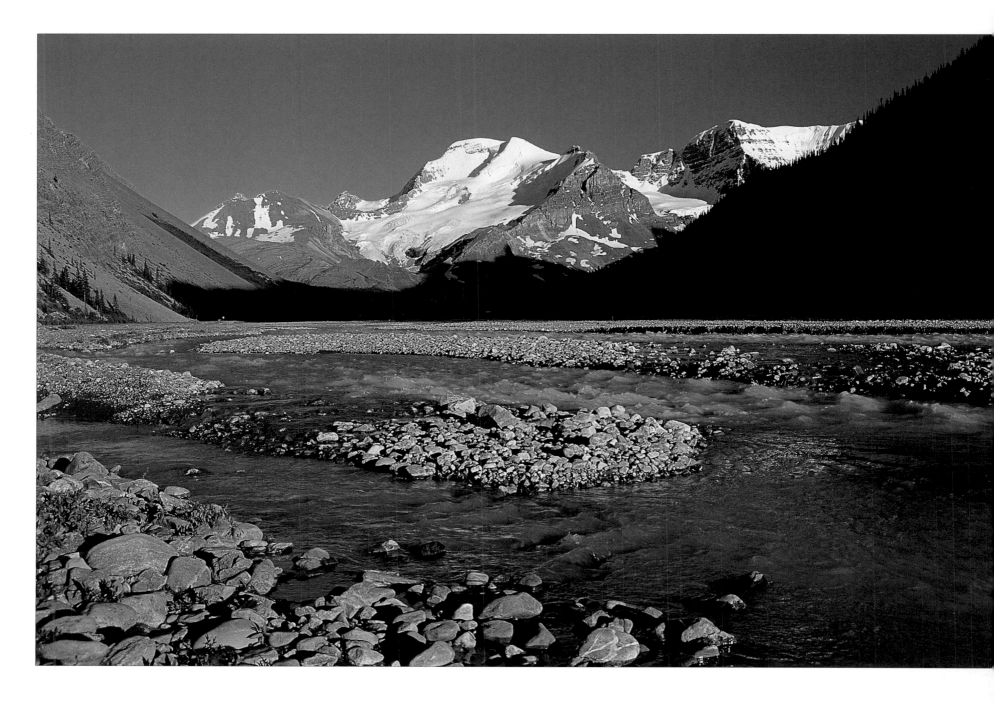

opposite: **Mt. Edith Cavell**
Jasper National Park

above: **Mt. Athabasca, Sunwapta River**
Jasper National Park

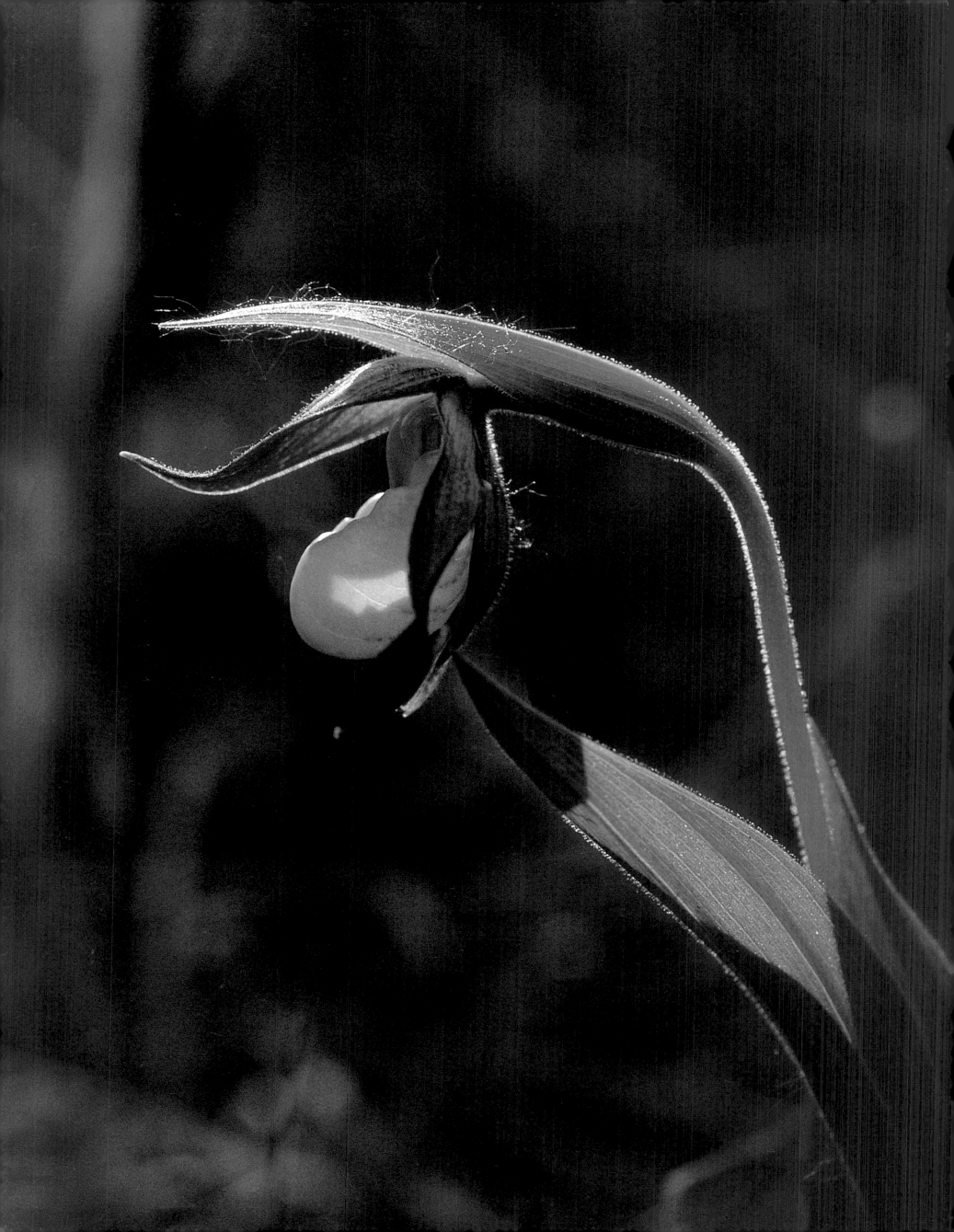

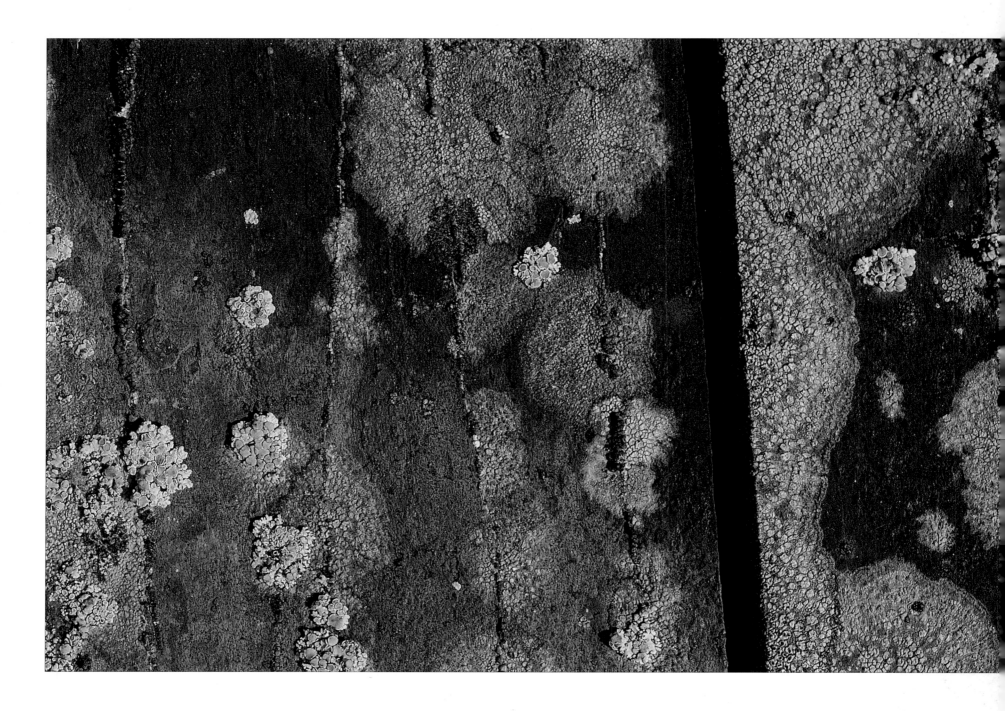

opposite: **Yellow Ladyslipper**
Banff National Park

above: **Lichen on rock**
British Columbia

next pages: **Mitchell Range, Kootenay River**
Kootenay National Park

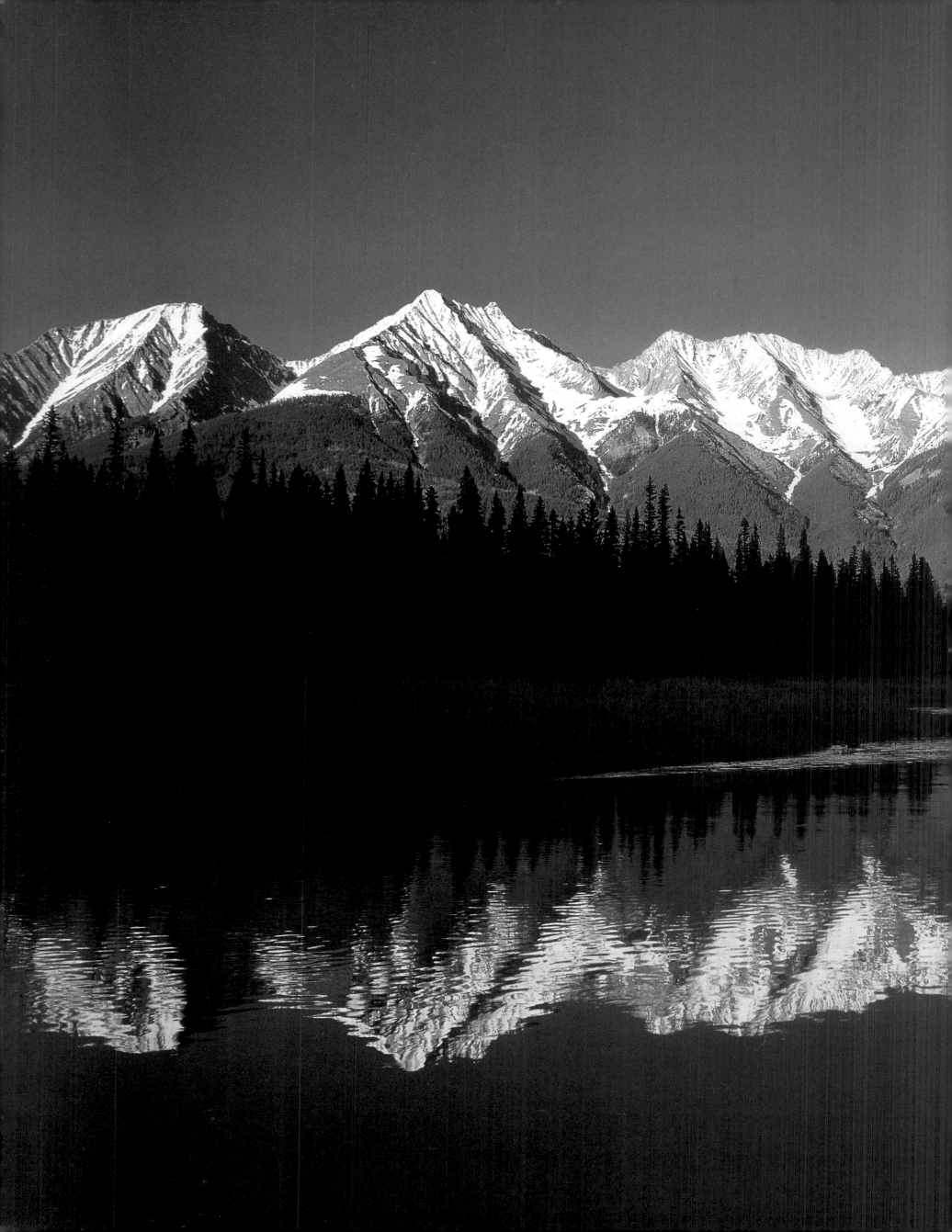

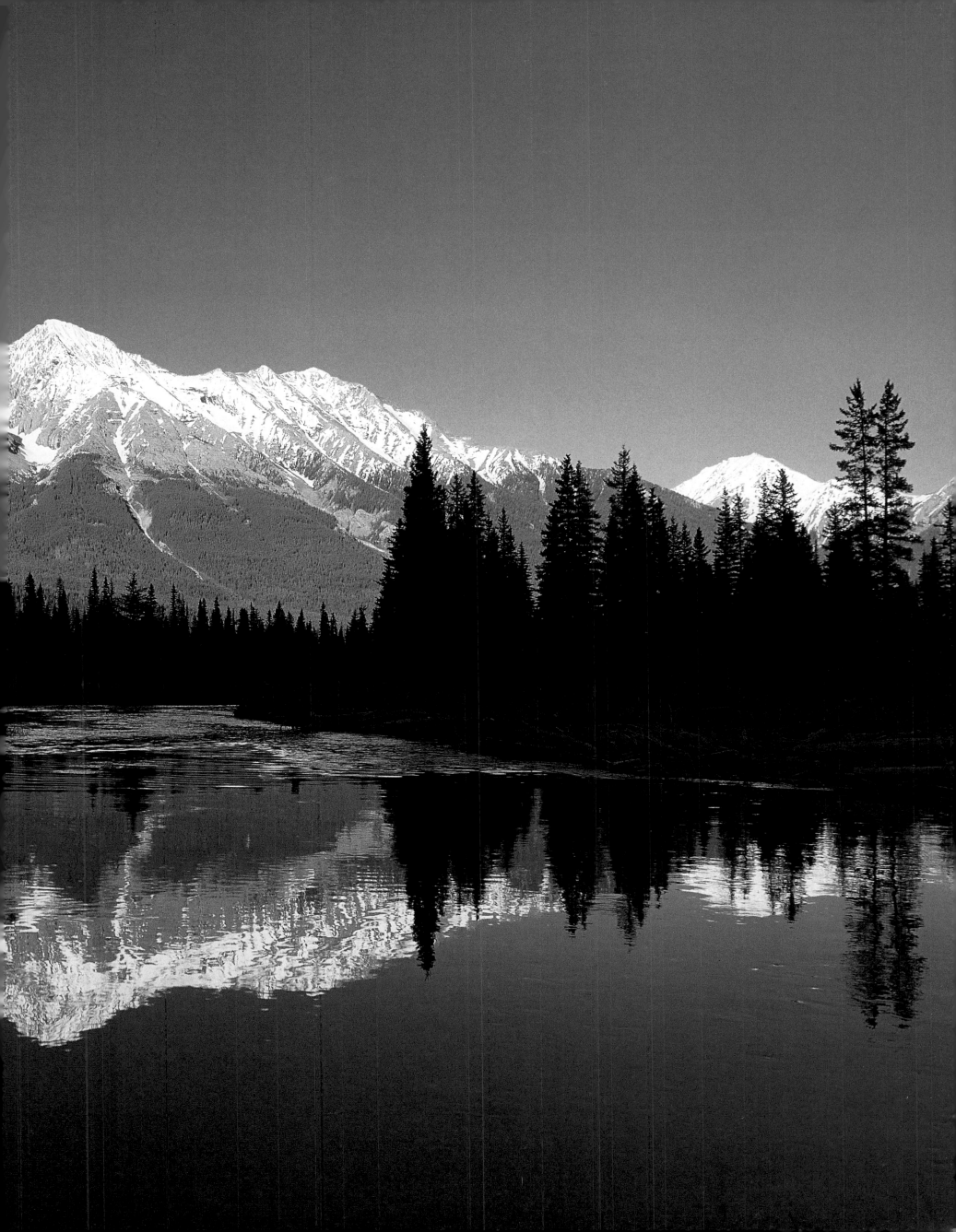

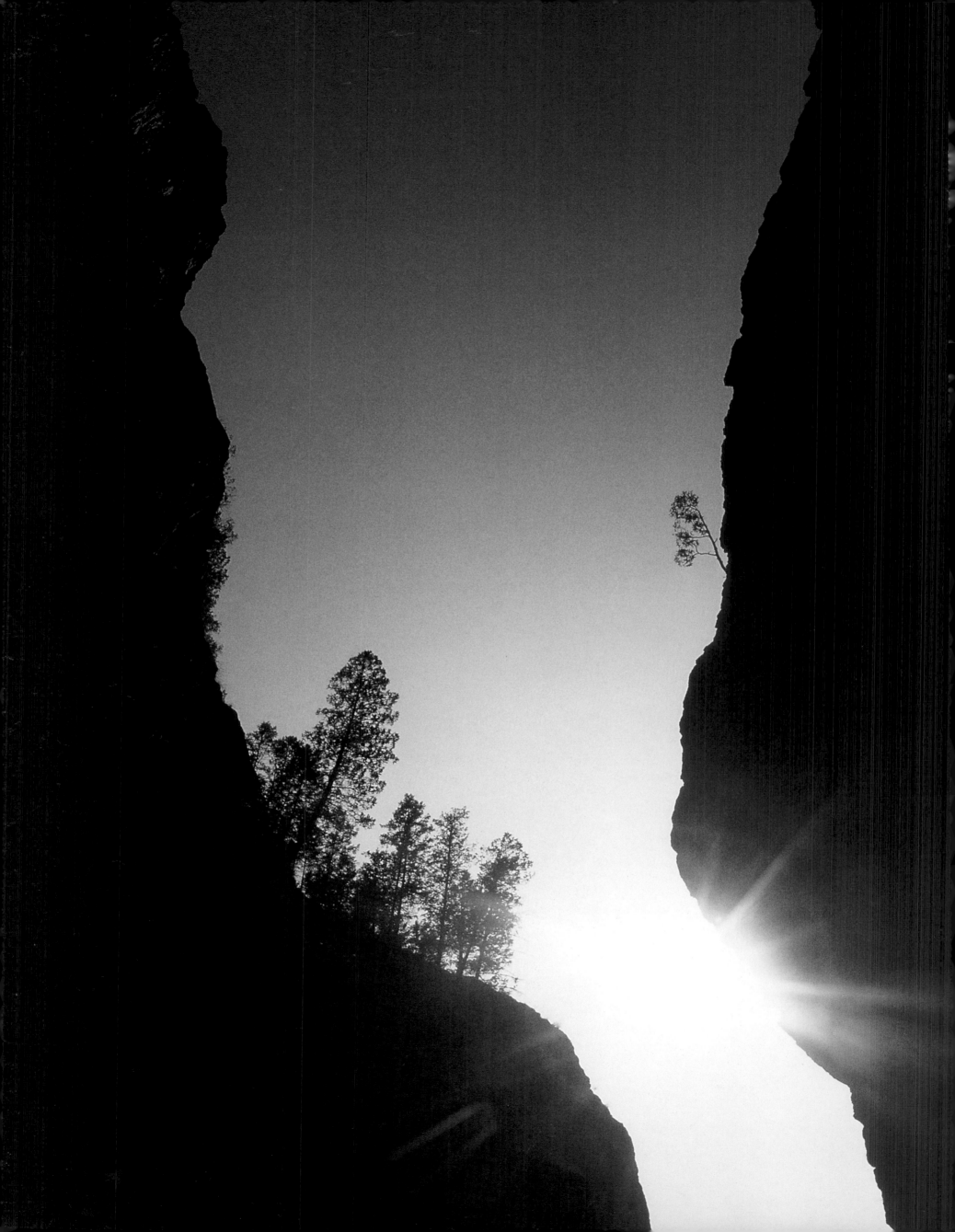

opposite: **Sinclair Canyon**
Kootenay National Park

above: **Sunwapta Falls**
Jasper National Park

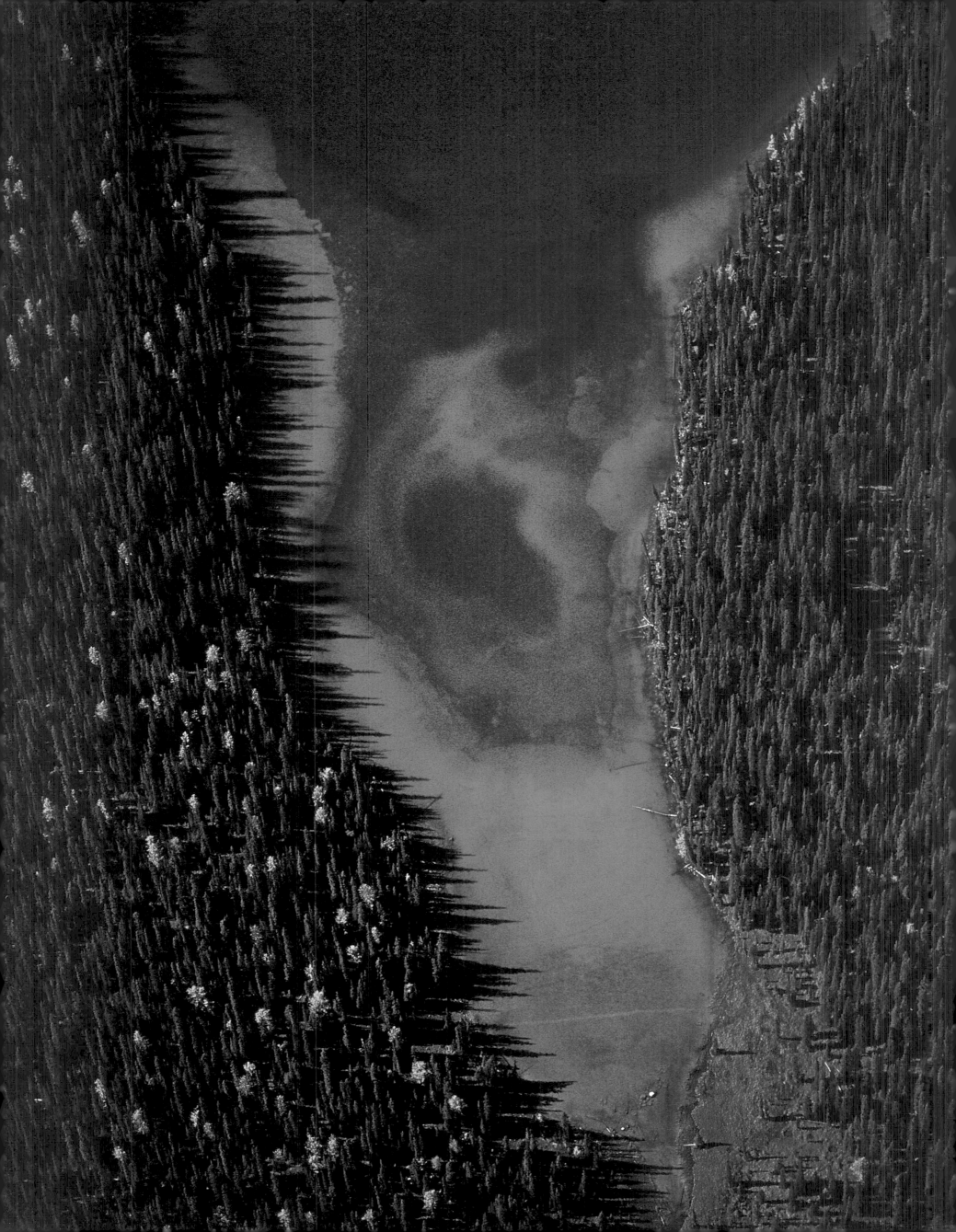

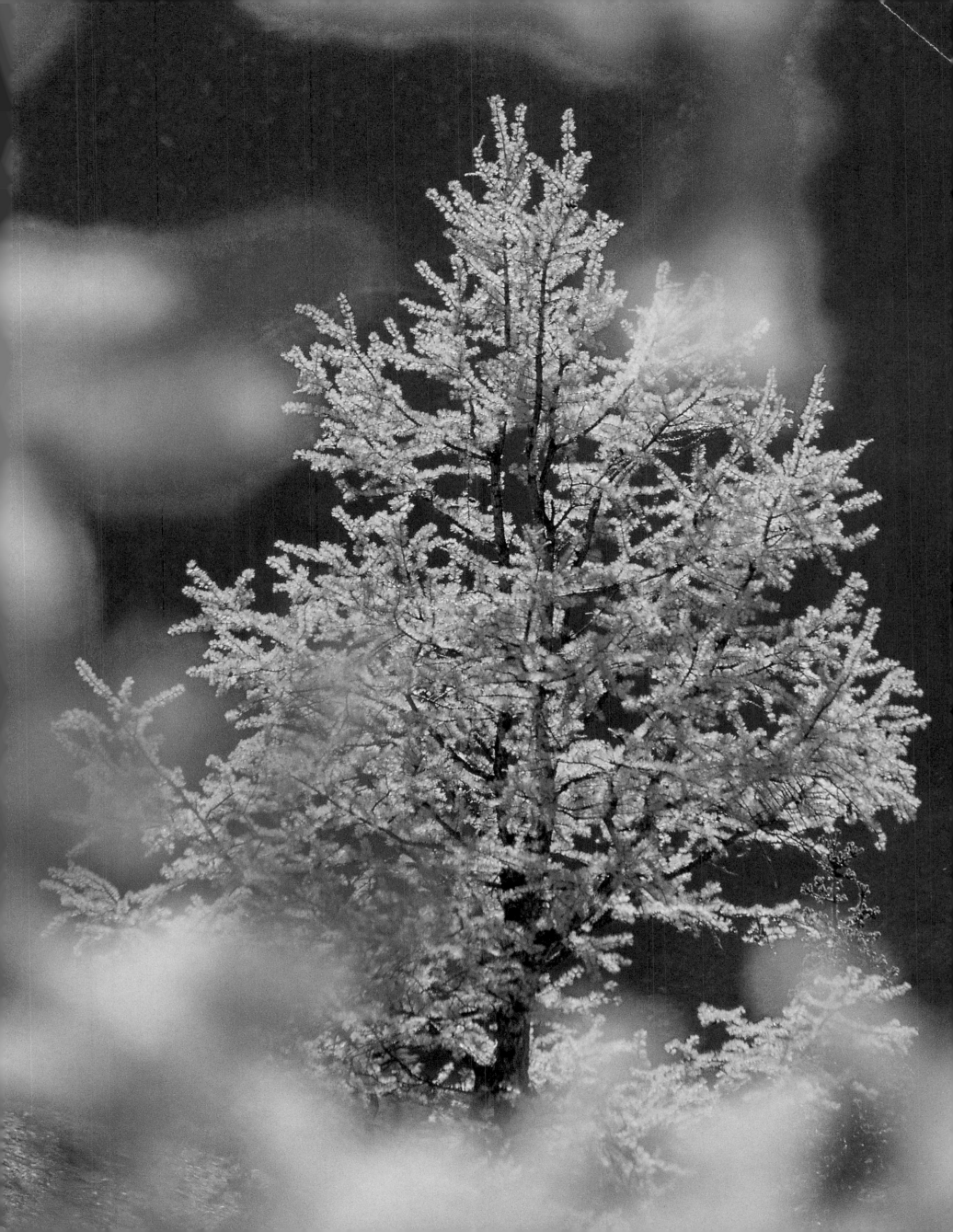

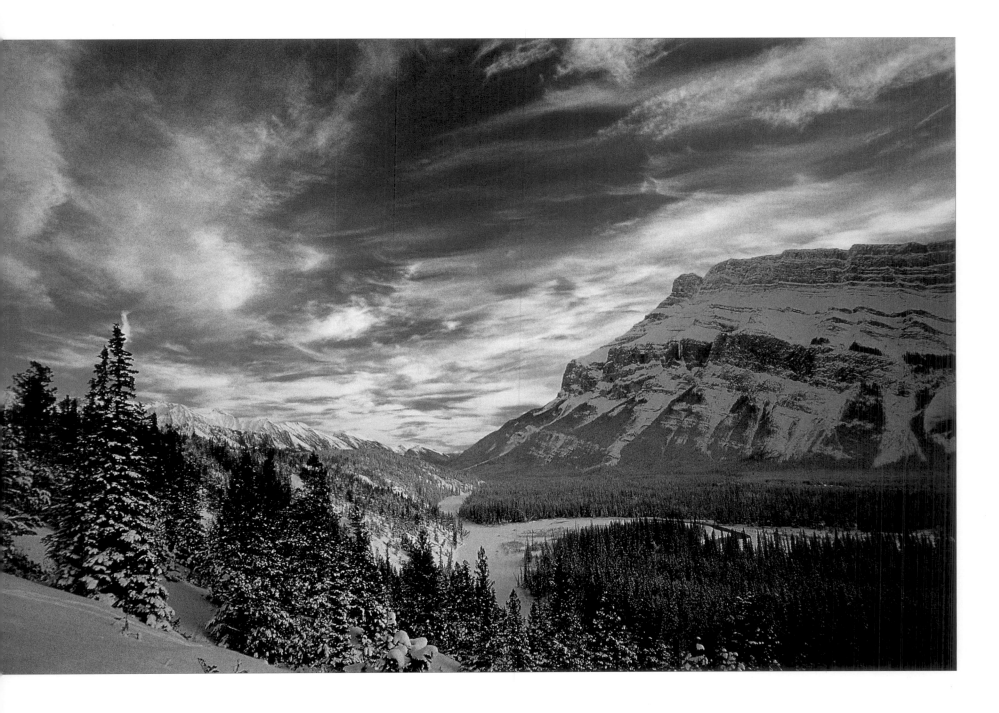

above: **Mt. Rundle, Bow Valley**
Banff National Park

previous page left: **Lower Twin Lake**
Banff National Park

previous page right: **Subalpine Larch**
Banff National Park

WINTER

When a clear morning breaks after a fresh snowfall, the Canadian Rockies look impossibly majestic and immaculate. The brilliant white snow is contrasted against a deep cobalt-blue sky. From foreground features to distant peaks, the snow applies a smooth covering that masks surface details while emphasizing the overall shape and contour of the alpine world. Under a mantle of snow, rivers and lakes lie flat and broad, the deep tones of coniferous trees become soft and muted, and the land all around lies quiet and still. In the distance, the mountains rise skyward peak after peak, like whitecapped waves in an unending ocean of snow.

Above the montane valley bottoms, when snow buries most of the landscape, building up wherever there is enough surface to hold it, photographers may be able to find new details traced by the snow along cliff faces, on the tops of mountains and in the textures of forests. The white of winter reflects the colours of dawn and dusk, making a moonlit landscape visible at night, and organizing the details of the world into a unified whole. With luck, one can find delicate tracks that lead to the beady black eye of an otherwise invisible white ptarmigan, or bigger tracks that lead to a snow-white snowshoe hare. Even without the animal, the tracks themselves are

revealing as they criss-cross the surface of the snow, creating silent stories in their path. At times like this, winter is like an open book.

On a cold winter morning when the temperature is -20°C, the air is frequently crisp and clear. One can see the details on a rock cliff from across the valley. When it is colder, the air can turn into a crystalline fog. Your breath can freeze; the landscape is shrouded as if by a veil of ice.

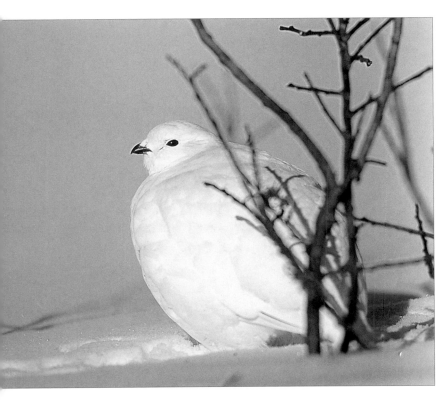

But all of this winter freeze can disappear in a moment when the chinook winds that flow eastward from the Pacific Ocean descend the eastern slopes of the Rockies onto the plains. Then the temperature rises and continues to rise, so that over the course of a few scant hours the southern Canadian Rockies can be bathed in warm spring-like air. The snows in the valleys start to melt, and if the chinook stays for a few days, the rivers open up and start to flow, until, the chinook departs and the alpine world is returned to the cold grasp of a winter's freeze.

The eastern slopes of the Rockies are home to large numbers of bighorn sheep, elk and deer. They are able to find winter grazing and browsing range on the open, windswept ridges of the high country as well as in the dry montane valley bottoms where snow levels are typically thin. Elk in particular can frequently be found grazing in Jasper's lower Athabasca Valley and Banff's lower Bow and North

above: **White-tailed ptarmigan in winter plumage**
Jasper National Park

Saskatchewan and upper Red Deer valleys.

Wolves follow the elk, and late winter is their prime travelling season. The hard snow crusts created by chinook weather allow them to travel easily and to hunt the elk and other hard-hoofed animals whose progress is slowed when they break through those same crusts. Conversely, when the snow is soft and deep, wolves can take advantage of cleared routes like railway tracks and roads, and packed paths like ski trails, to travel long distances in pursuit of large game. Sometimes one can spot wolves crossing a frozen lake or river, leaving a perfectly straight line of tracks in the snow.

In winter, photographers face a number of novel challenges. Short days limit outdoor shooting to just a few hours at a time. The low angle of the sun means that there are many places that never emerge from deep shadow until the sun rises higher in the sky. Sometimes cameras and fingers freeze, or an errant breath fogs a lens with instant ice.

But these challenges are minor compared to the potential rewards. Sensational eastern slope sunrises, cold snap sunsets that cast a warm alpenglow on the tips of the frozen peaks, or the clear white snowbank with a deep, rich blue shadow of a fir arching up its side—these are worth all the inconvenience that winter throws your way.

above: **Snowshoe hare tracks**
Banff National Park

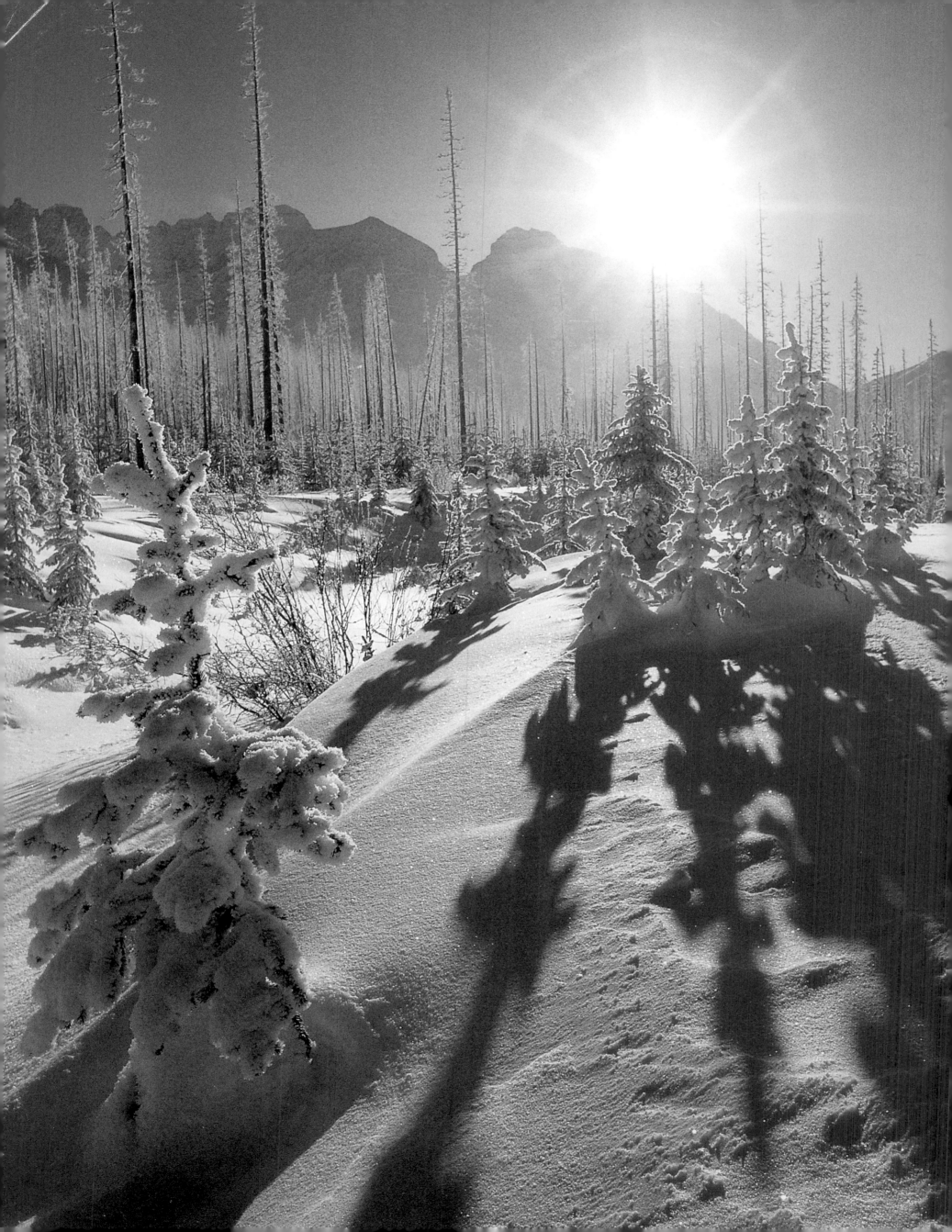

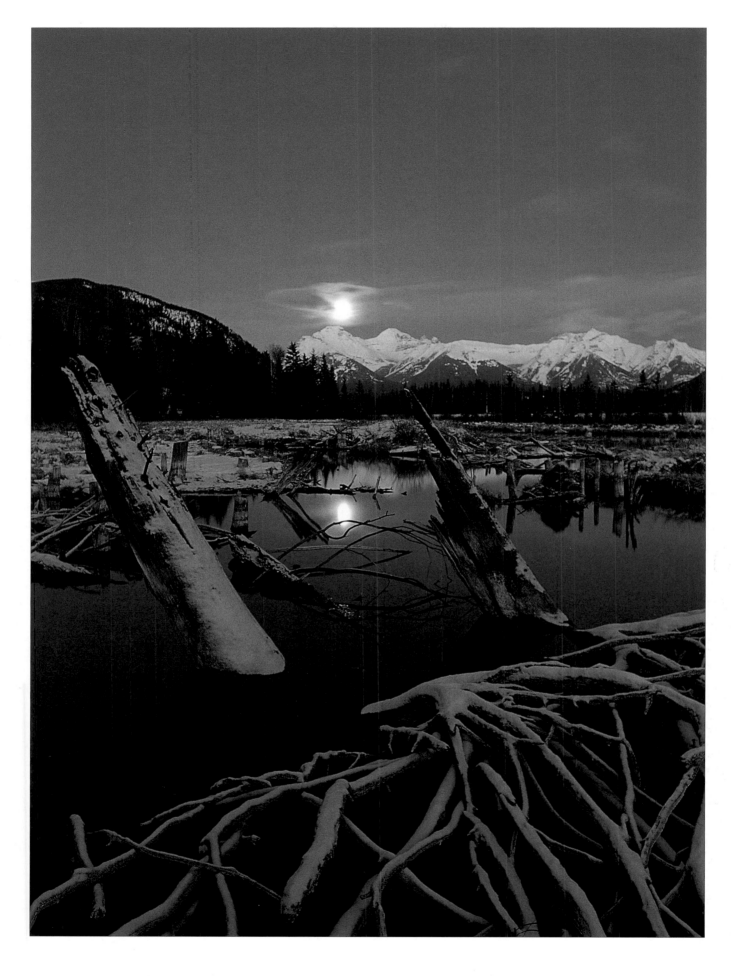

opposite: **Vermilion Pass**
Banff National Park

above: **Fairholme Range, Vermilion Lakes**
Banff National Park

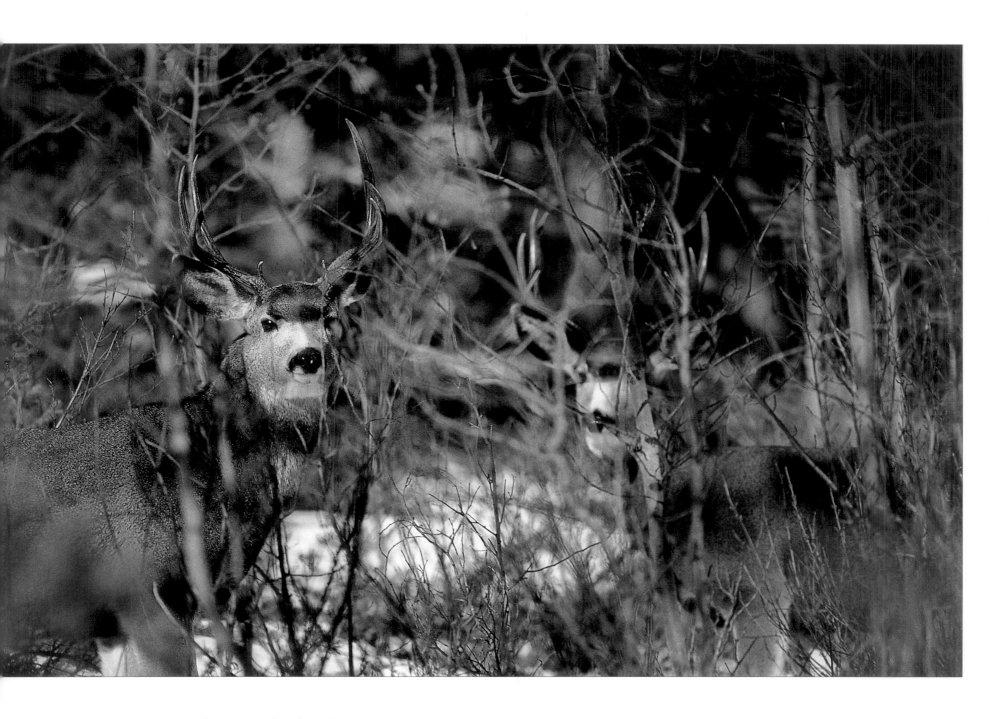

above: **Mule deer bucks**
Banff National Park

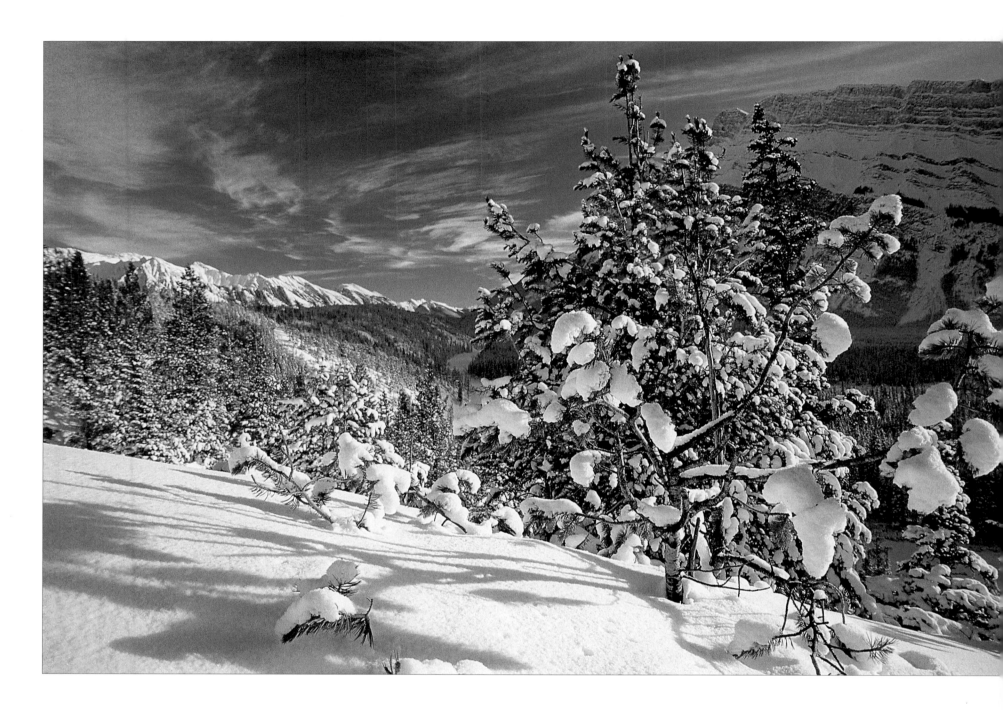

above: **The Bow Valley and Mt. Rundle**
Banff National Park

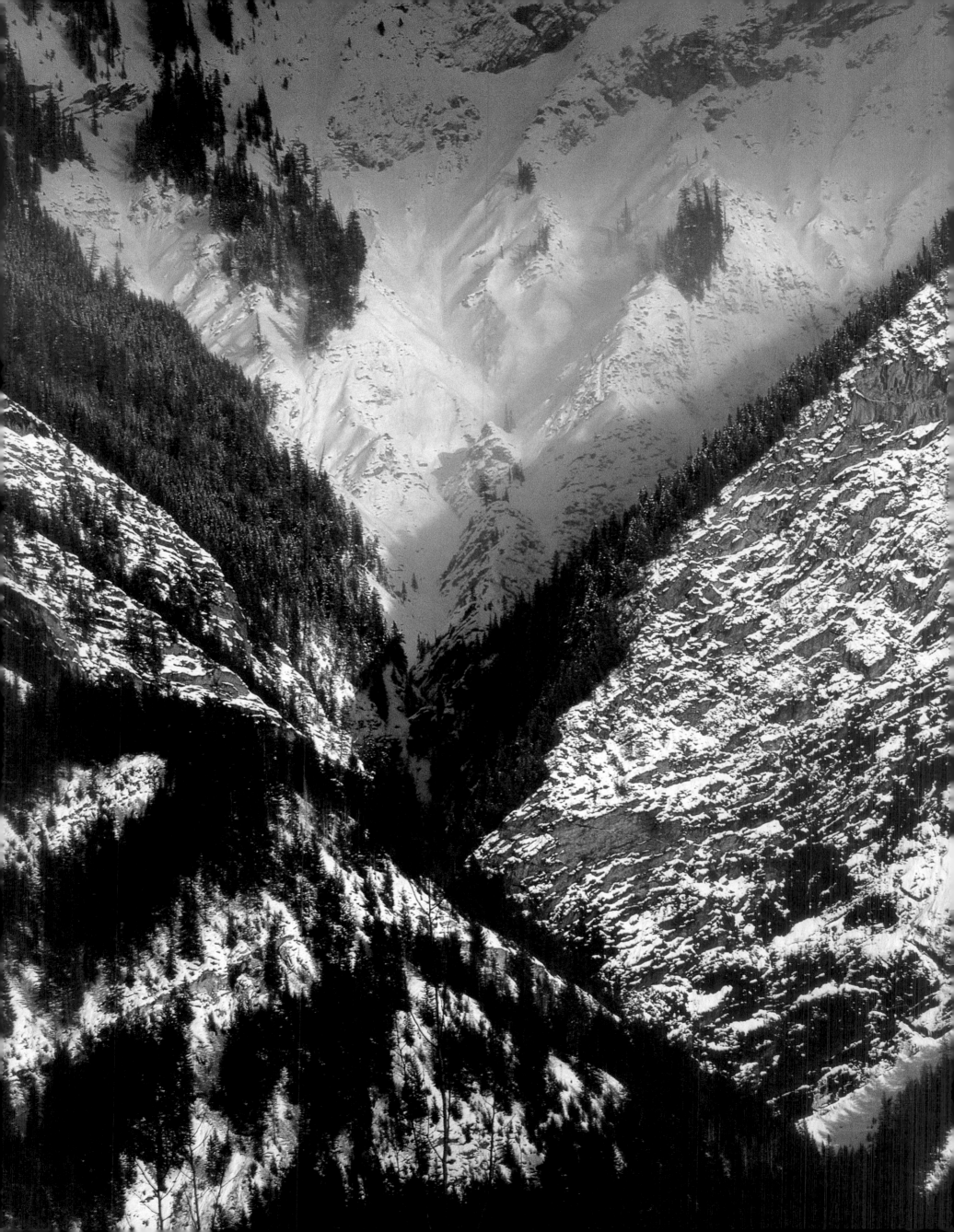

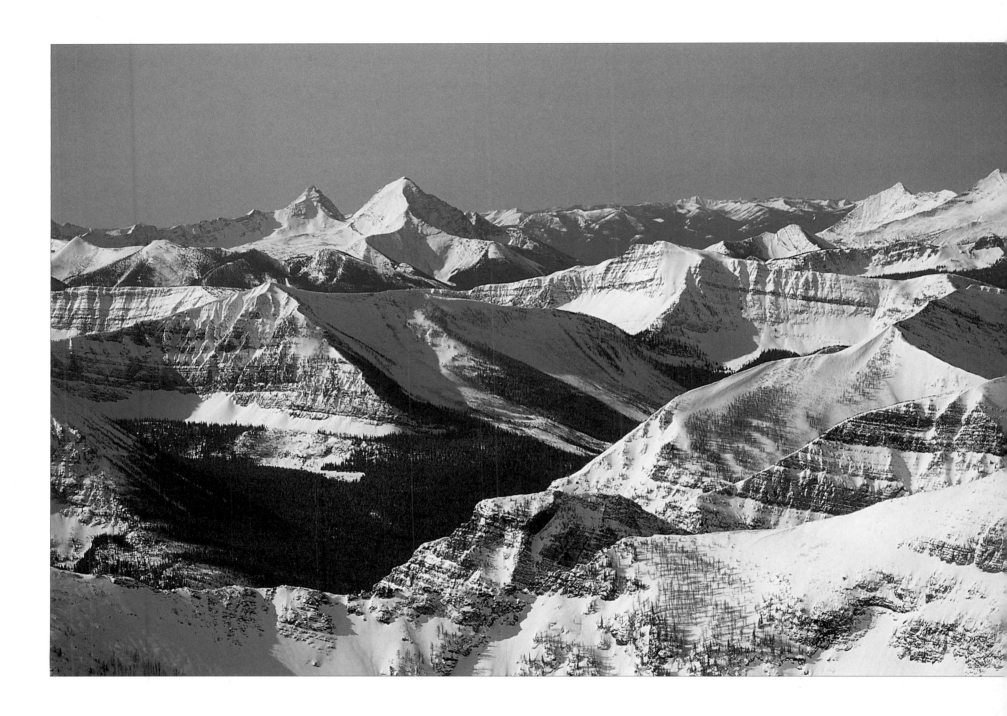

above: **Peaks above Highwood Pass**
Peter Lougheed Provincial Park

opposite: **Cliff patterns, Blaeberry Valley**
British Columbia

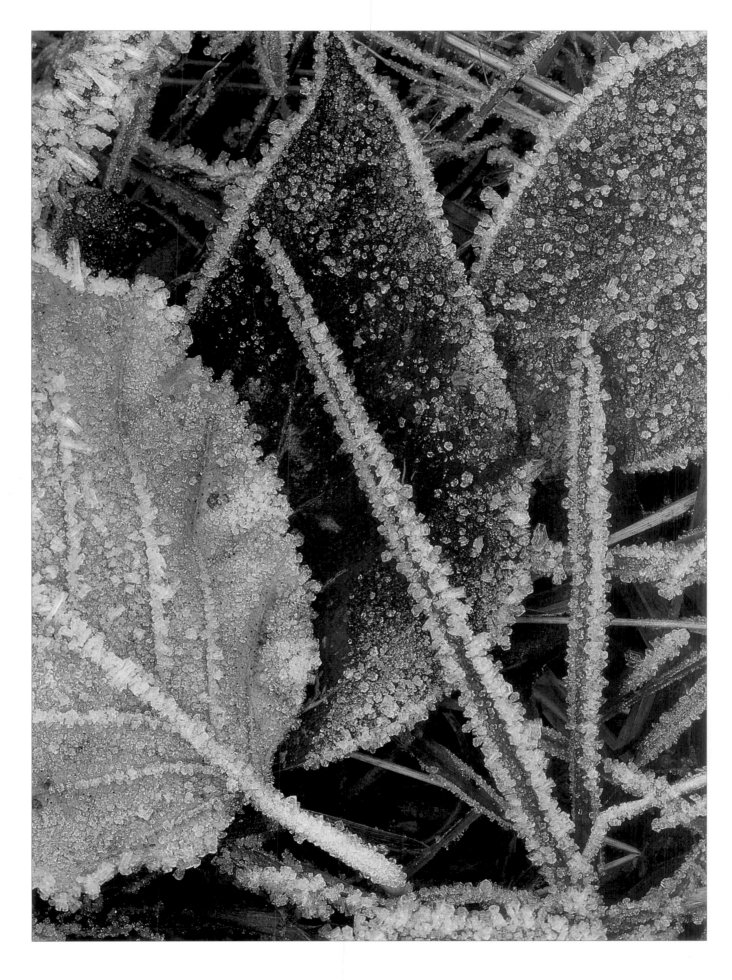

above: **Frosted leaves**
Yoho National Park

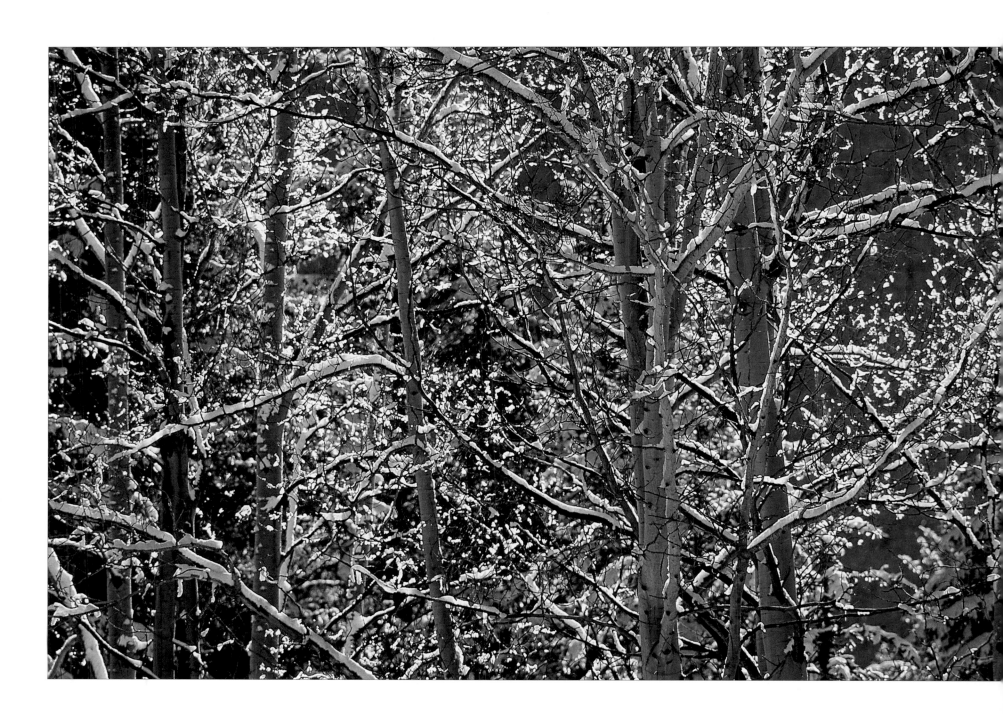

above: **Snow-covered aspens**
Banff National Park

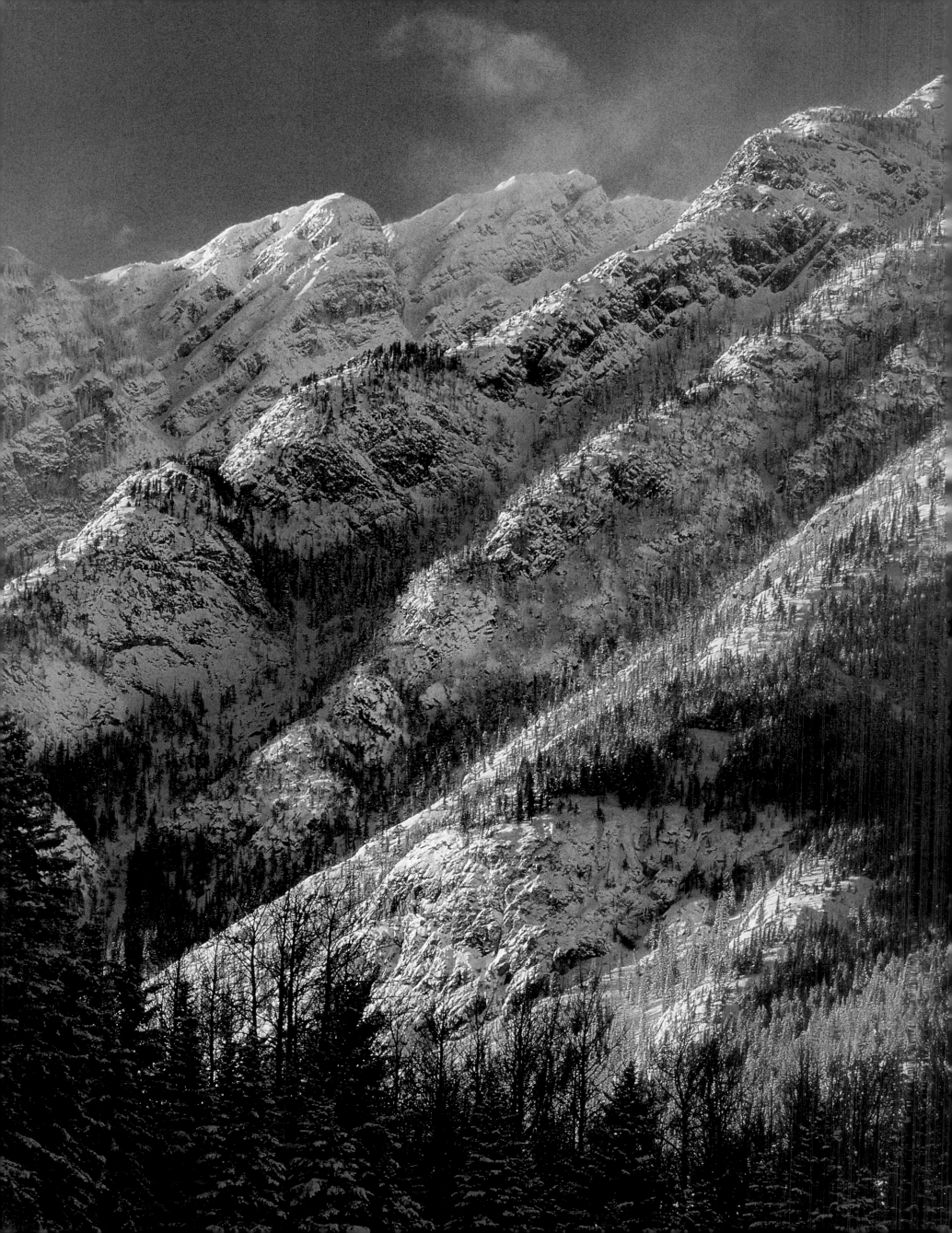

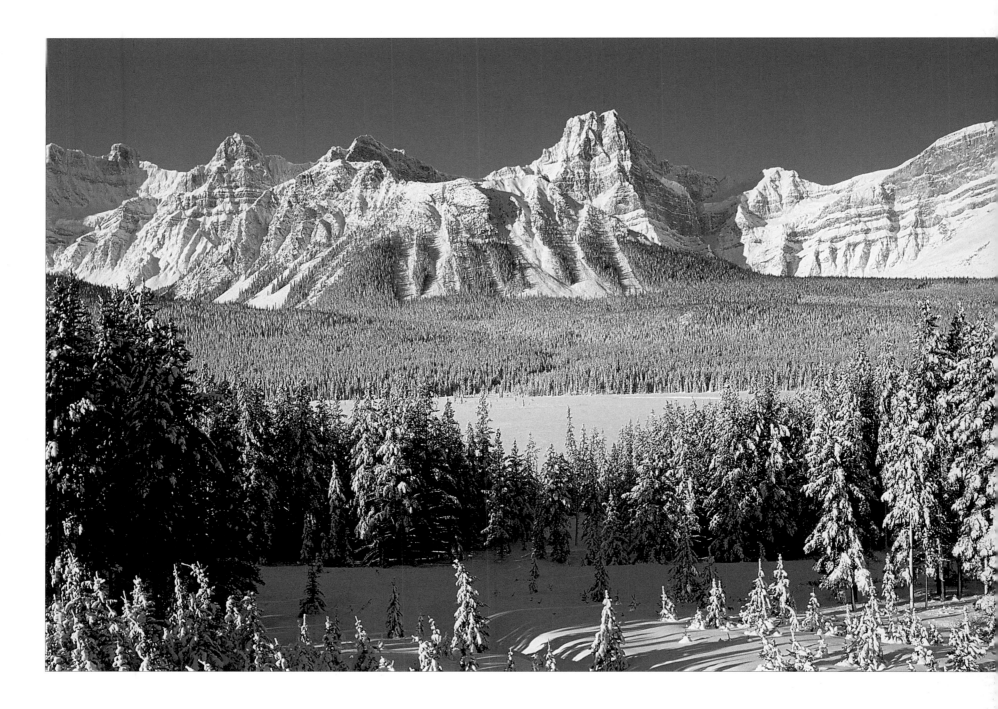

above: **Upper Waterfowl Lake, Howse Peak**
Banff National Park

opposite: **Ridges on Mt. Norquay**
Banff National Park

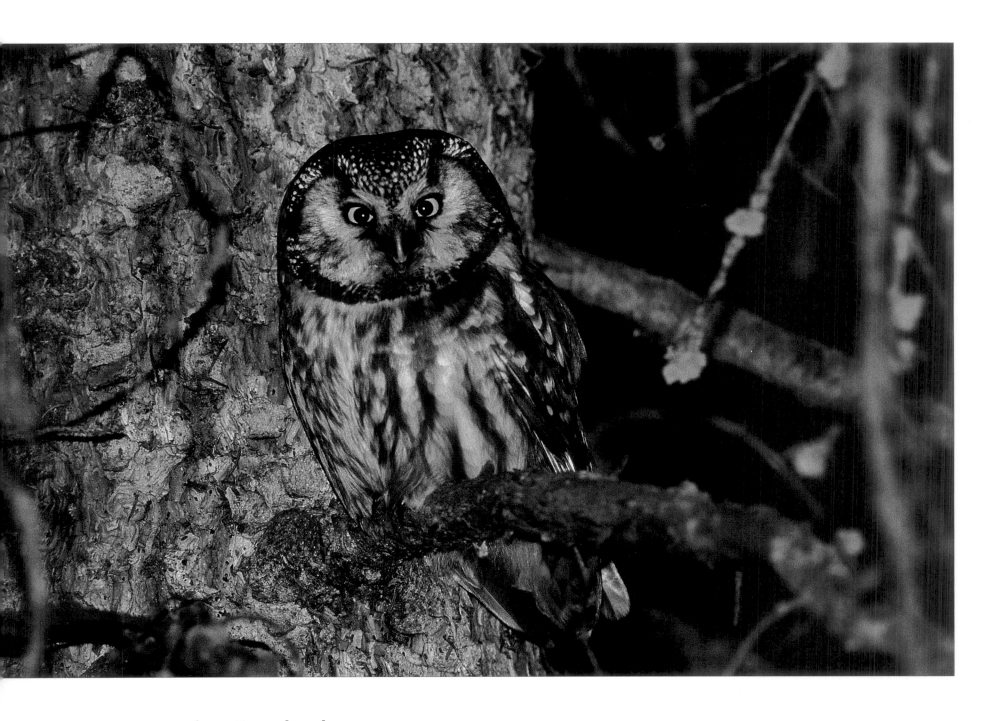

above: **Boreal owl**
Banff National Park

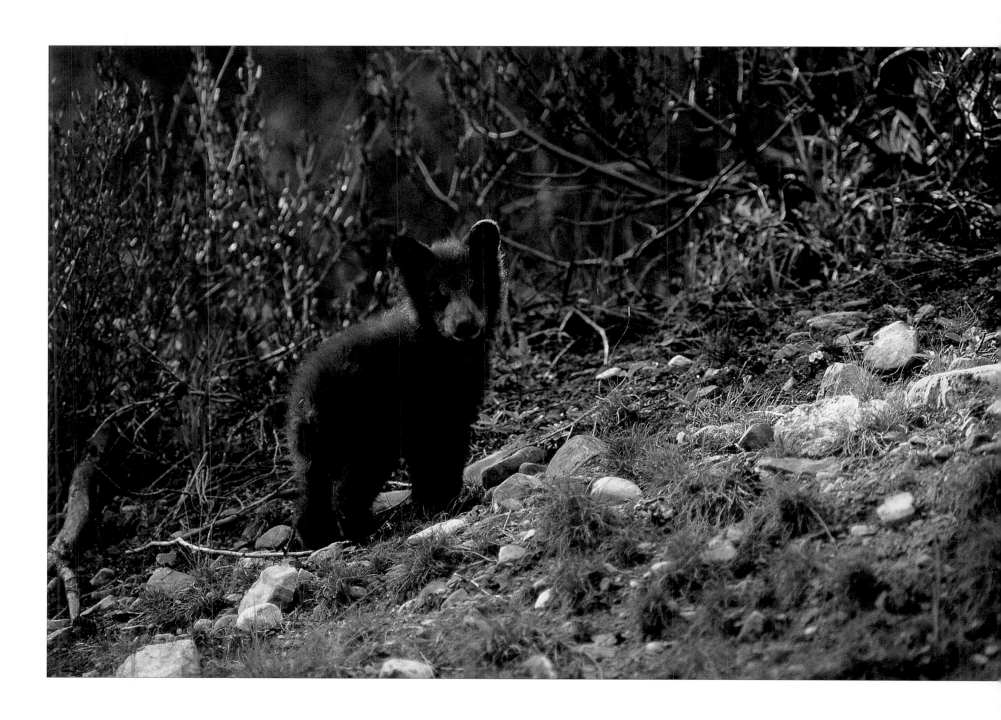

above: **Black bear cub**
Banff National Park

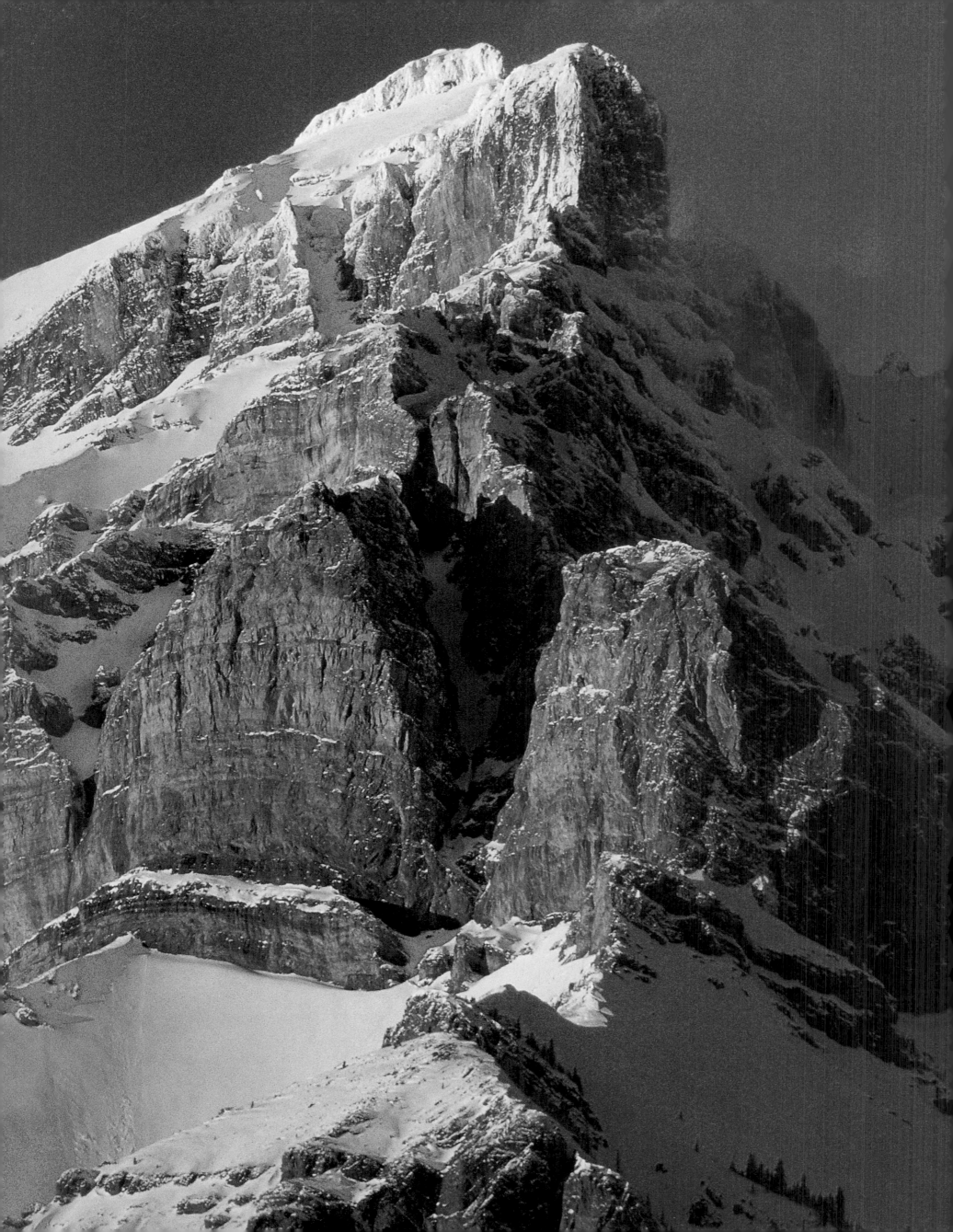

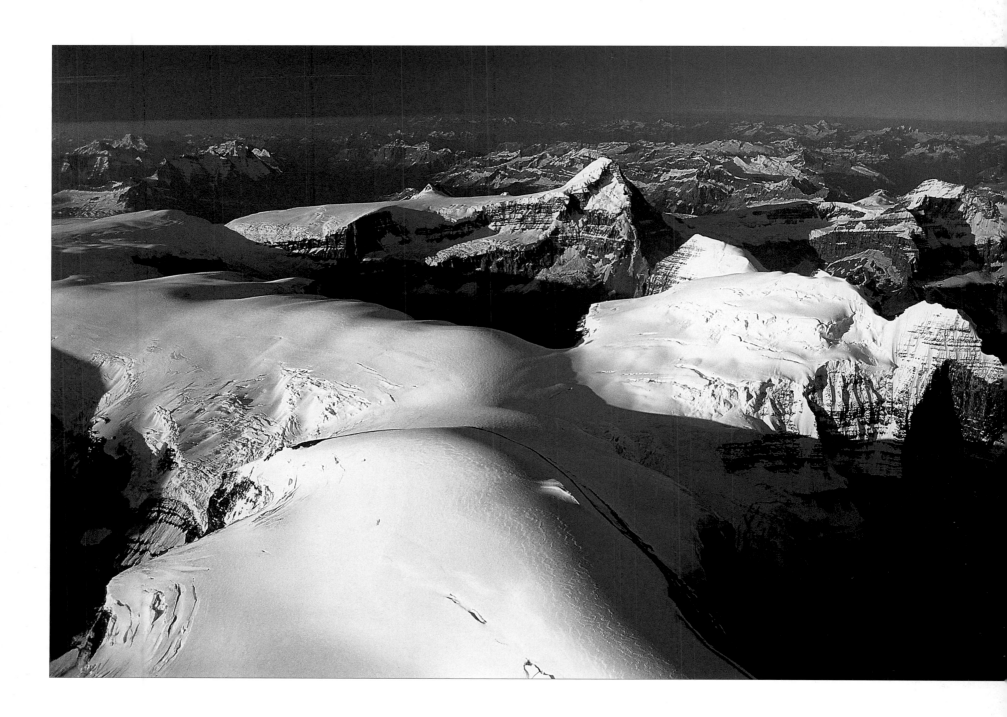

above: **Columbia Icefield**
Jasper National Park

opposite: **Cascade Mountain**
Banff National Park

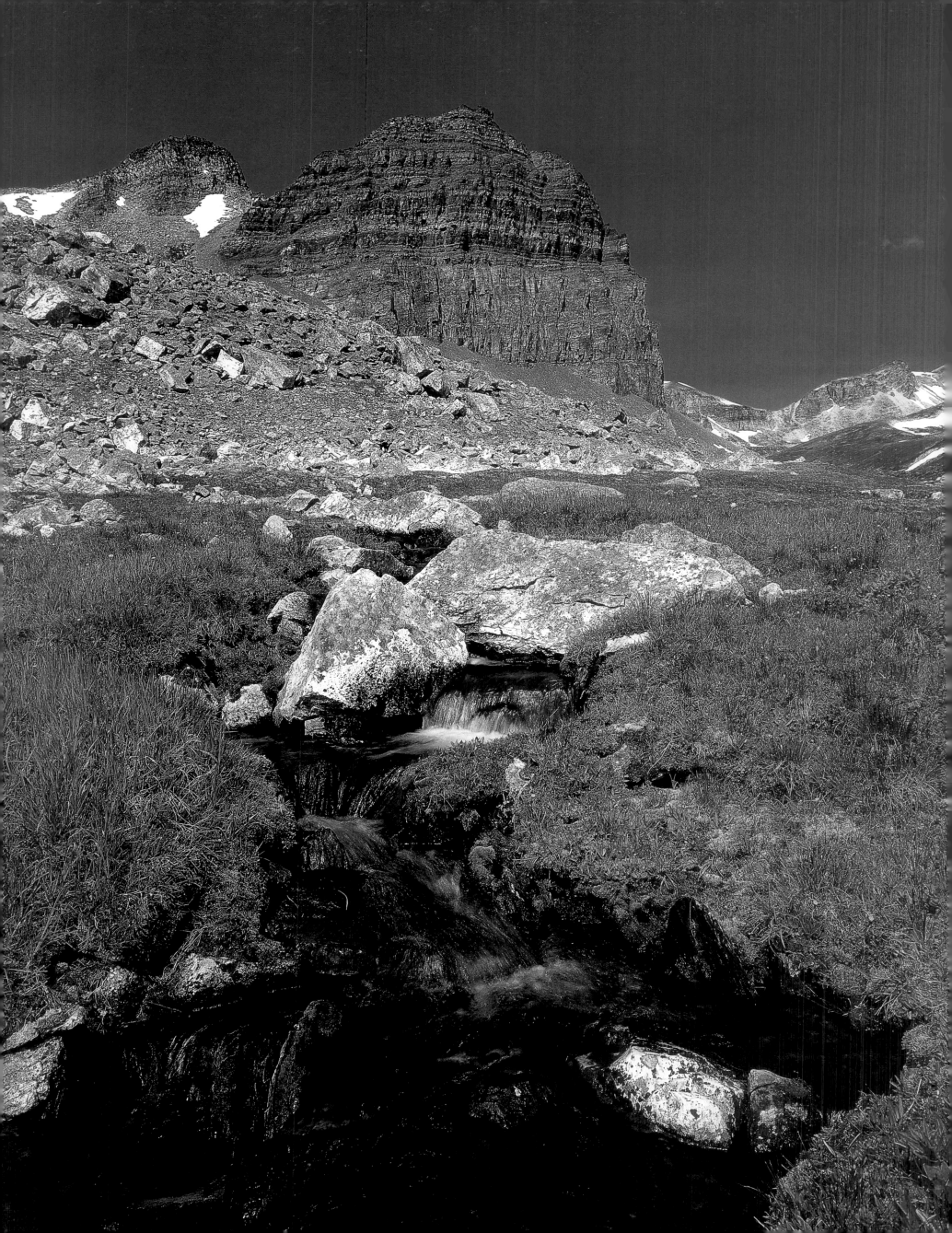

SPRING

After a long winter with a landscape dominated by white, blue and grey, spring—nature's annual miracle of rebirth—brings the return of inspirational colour. There is a sudden and dynamic explosion of myriad shades of green as new conifer needles and deciduous leaves sprout and mature. In the alpine valleys, the first aspen leaves of the season stand out in crisp contrast against a background of snow-covered peaks, visually defining the clarity and brilliance of springtime in the Rockies.

The sight of the first greens is also significant to elk, deer, bighorn sheep, moose, mountain goats and other vegetarians of the Rockies. After winter's sparse food offerings, these large animals are at their weakest in early spring, and the first green plants, charged with the nutrients they desperately need, are a welcome sight for these hungry animals.

In spring, the noise of water is everywhere: cacophonous, thunderous, overpowering. The whole alpine world is caught up in the liquid energy of spring. When the warm sun shines on the mountains' winter-long accumulation of snow and ice, the result is a rush of melting water that picks up speed as it heads down from the summit. Mountainside trickles become streams and streams become torrents as water cas-

opposite: **Alpine meadows near Helen Lake**
Banff National Park

cades over rocks and cliffs in a rush to join the rivers on the valley floors. Water flows everywhere, turning the alpine meadows into bogs, seeping under fallen logs and squeezing into narrow cracks in the rocks. The slopes are alive with a thousand waterfalls, shining and silver in the clear light of a spring afternoon. The spray

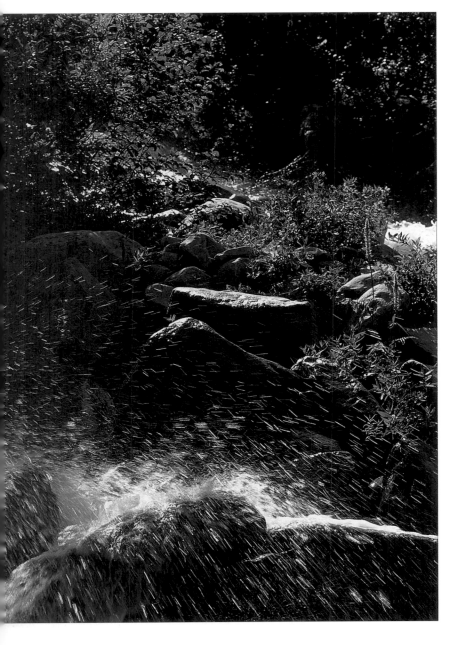

bounces into the air, catching the light and shattering it into a thousand pieces. The photographic images of spring waterfalls are always exciting, always new. You never quite know for certain what the spray may do at the moment you press the shutter: exposures reveal that every 1/60 or 1/1000 of a second the stream is unique, the pattern of the water never repeated.

Perhaps the most glorious aspect of the alpine spring is the appearance of mountain wildflowers. Diminutive and delicate, they nonetheless contribute new colour as well as a new scale to the mountain world. Whether they are yellow crocuses poking up through the snow, or white and yellow mountain avens clustered along a riverbank, spring flowers are a cause for celebration.

As spring progresses, the ungulates shed their long winter coats for sleek summer ones. In an unfortunate paradox for photographers, although it is easier to find

above: **Glacial stream with Monkey flowers**
near Golden, British Columbia

and photograph these animals when they are feeding alongside the open roads, this is also the time they look their shaggy worst.

Spring roadsides are also a powerful lure for bears hungry after a winter of hibernation. Both black and grizzly bears are primarily vegetarian and they love roadside dandelion flowers and alfalfa. Those fortunate enough to travel through the Canadian Rockies at this time of year will find that roadside animal sightings are common.

In contrast to some of the spring season's more ragged-looking wildlife, the migratory birds return from their winter ranges in their finest, freshest and most colourful plumage. Each mountain habitat hosts different bird species and each area is thus replete with different birdsongs and different colours of plumage. Behind every photograph taken in the spring lurks the beautiful song of a bird—implied but silent, missing in the photograph but ever-present in nature. And while it is always beautiful to hear a loon call or a thrush song no matter where you may be, to hear them echoing from towering cliffs over a calm dawn lake in the Canadian Rockies is to have a new dimension added to the experience.

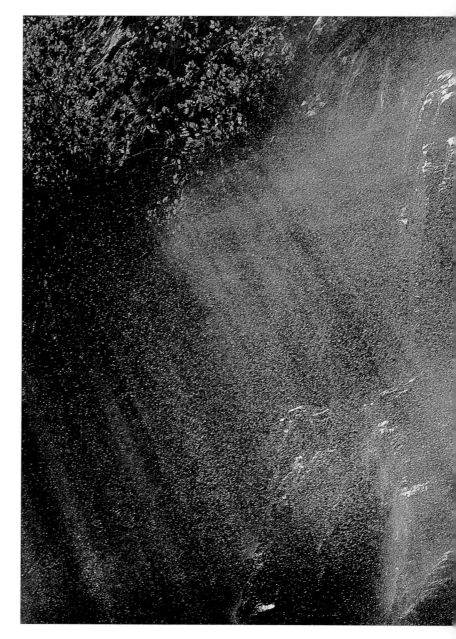

above: **Spring spray, Beaverfoot Valley**
near Golden, British Columbia

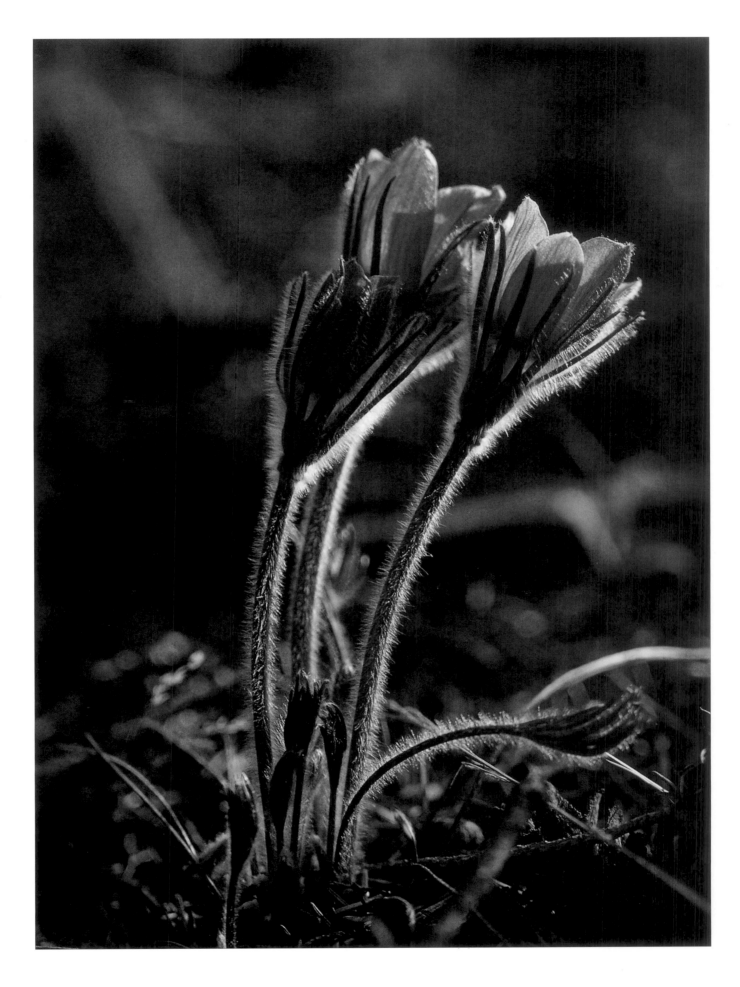

above: **Pasque flowers**
Kootenay National Park

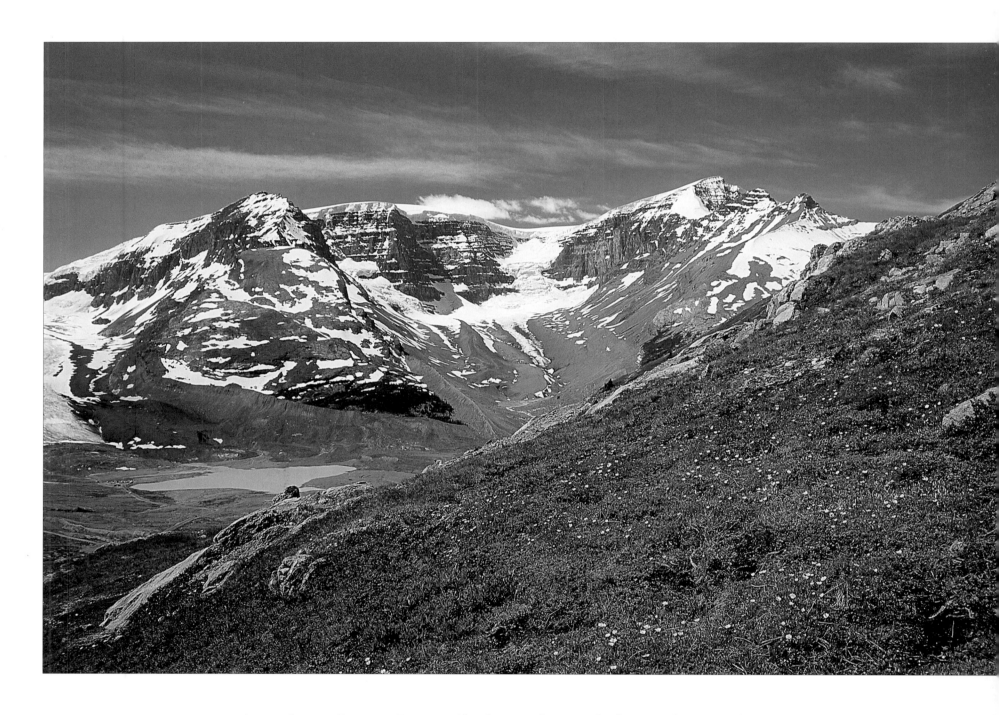

above: **Snow Dome, Dome Glacier and Mt. Kitchener from Wilcox Pass**
Jasper National Park

opposite: **Western anemone**
Yoho National Park

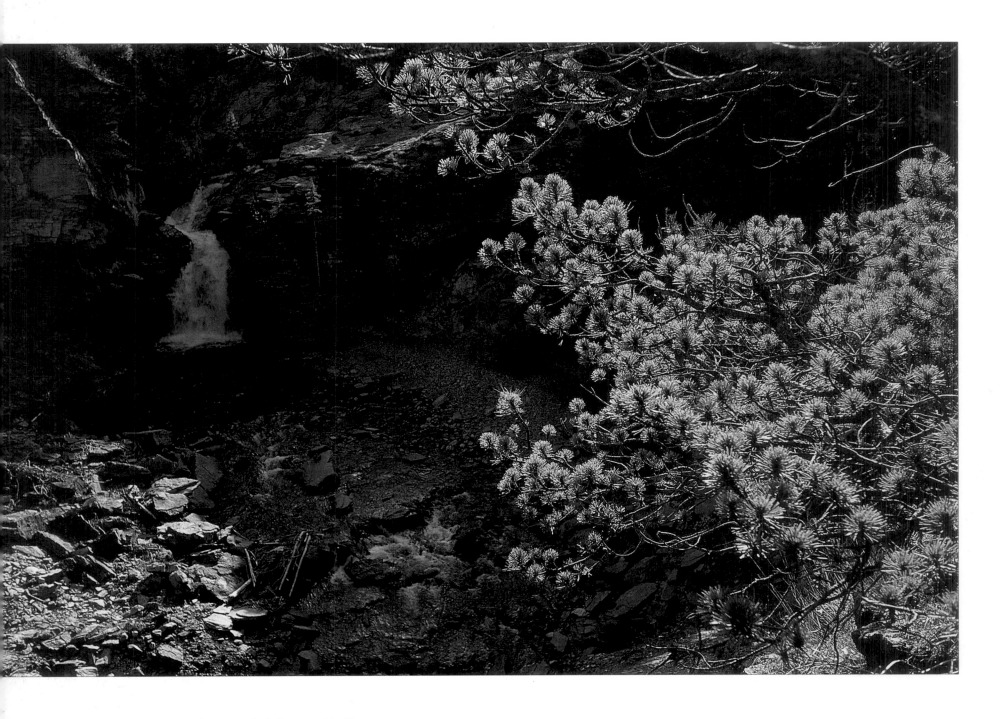

above: **Blakiston Falls**
Waterton Lakes National Park

opposite: **Dolomite Pass**
Banff National Park

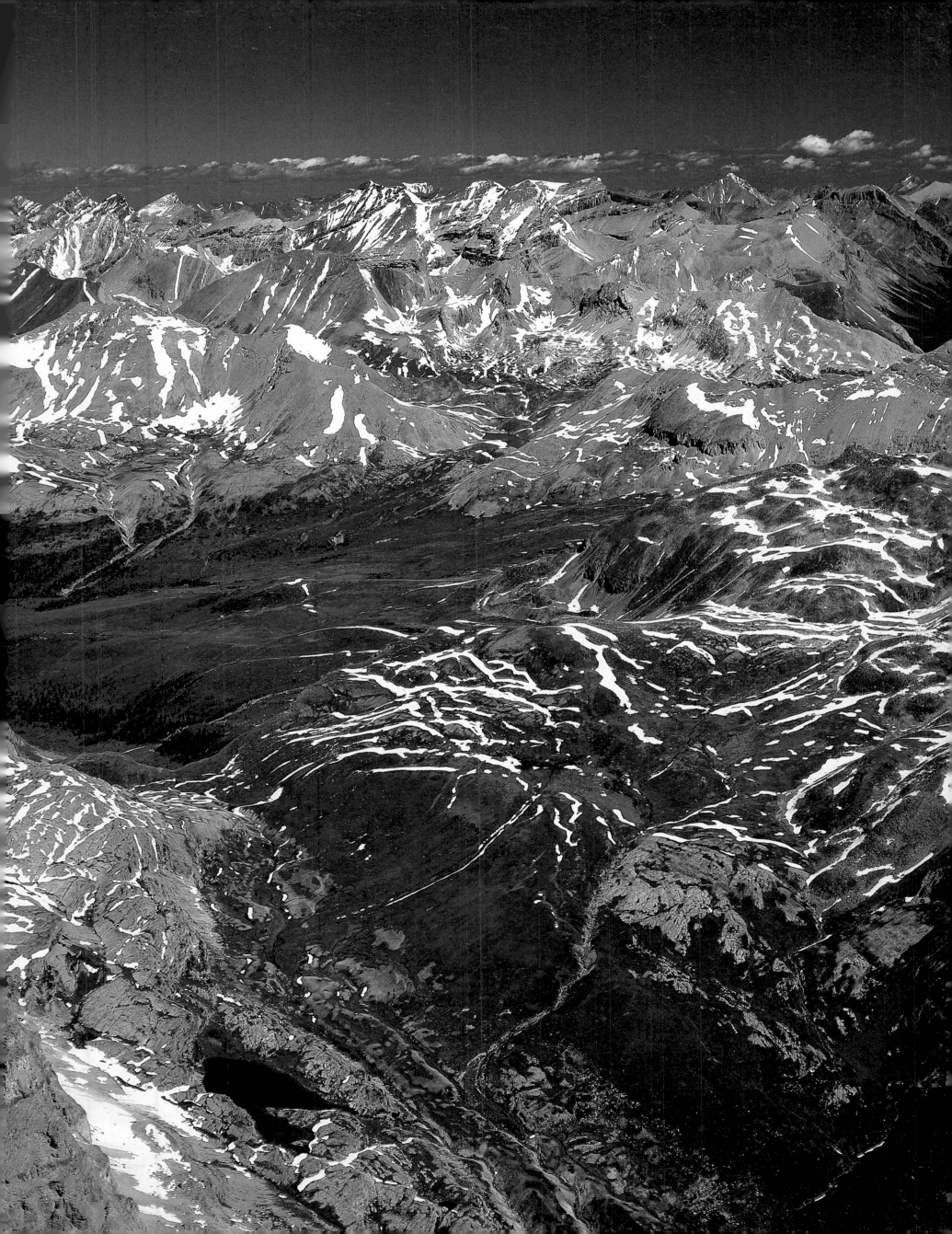

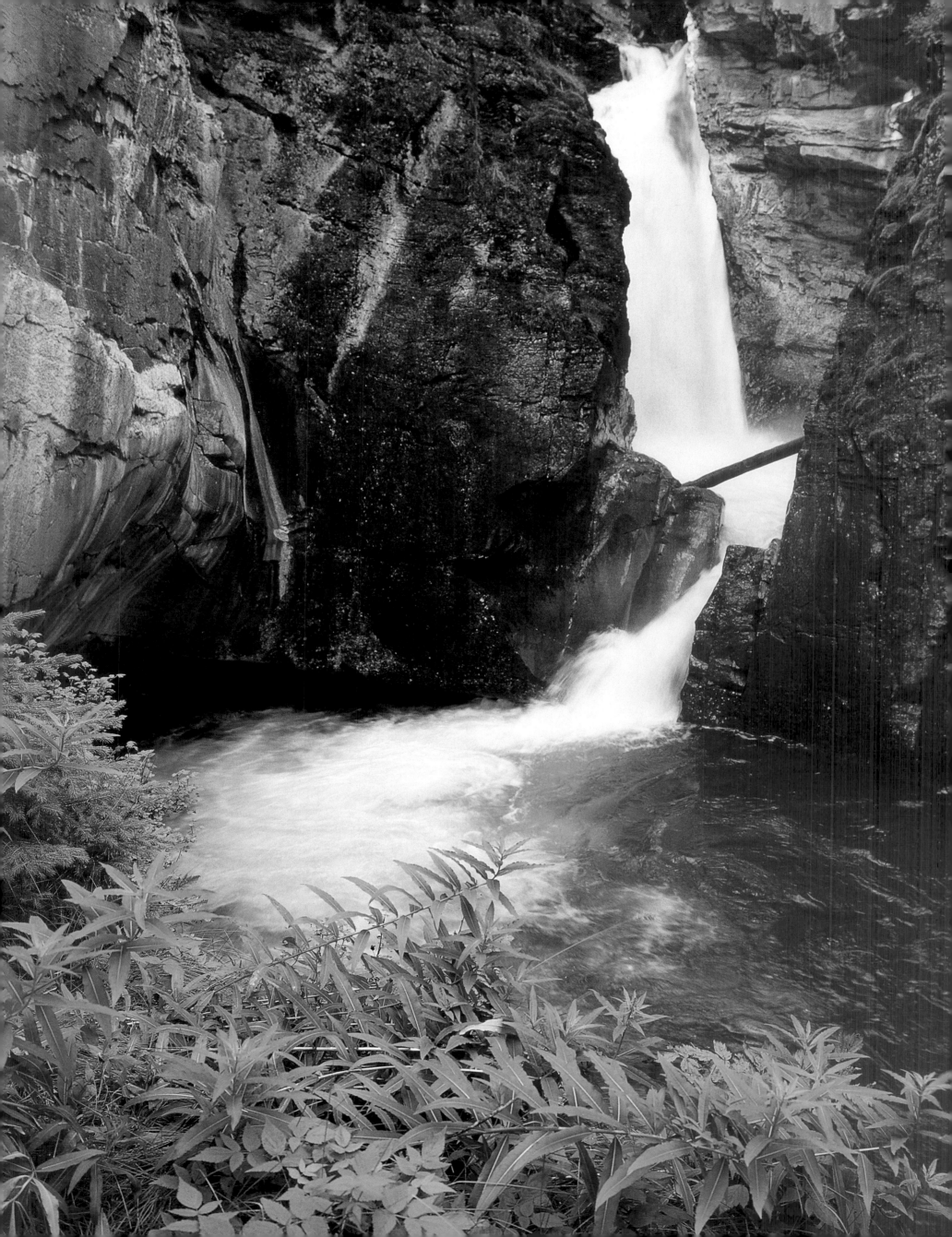

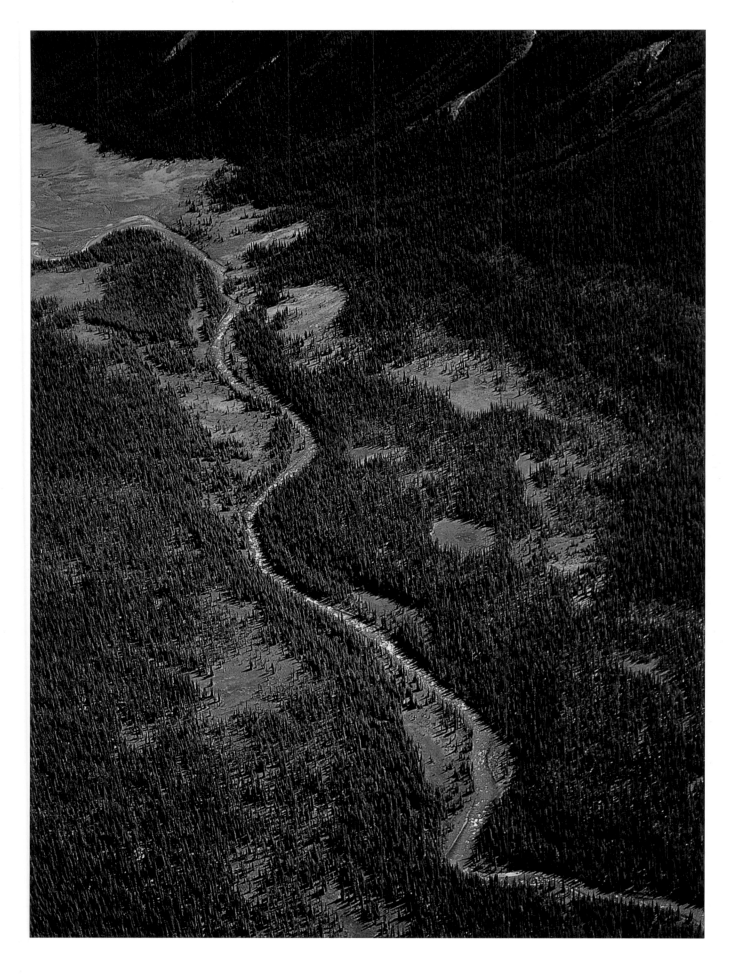

opposite: **Lower Falls, Johnston Canyon**
Banff National Park

above: **Upper Johnston Creek Valley**
Banff National Park

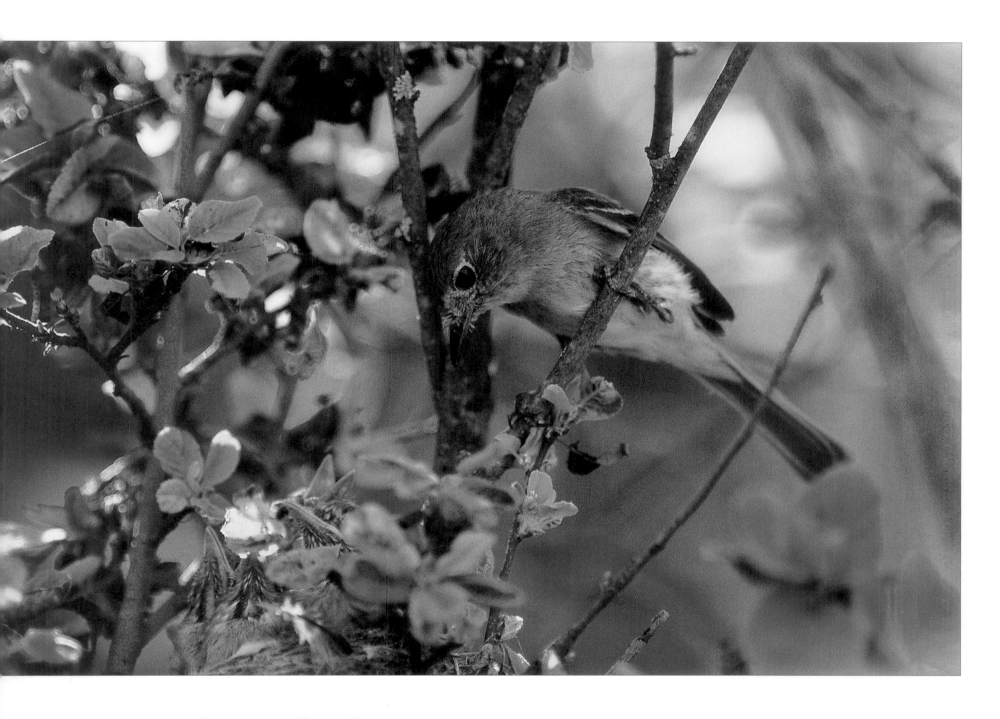

above: **Dusty flycatcher**
Blaeberry Valley, British Columbia

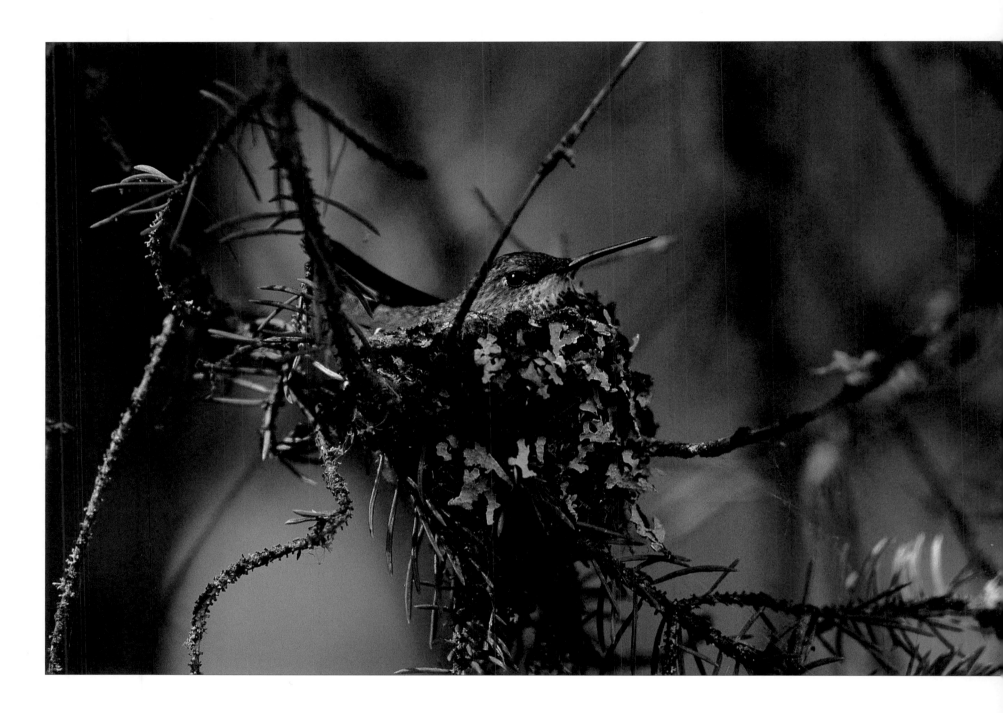

above: **Rufous hummingbird**
near Golden, British Columbia

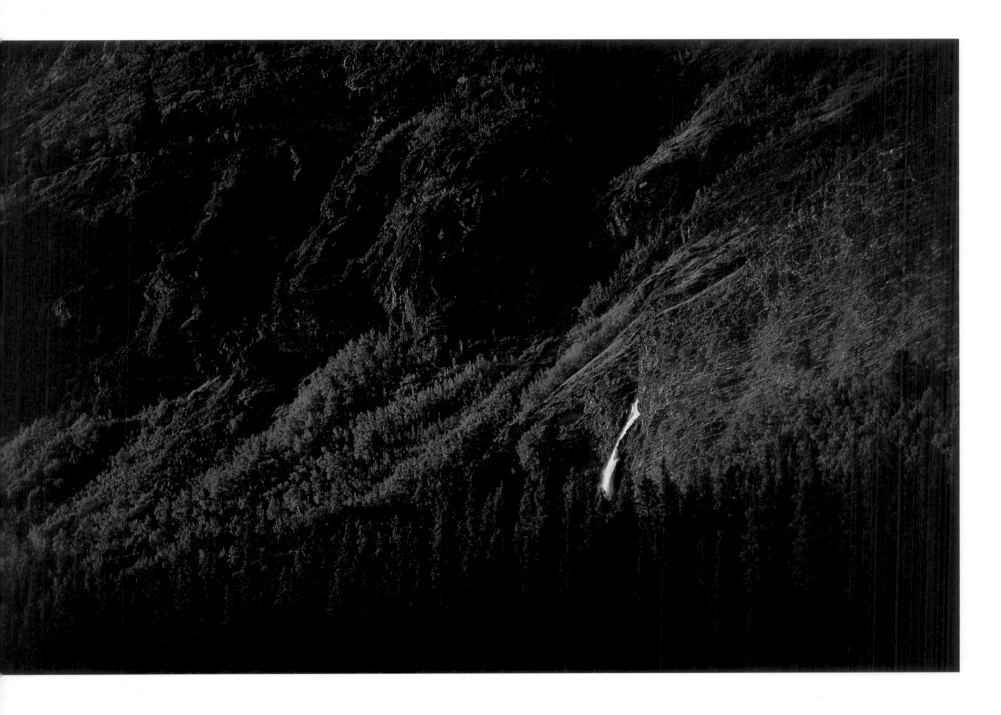

above: **Waterfall on Mt. Wilson**
Banff National Park

opposite: **Mt. Stephen and the Kicking Horse River**
Yoho National Park

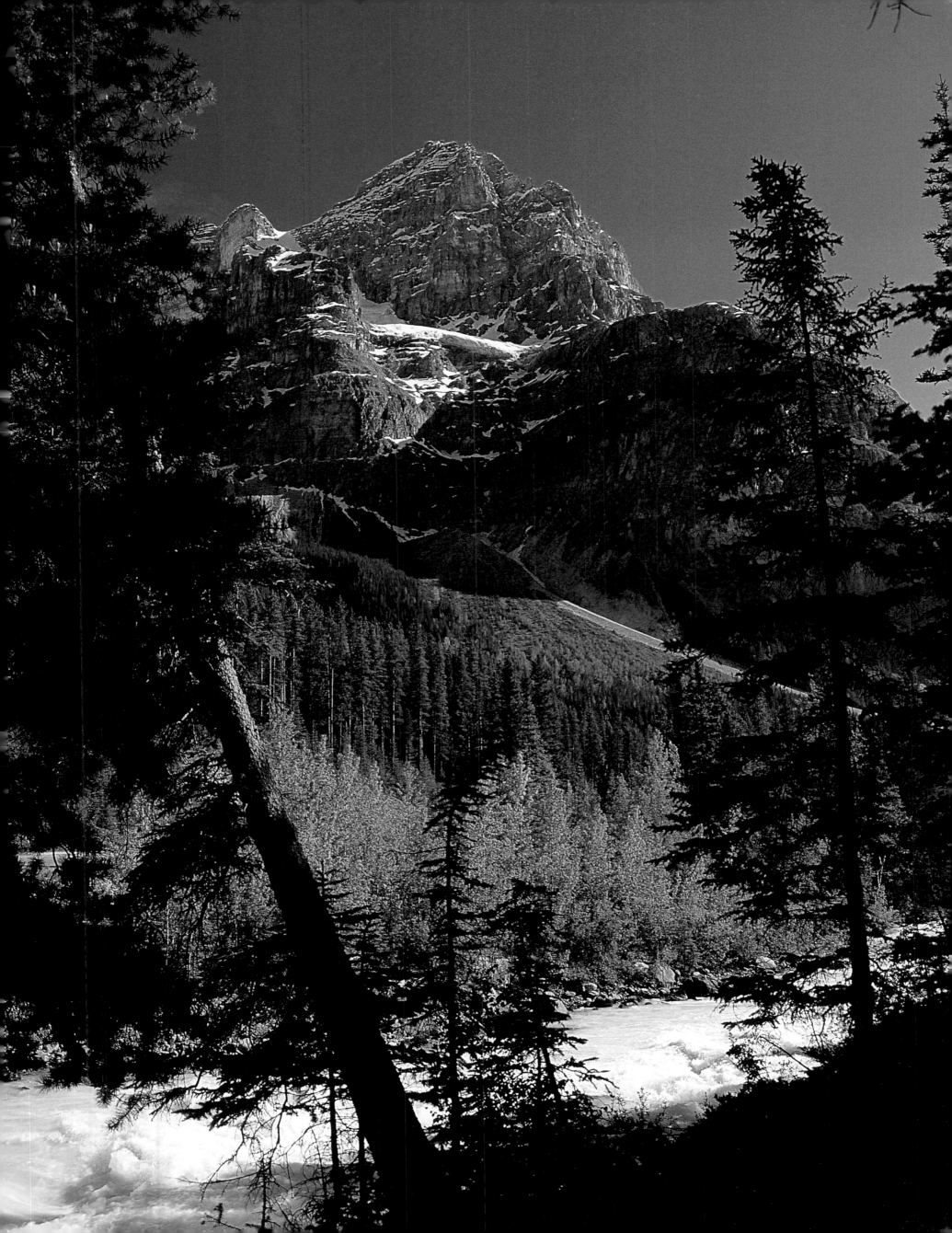

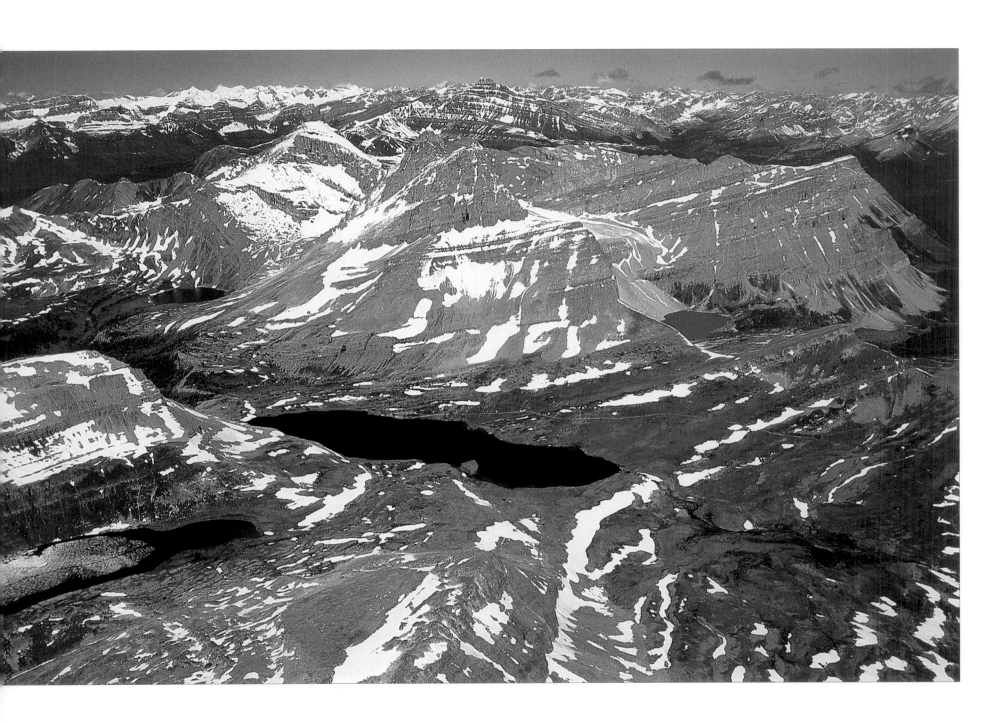

above: **Ptarmigan Lake, Upper Skoki Valley**
Banff National Park

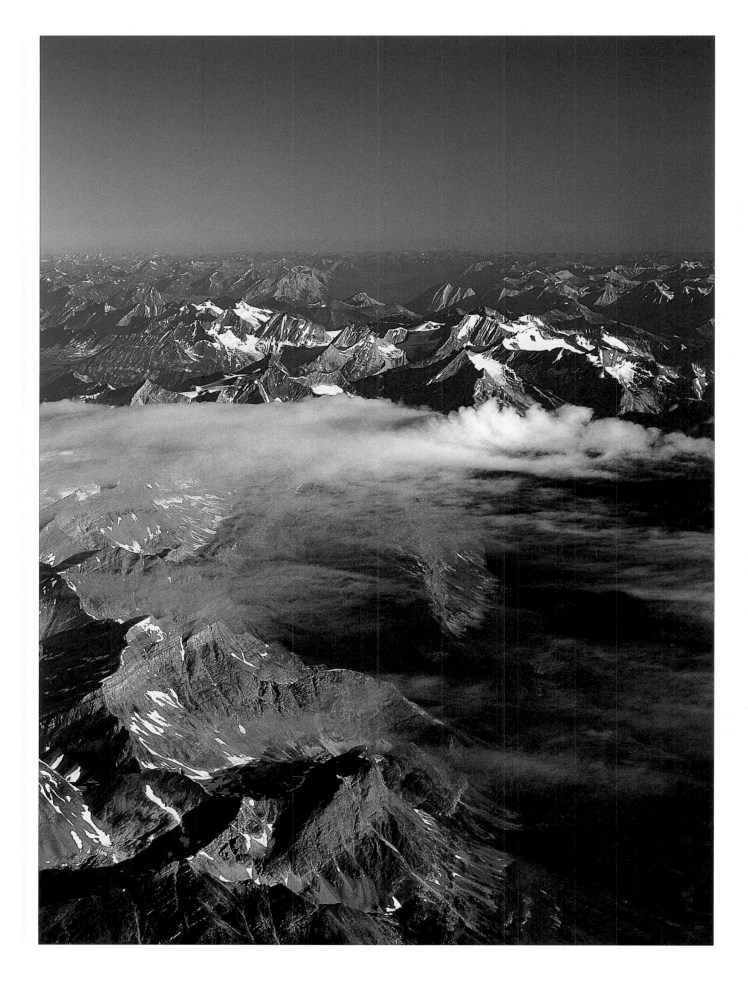

above: **Main Range peaks**
Jasper National Park

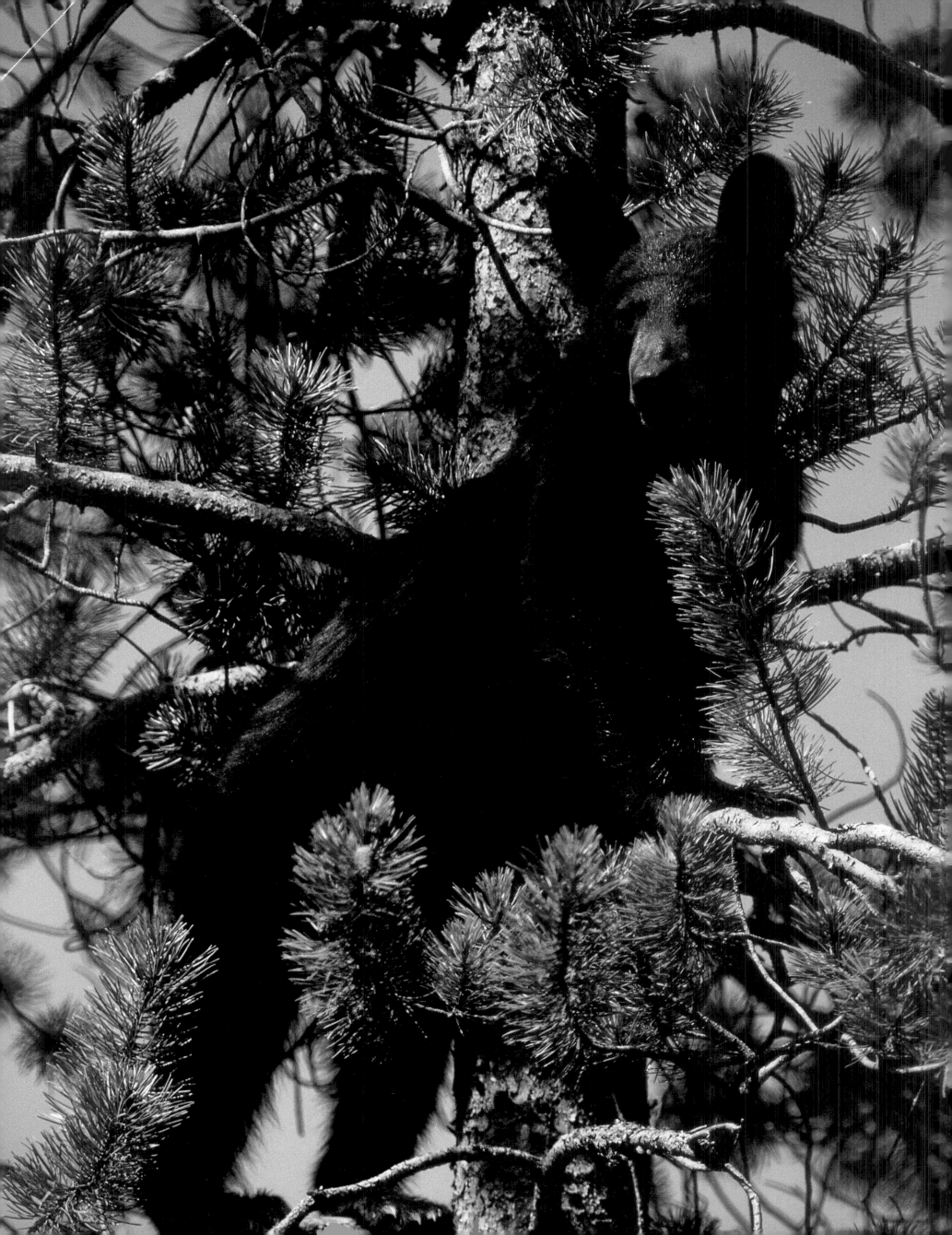

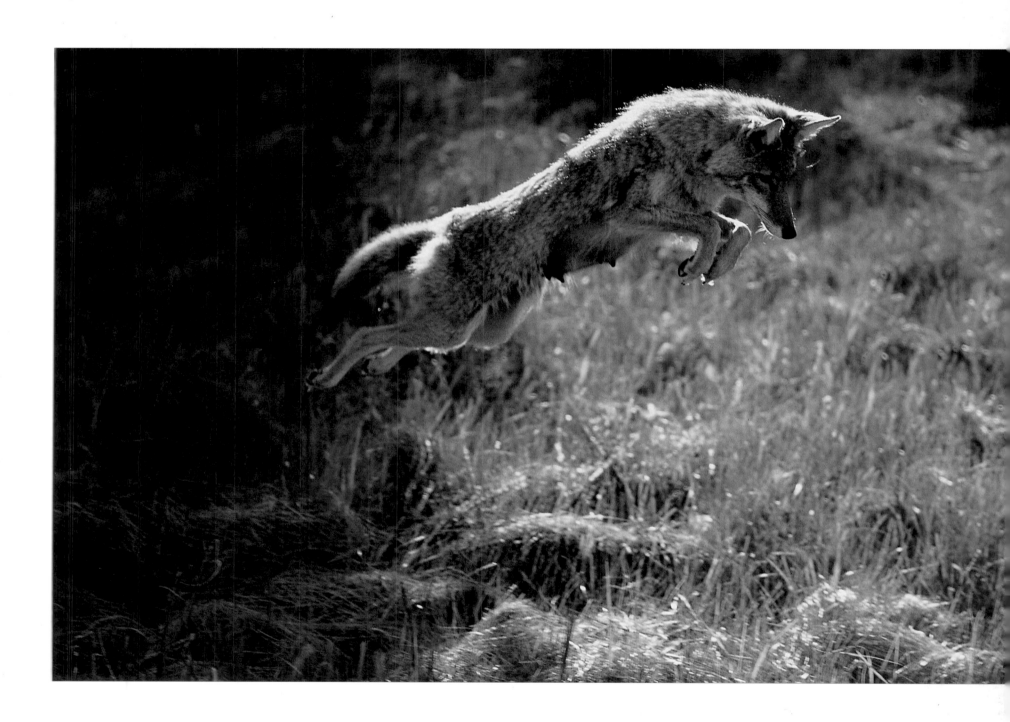

above: **Female coyote**
Kootenay National Park

opposite: **Young adult black bear**
Bush River Valley, British Columbia

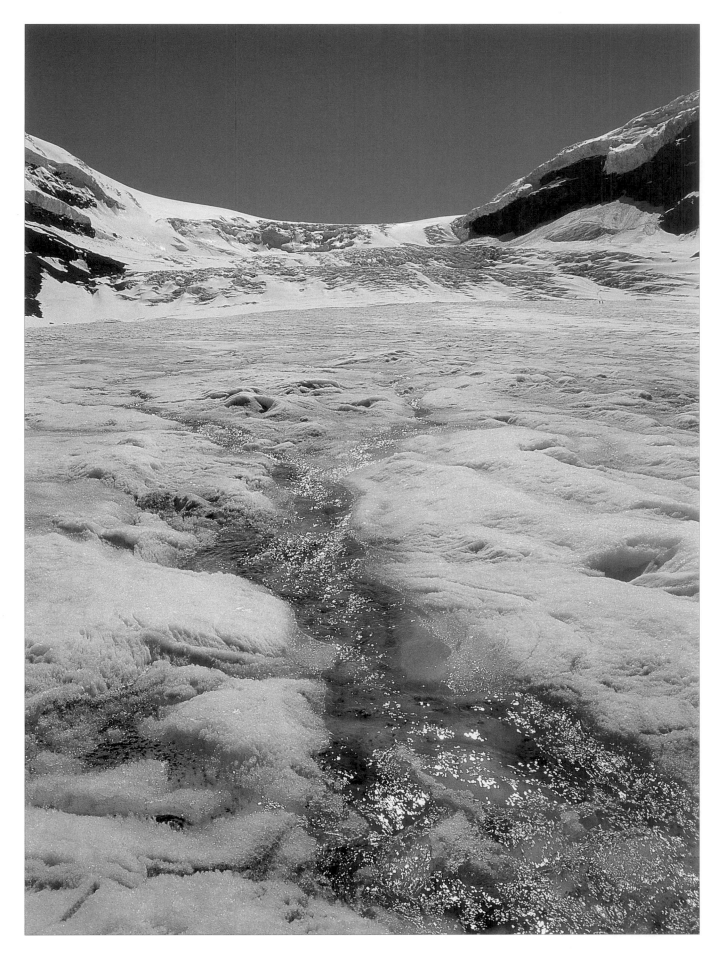

above: **Meltwater on Athabasca Glacier**
Jasper National Park

opposite: **Little Merlin Lake**
Banff National Park

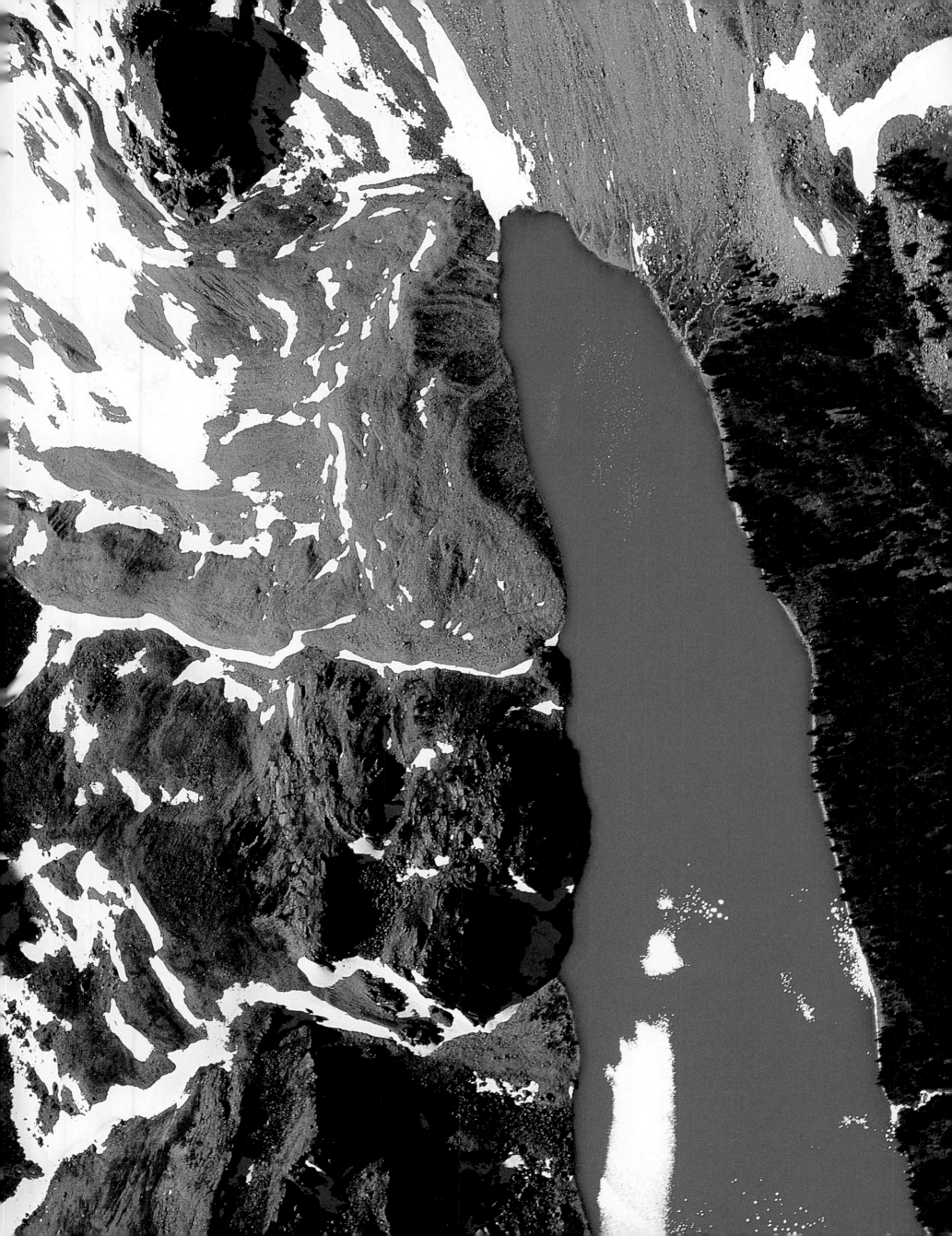

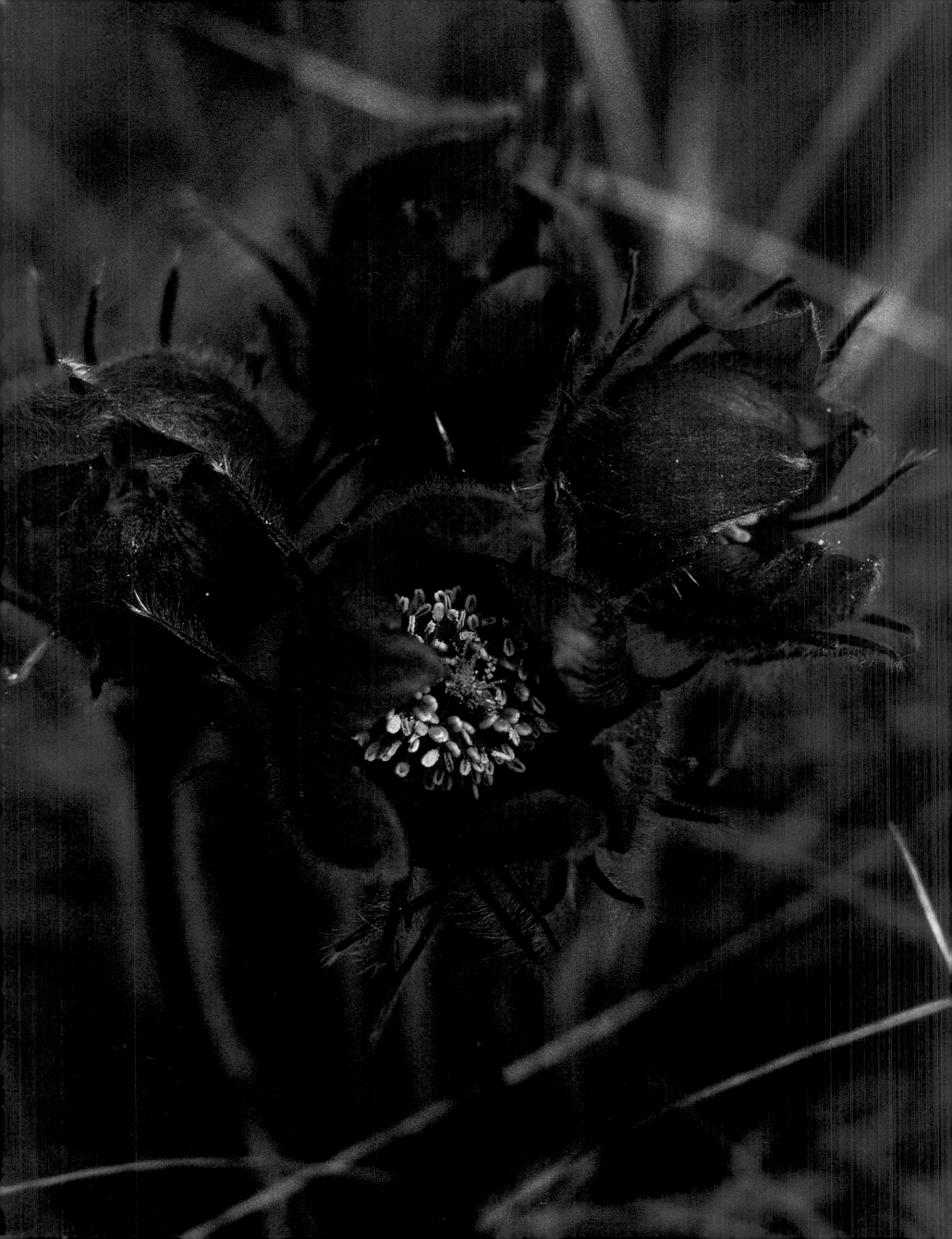

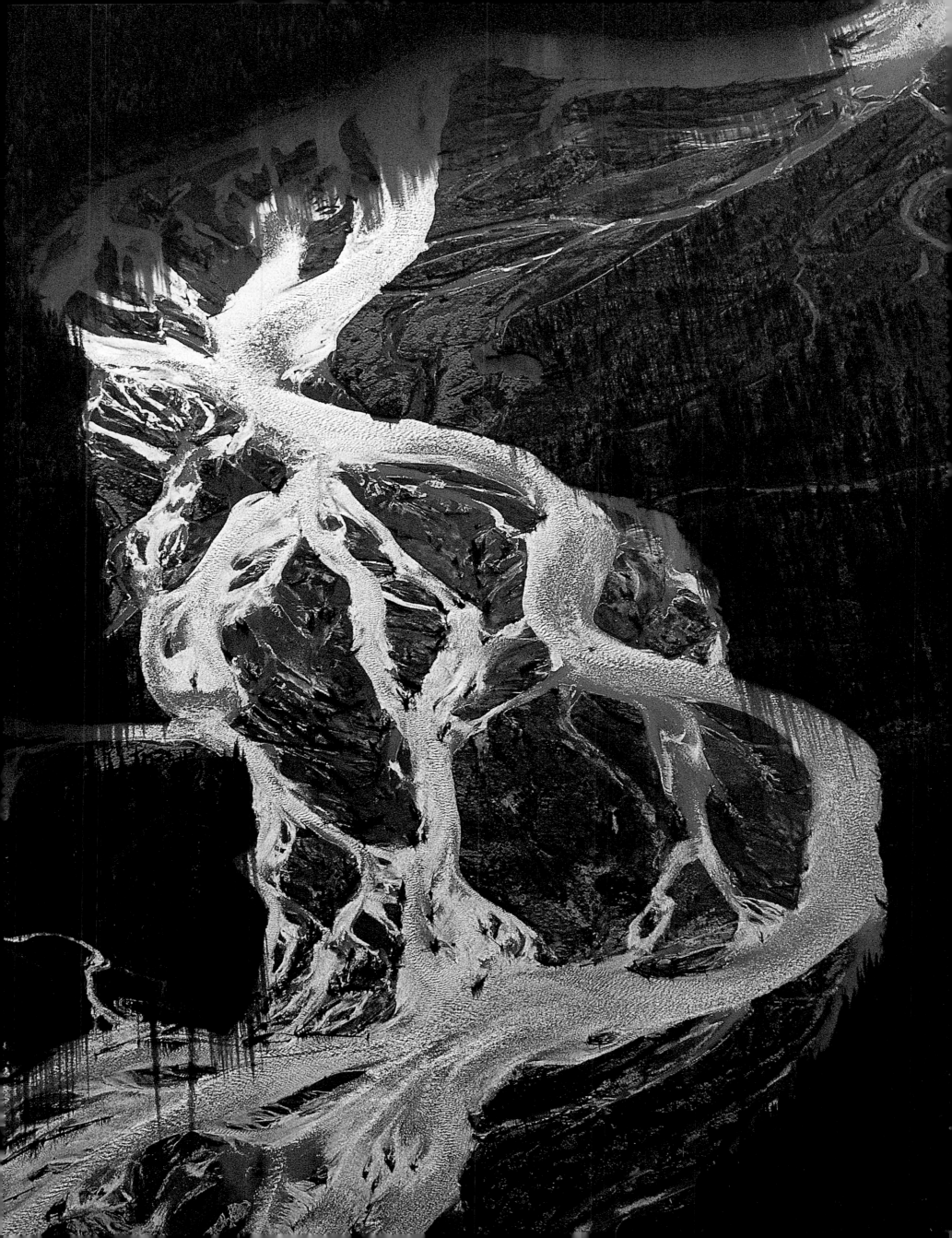

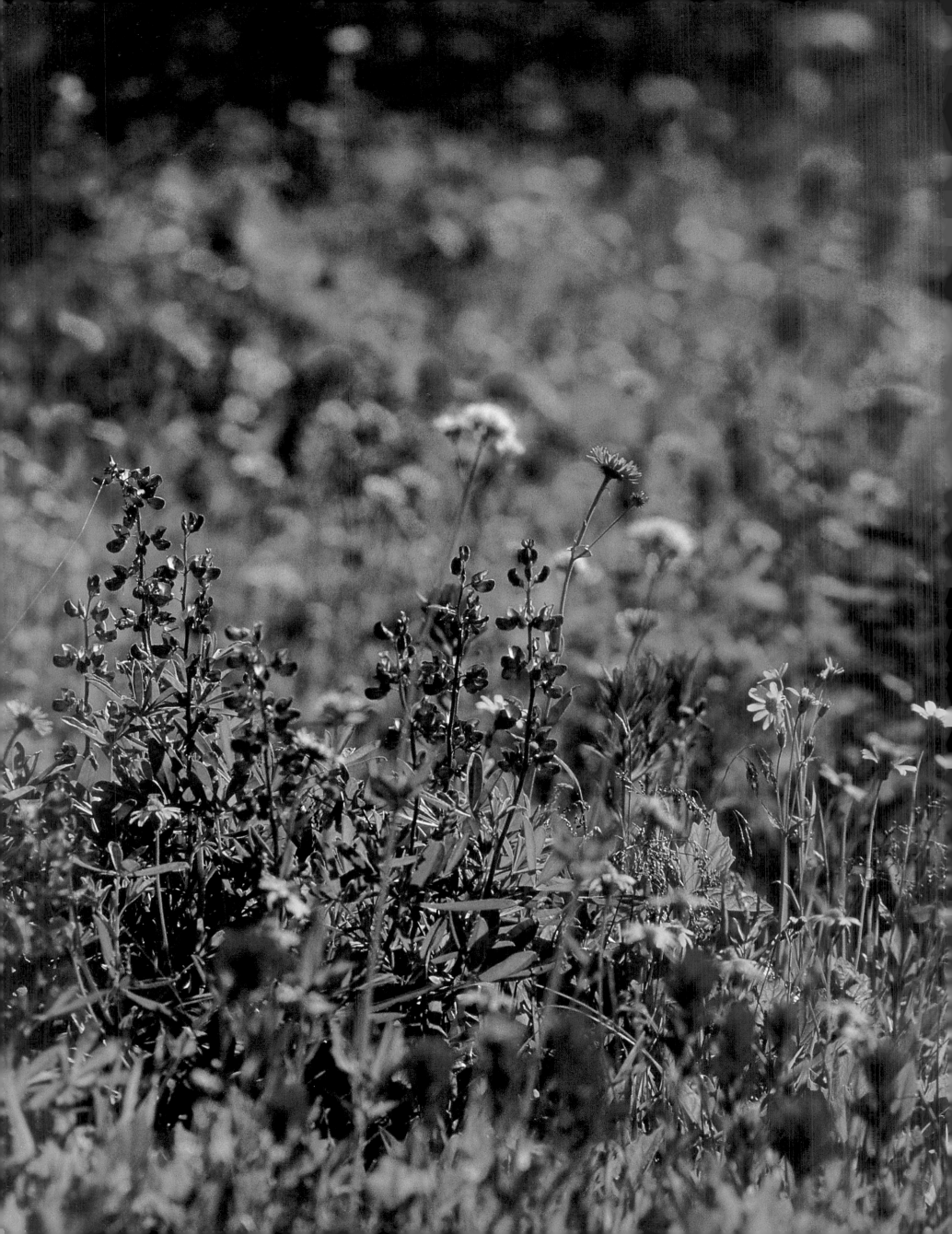

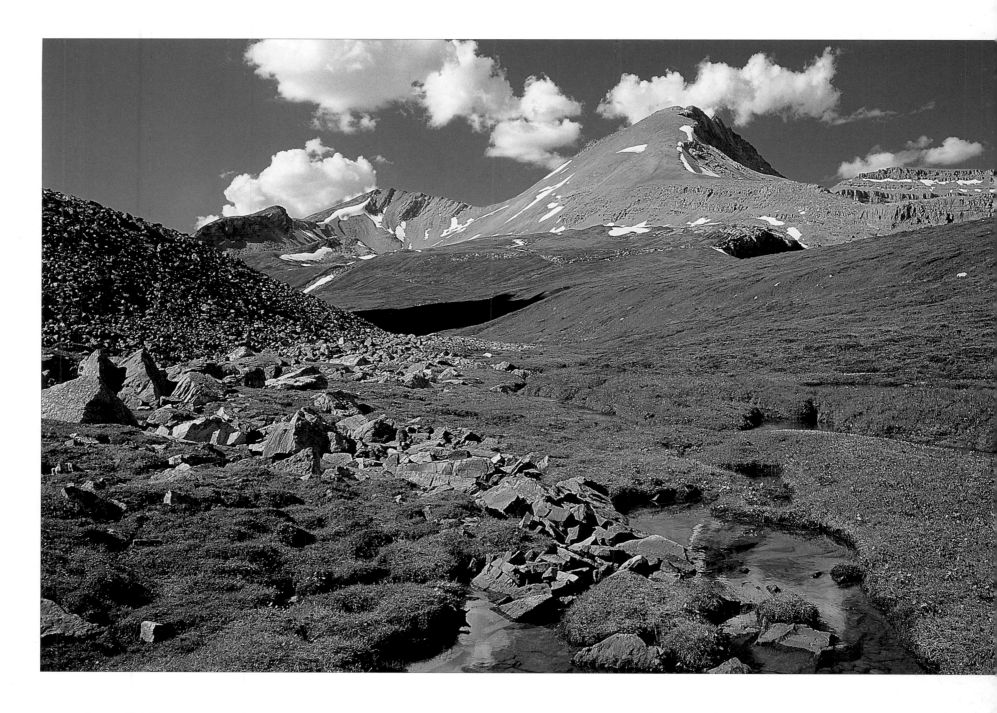

opposite: **Wildflowers in a subalpine meadow**
near Golden, British Columbia

previous page left: **Pasque flower**
Kootenay National Park

above: **Dolomite Pass**
Banff National Park

previous page right: **Kicking Horse River**
Yoho National Park

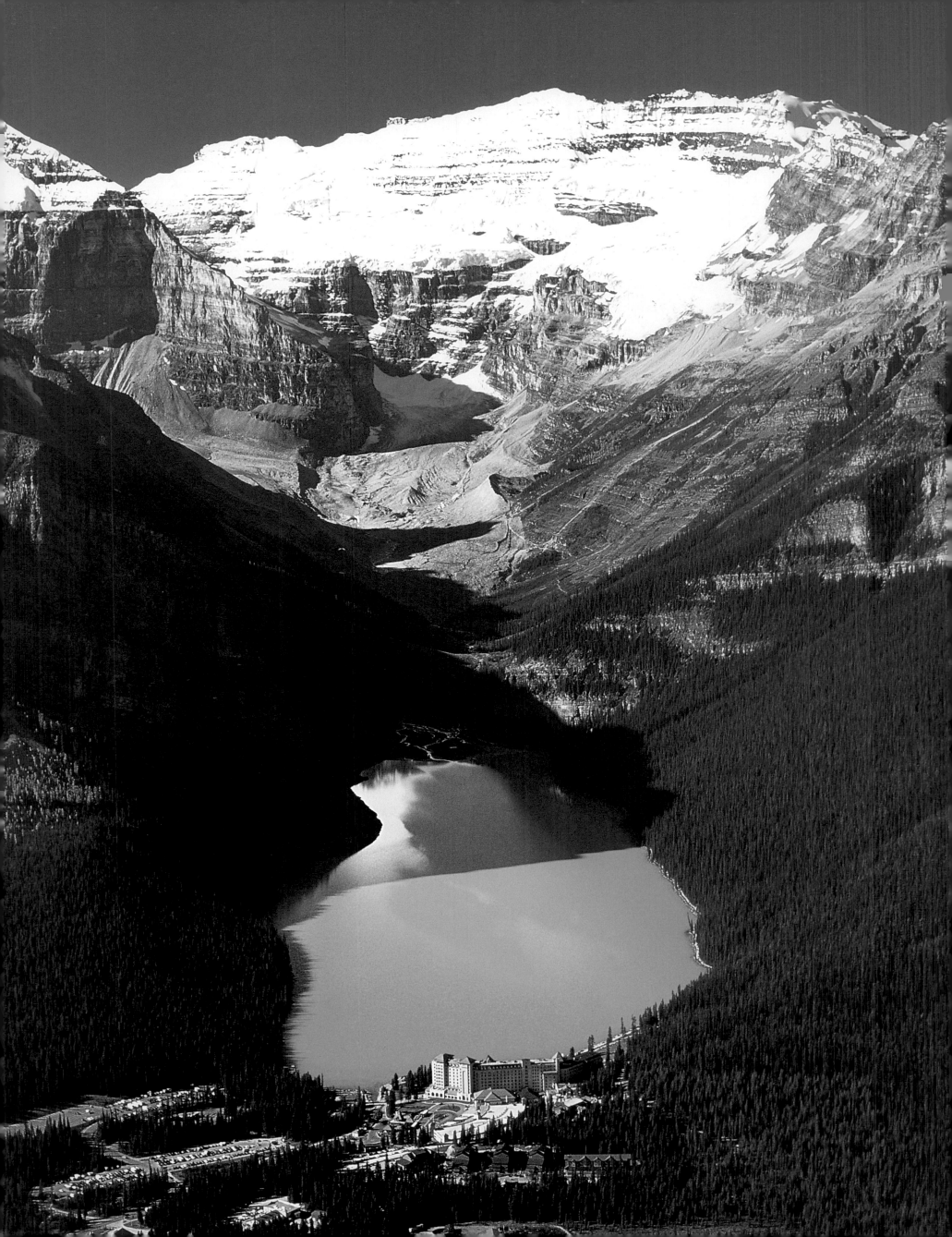

SUMMER

S ummer in the Canadian Rockies falls outside our more usual notions of that season. In the low Columbia and Kootenay valleys at the western foot of the Rockies in British Columbia, there are, indeed, warm-water beaches and muggy evenings. But as you climb into the higher alpine areas, the thinning air loses its grip on summer and can be brisk and chilly. Although summer days are hot, the nights are decidedly cool, frosting the peaks and air conditioning the mountain valleys. The mixing of chilled air from the glaciers with warm, moister air from the valley bottoms can bring snow any and every month. It is not unusual to awake in the middle of July to find a deep covering of snow on the ground—and it might still be there the next day.

Summer allows access into the high alpine areas, to where the living landscape pushes its margins to the inhospitable edge of rock and ice. These were the Rockies experienced by the first Ice Age humans when they hunted bighorn sheep and bison in this area 11,000 years ago. These people roamed the ice-free ridges above the lingering valley glaciers. From winter camps in the warmest and driest valleys, they roamed this landscape, hunting and gathering during the summer months, likely following some of the same routes as modern hikers.

opposite: **Lake Louise and Mt. Victoria**
Banff National Park

Photographers find the wildflowers of summer an irresistible subject. Not only are they beautiful subjects in their own right, but they offer an outstanding opportunity to study and use light. By moving one's position around a blossom, one can change the lighting conditions from "front-lit with a dark background" to "back-lit against the sun." Other minor shifts of position can change compositions dramatically, allowing the photographer to arrange background colours and shadows to

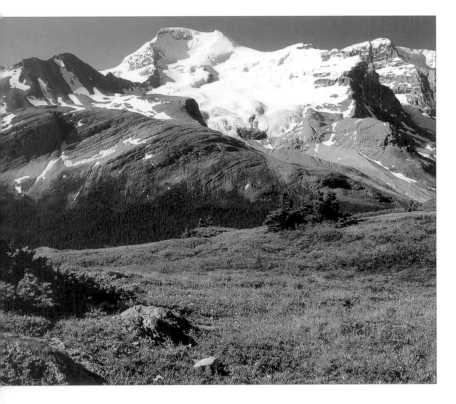

complement the subject. I learned about natural lighting by photographing tiny flowers, where a main requirement was a willingness to sprawl on the sometimes wet ground to explore the blossoms from all angles. While searching this micro world for flower compositions, one inevitably discovers another set of tiny, rarely-noticed lifeforms.

The force driving these displays of colour is the same as it is everywhere—to attract pollinating insects and hummingbirds. While valley species can reduce their competition for pollinators by flowering at different times over a long season, the short alpine growing season produces an intense colour competition. These species must all attract the same insects at the same time. Fortunately for the flowers (if not for some hikers!) there are more than enough insects in the high country.

Humans, hummingbirds and insects are not the only species that are sensitive to

above: **Mt. Athabasca from Wilcox Pass**
Jasper National Park

the colours of the Rockies; bears also have colour vision. It helps them to see the flowers, like hedysarum, glacier lilies, and spring beauties, which rise from the roots that grizzly bears dig up, and the berries that all bears feast on in summer and fall. However, their delight in colour might not be limited to locating and identifying food. Naturalist Enos Mills (1870-1922) wrote of the grizzly: "When looking at scenery or sunsets, his appearance is one of enjoyment....I have seen a grizzly looking at a

magnificent and many-coloured sunset, completely absorbed...another gazed for seconds at a brilliant rainbow."

Humans and grizzlies enjoy another colour phenomenon that progresses through a Canadian Rockies summer: the changing shades of glacial lakes. As the amount of glacial silt carried by the spring runoff gradually decreases and settles out, the lakes turn from a milky blue to hues of turquoise and aquamarine. They look almost trop-

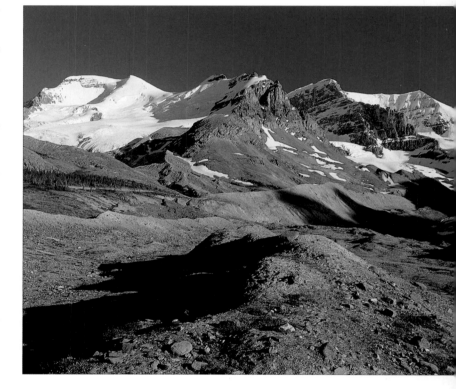

ical—until you feel them! These colours are so unusual that some observers have insisted that photographs of these glacially-coloured lakes must have been digitally altered. (None of mine are, incidentally.) I do understand their scepticism; with colours such as these, one truly has to see them to believe them.

above: **Mt. Athabasca**
Jasper National Park

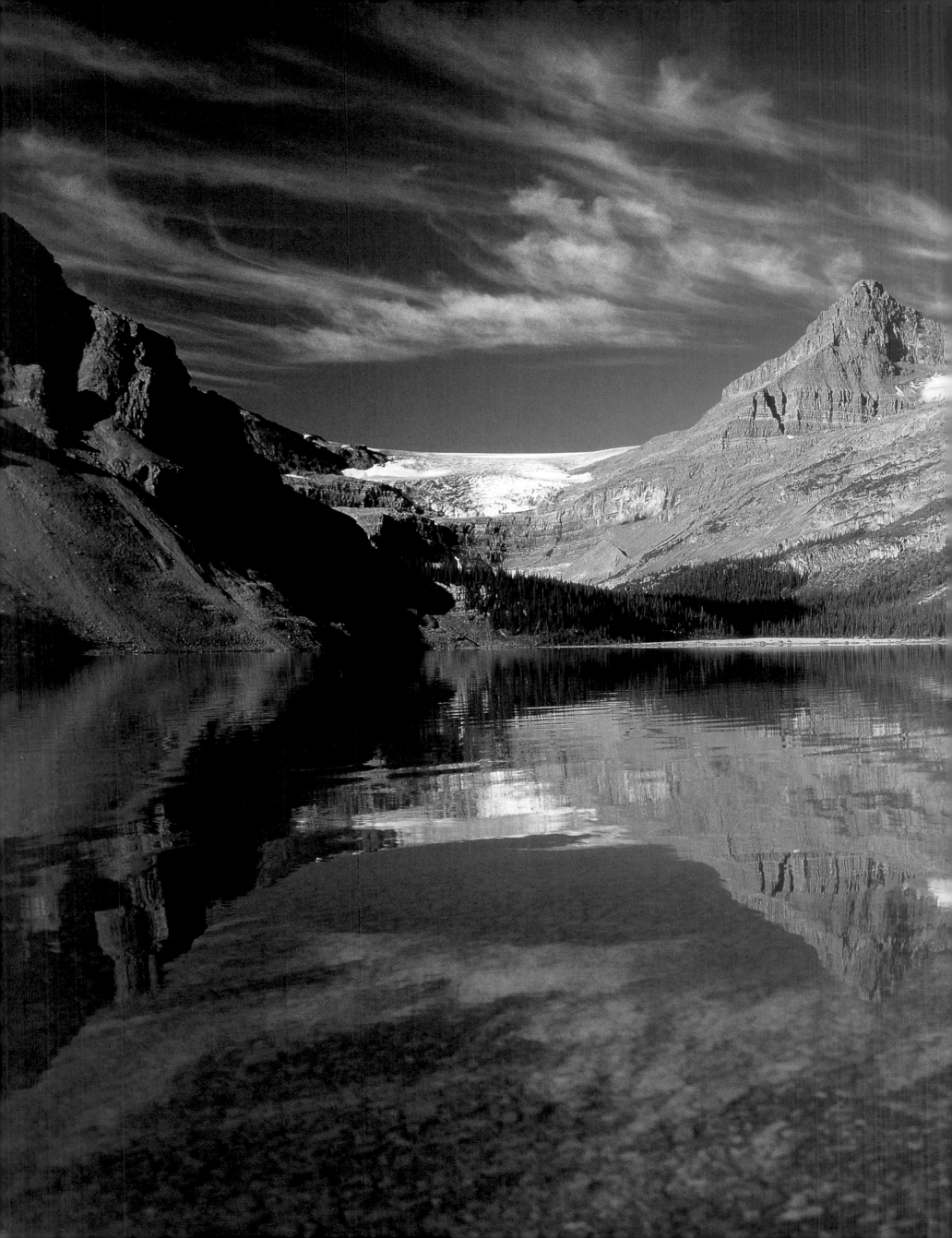

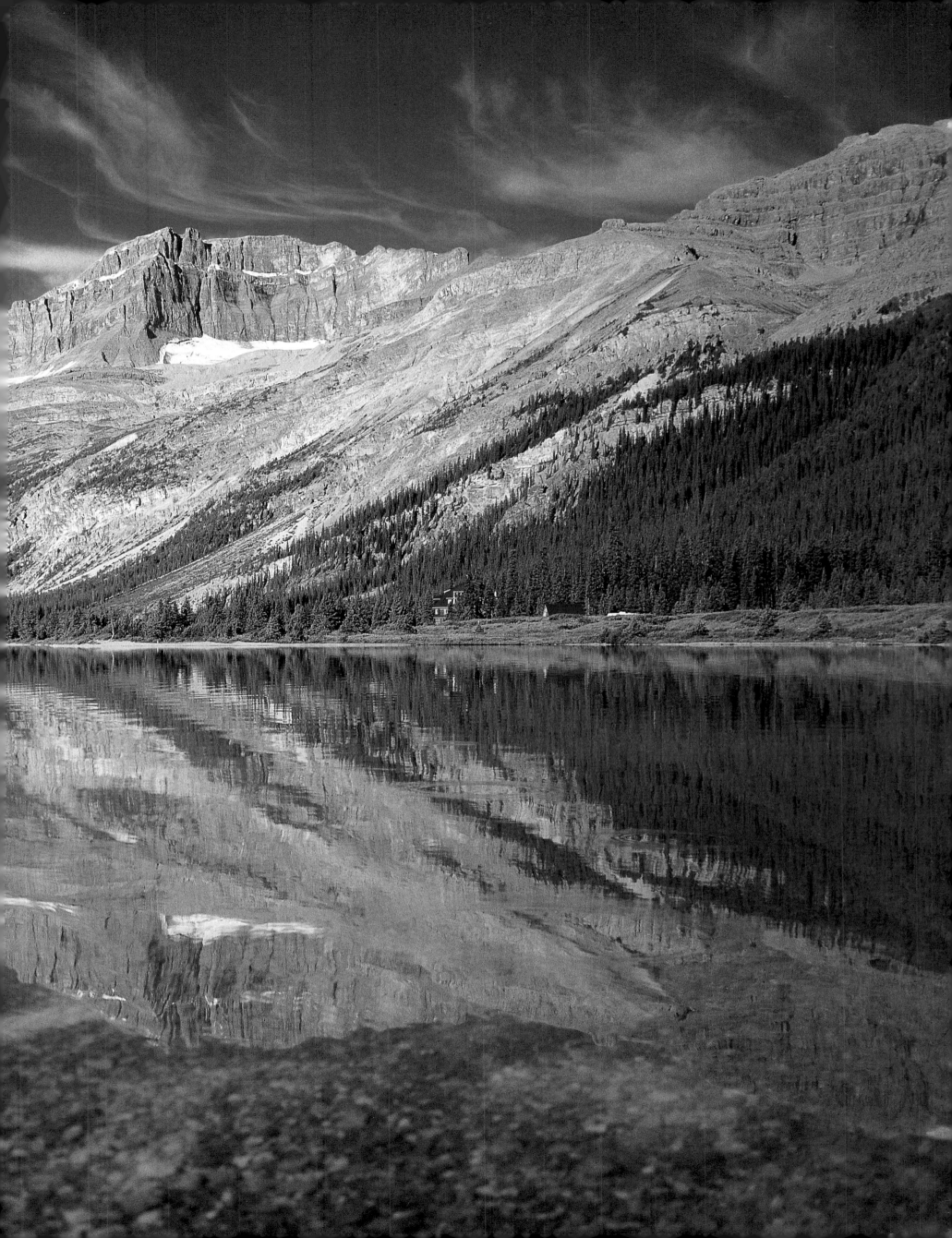

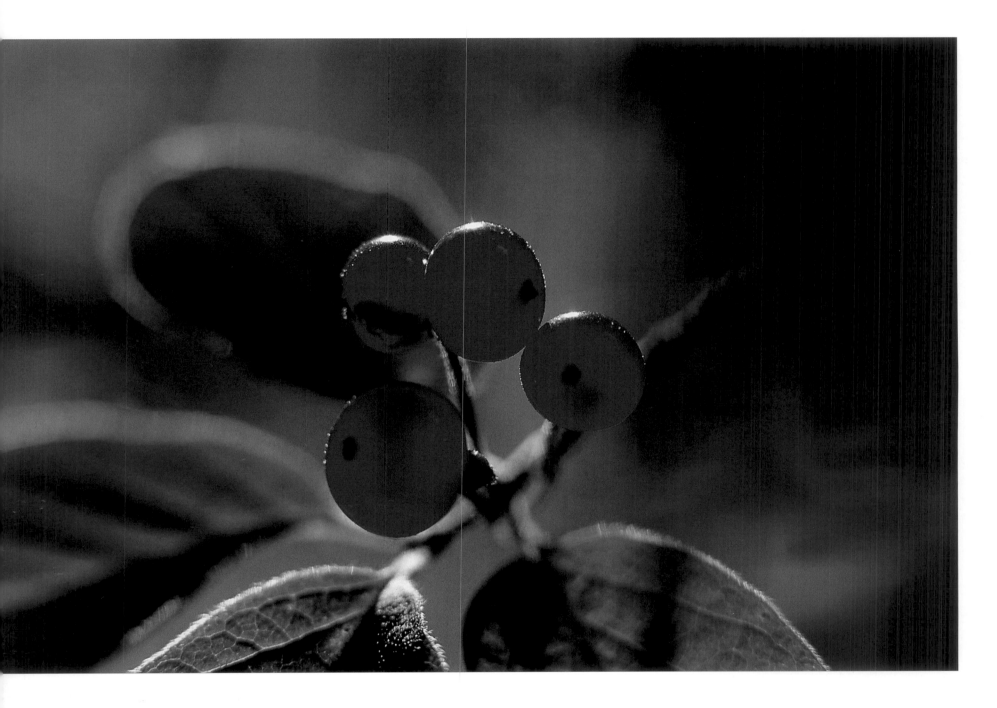

above: **Red twinberries**
Banff National Park

opposite: **Goat Range, Upper Spray Valley**
Banff National Park

previous pages: **Bow Lake**
Banff National Park

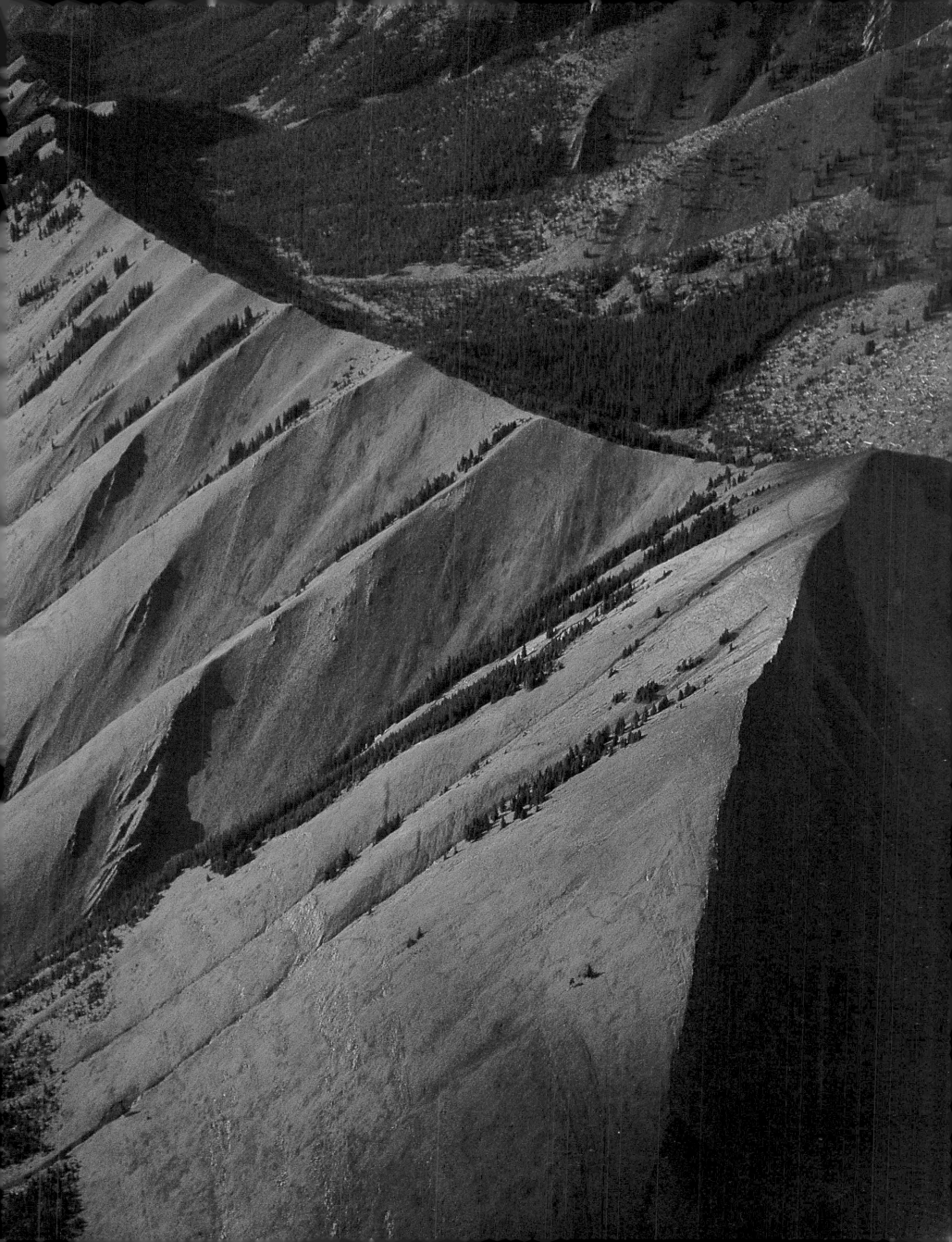

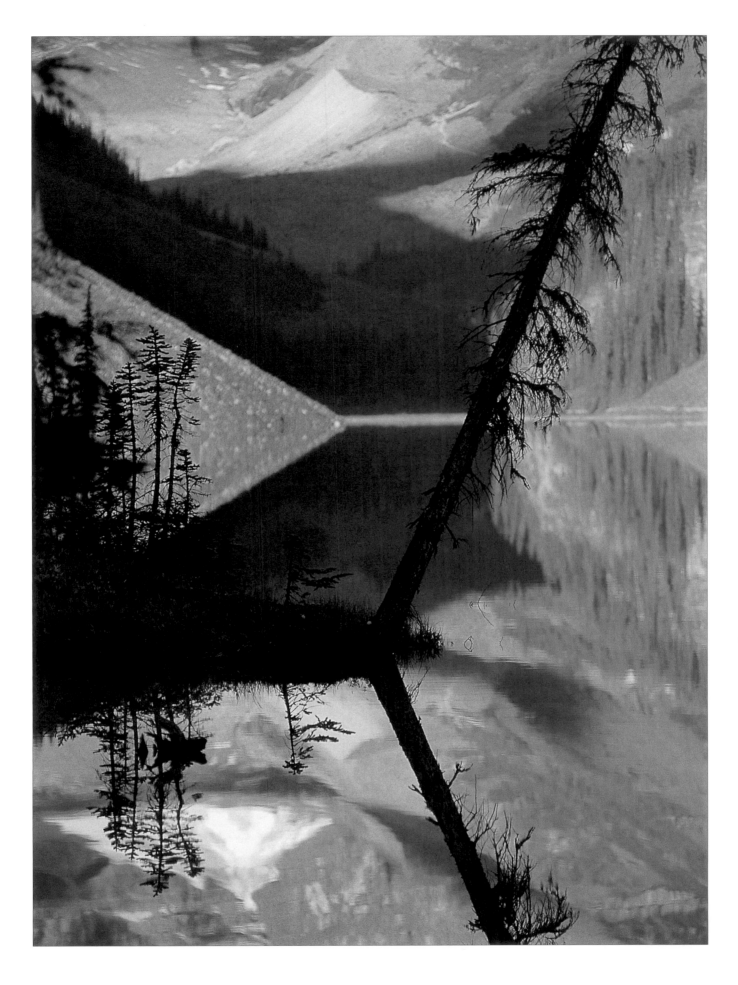

above: **Lake Louise**
Banff National Park

opposite: **Johnston Canyon**
Banff National Park

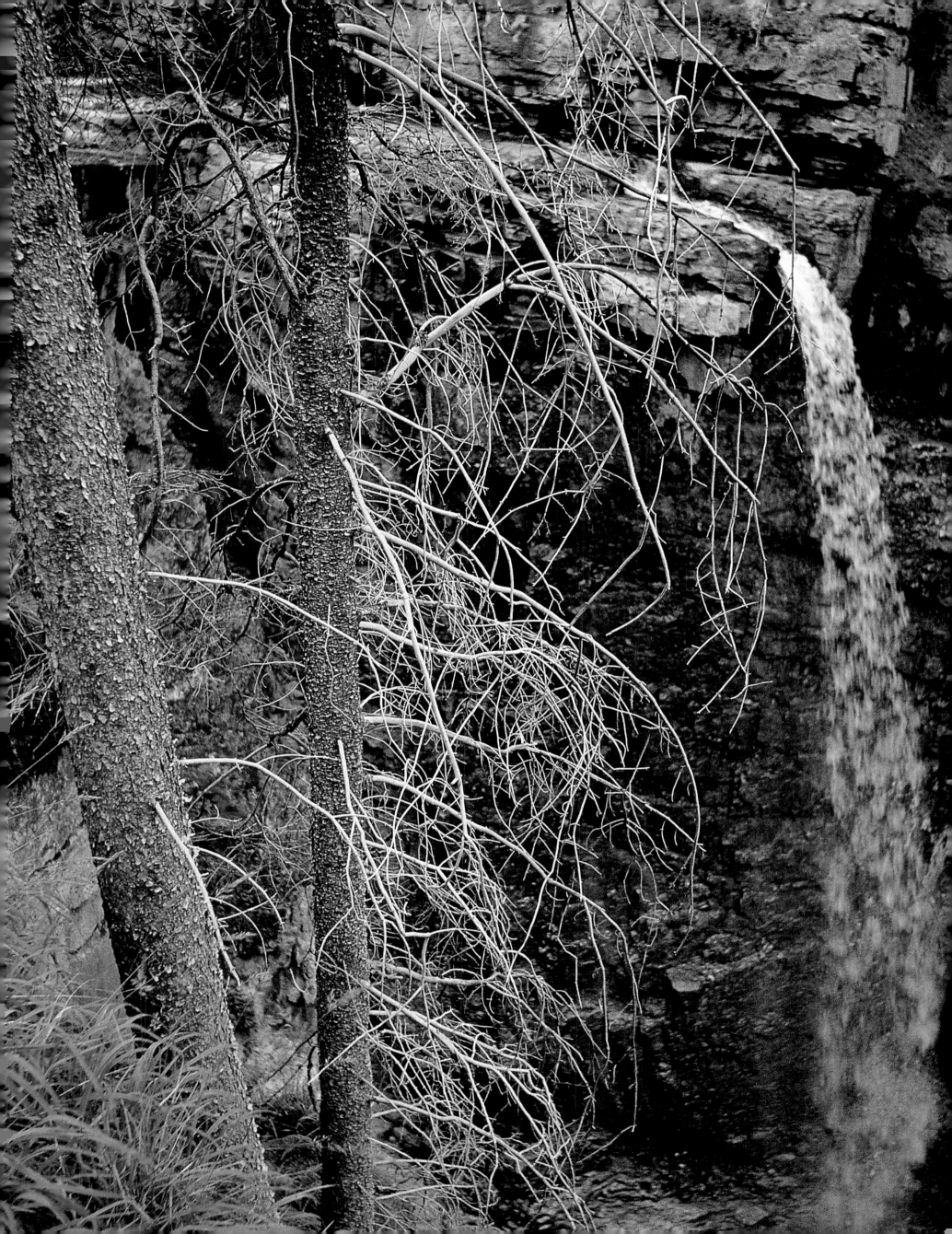

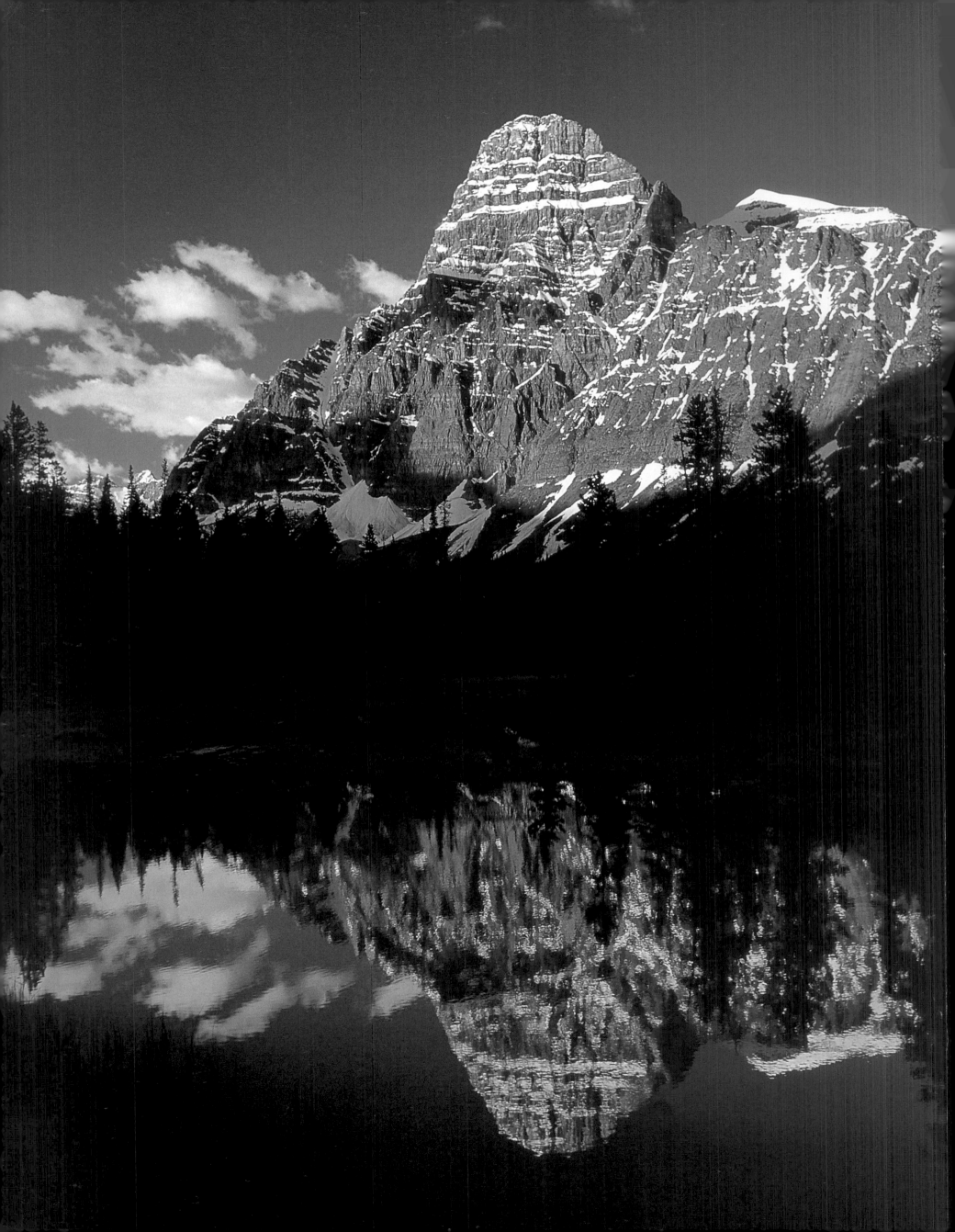

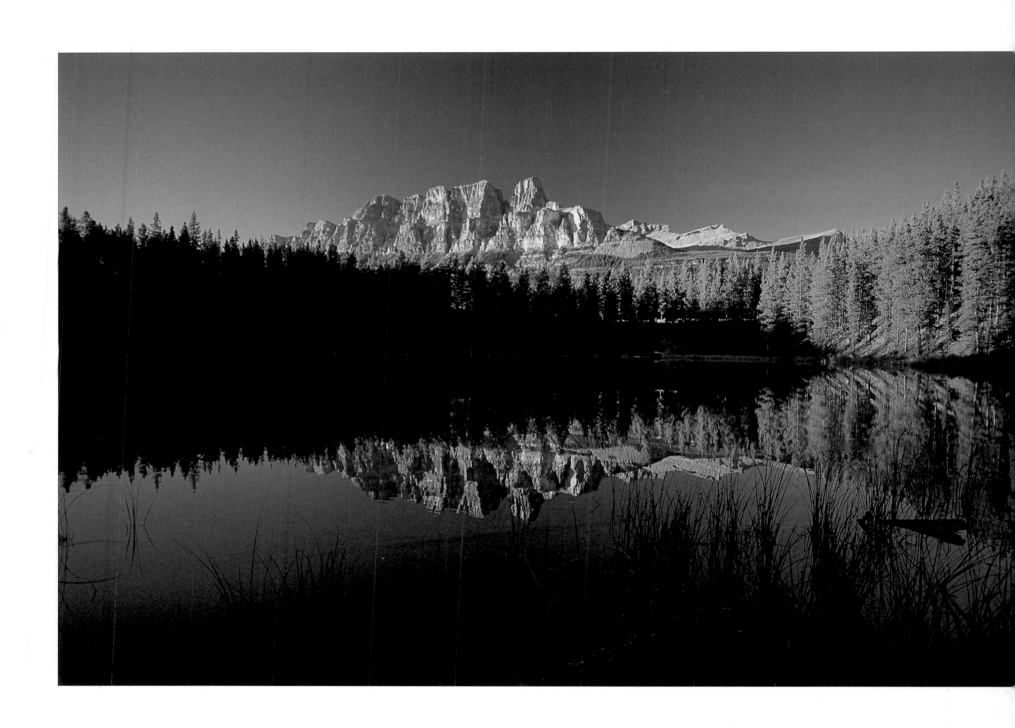

above: **Castle Mountain**
Banff National Park

opposite: **Mt. Chephren**
Banff National Park

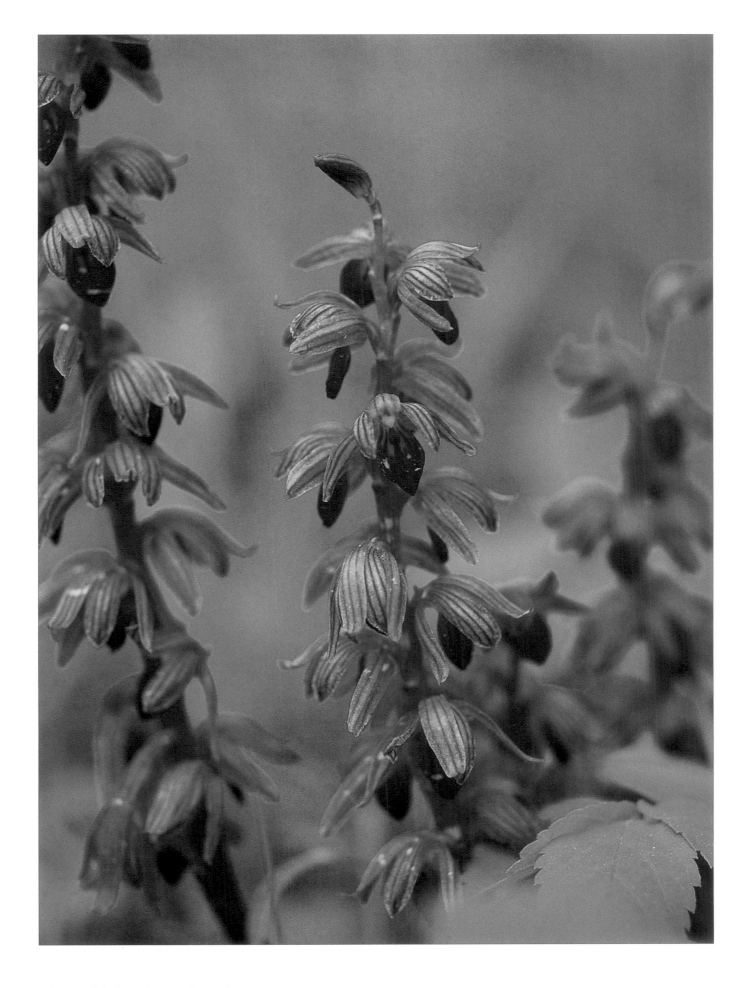

above: **Striped coralroot**
Kootenay National Park

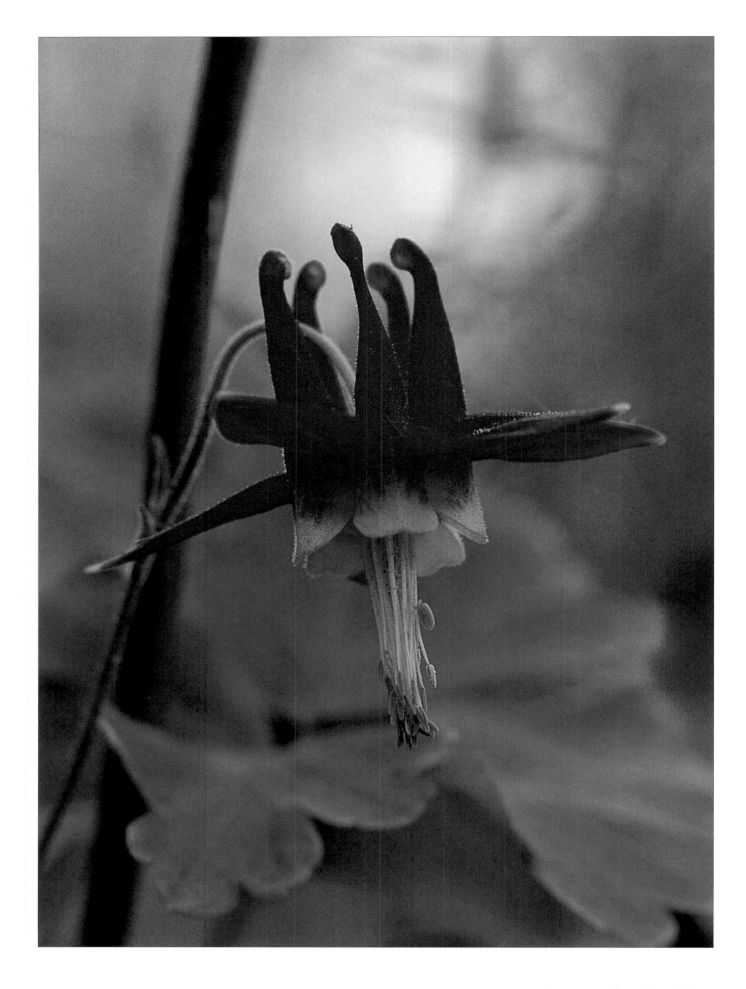

above: **Red columbine**
near Golden, British Columbia

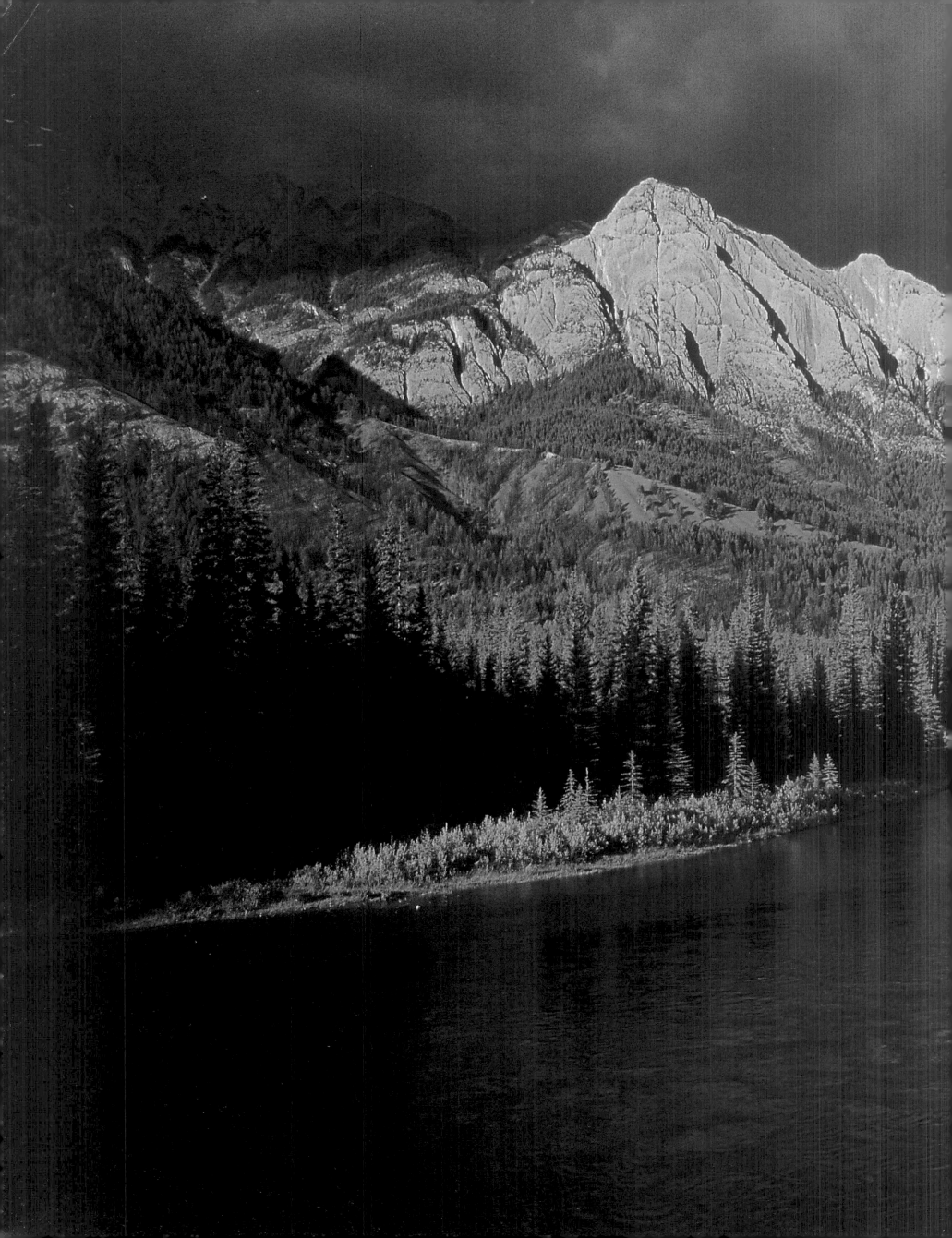

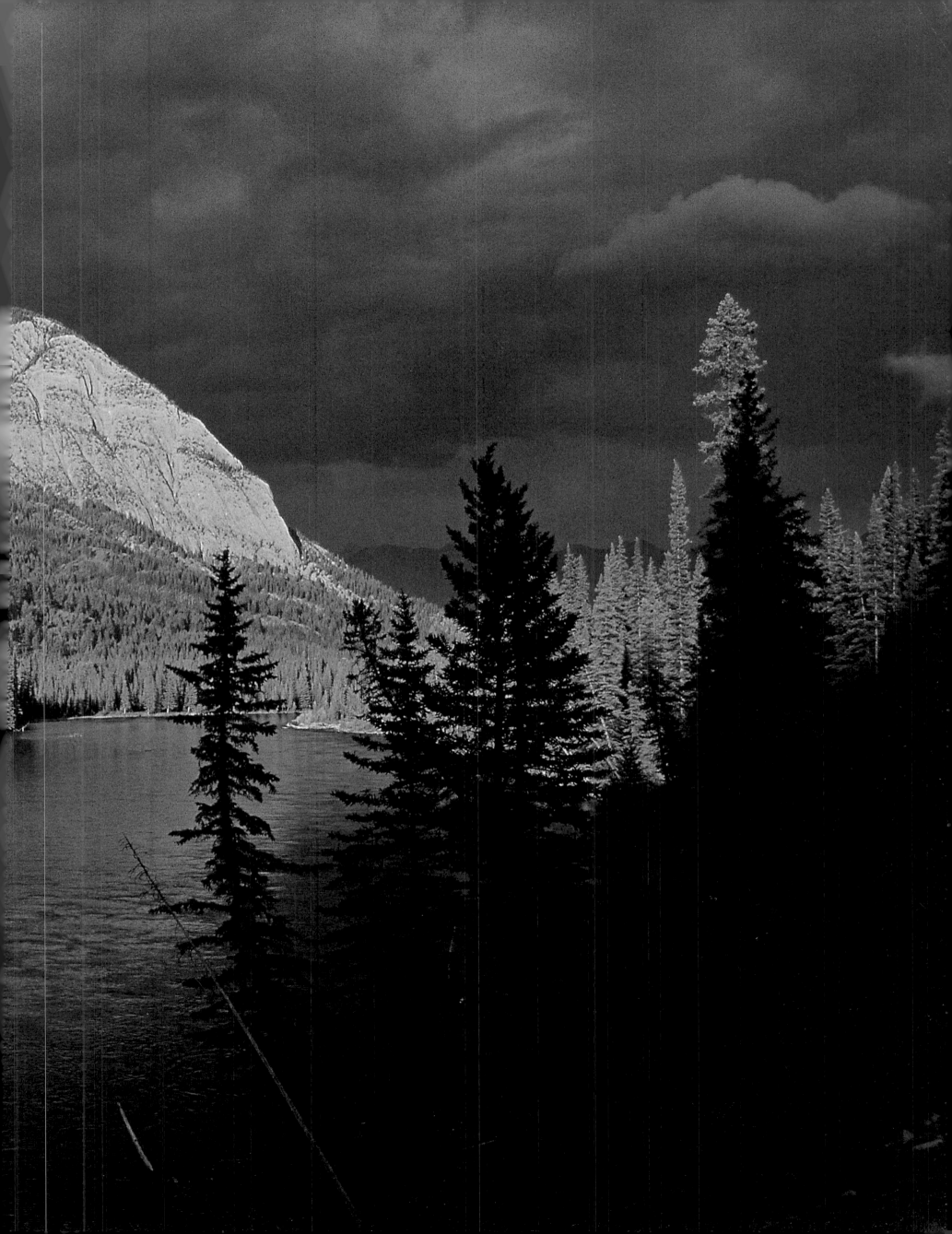

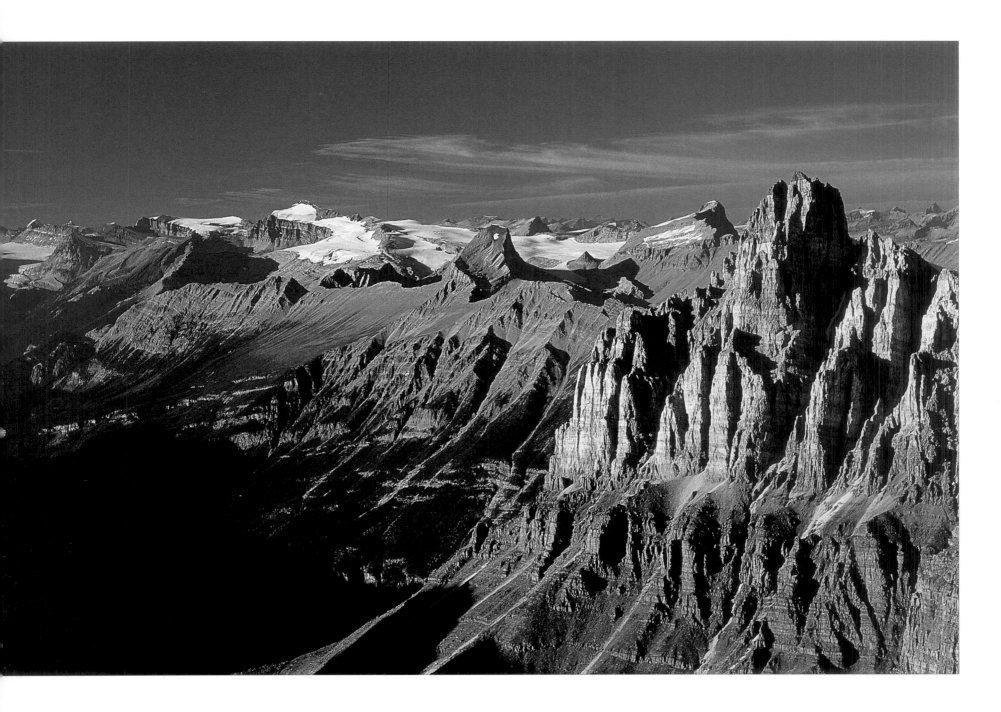

above: **Cathedral Mountain**
Yoho National Park

opposite: **Lake Oesa, Lake O'Hara and Odaray Mountain**
Yoho National Park

previous pages: **Storm over Mt. Cory**
Banff National Park

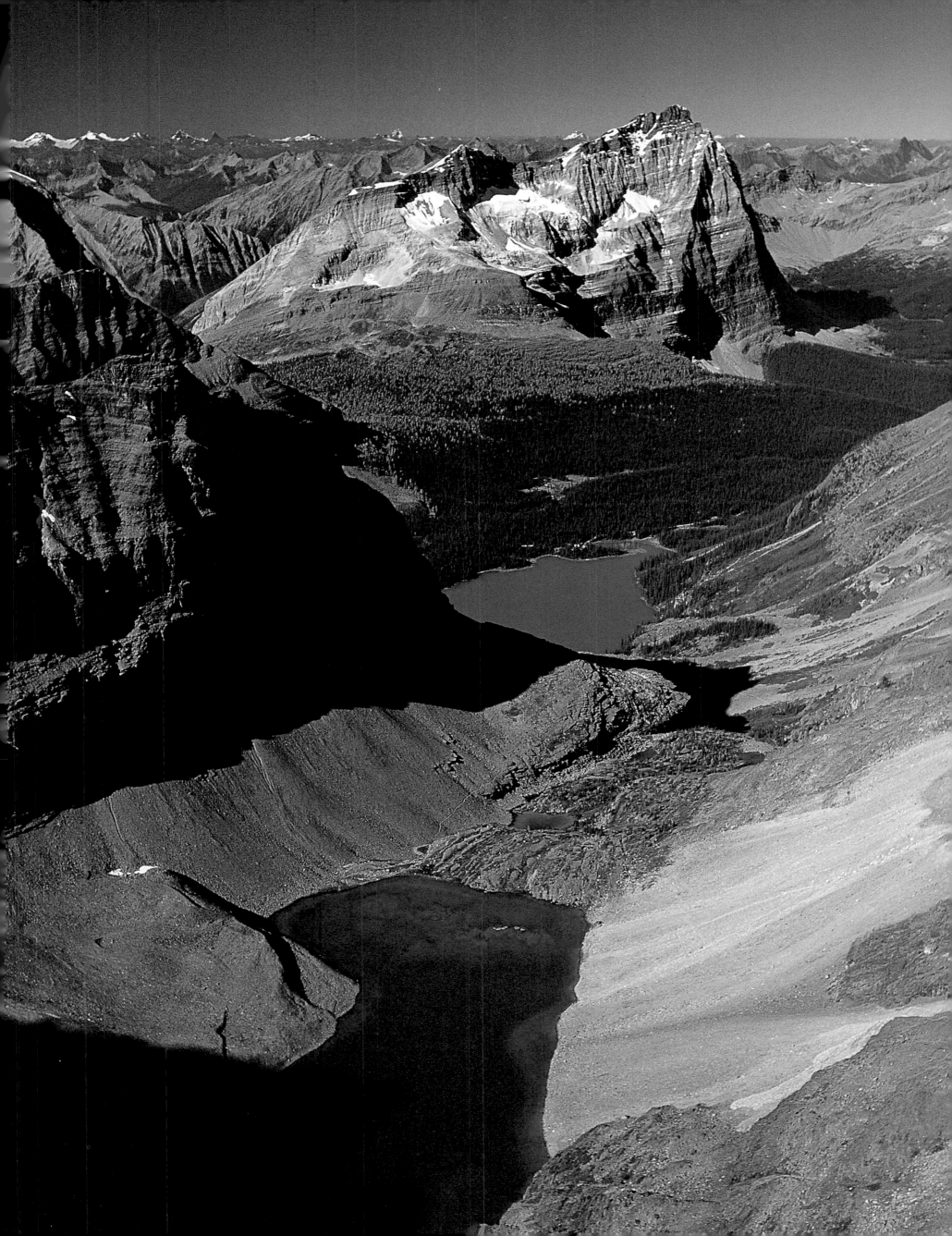

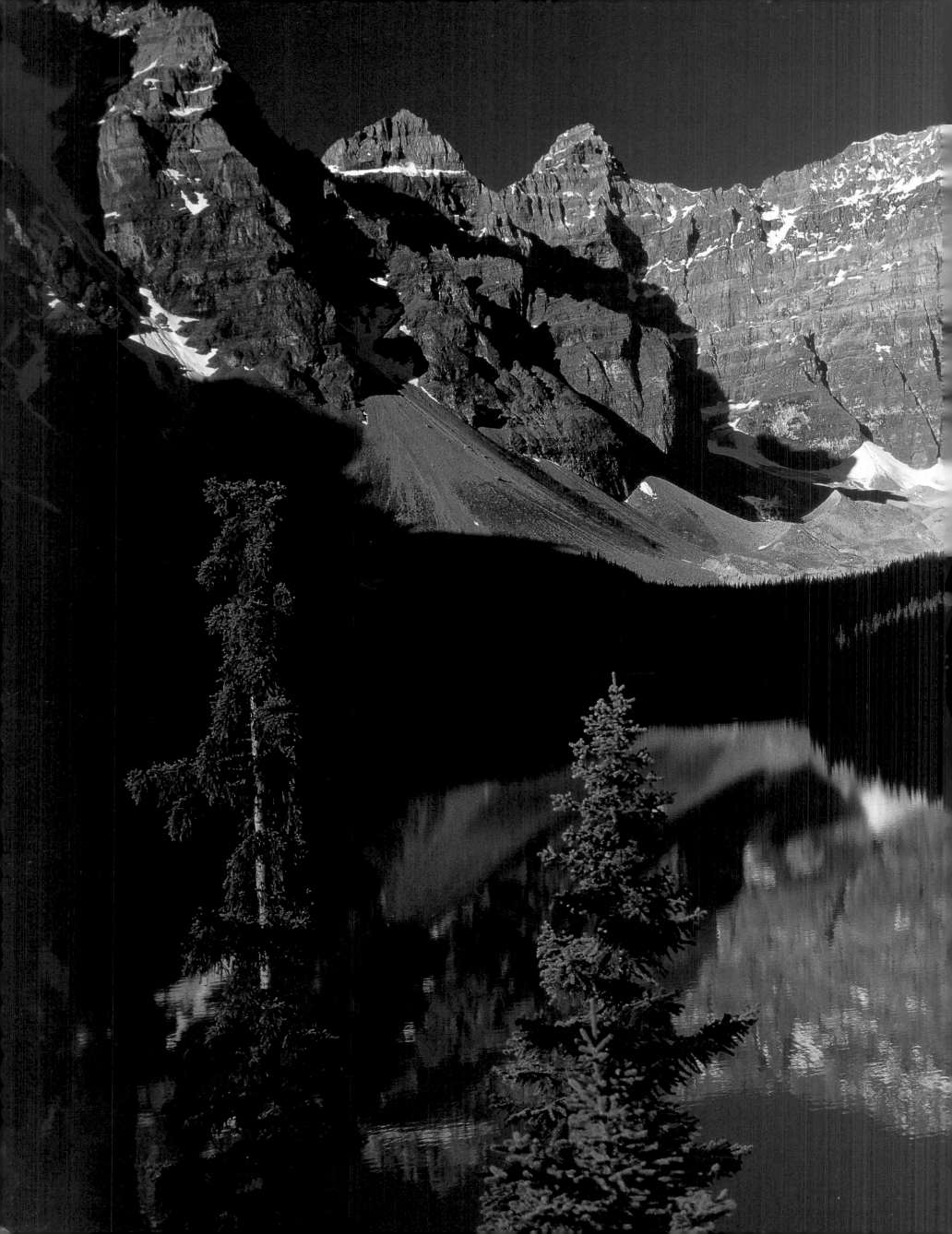

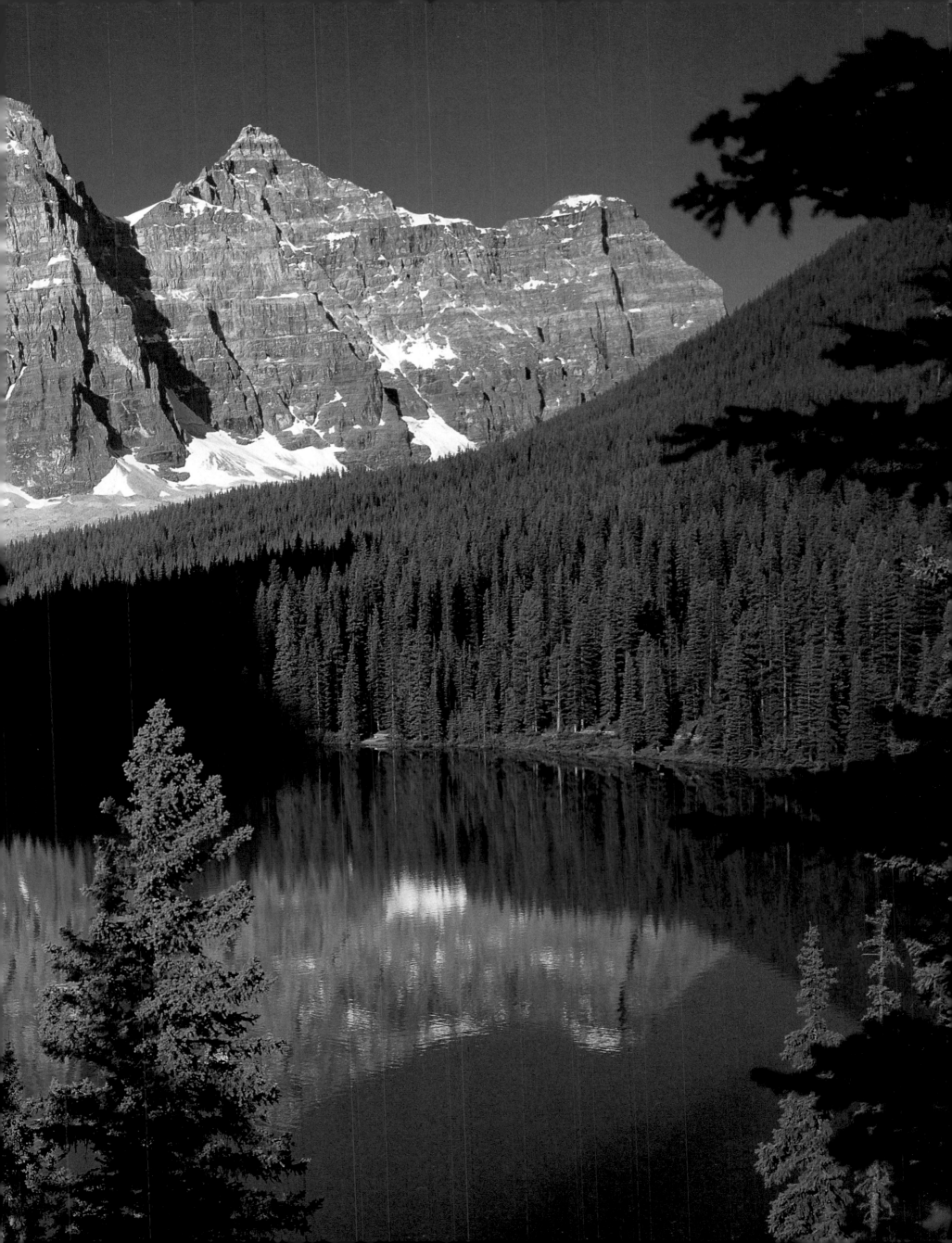

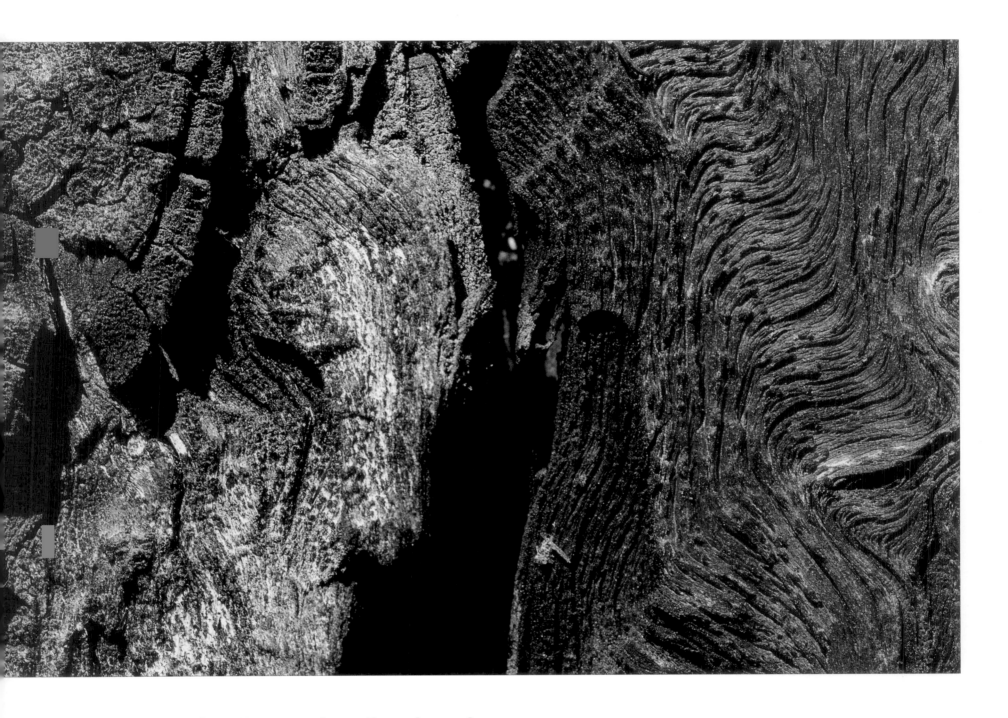

above: **Burnt and weathered wood**
Kootenay National Park

previous pages: **Moraine Lake and the Valley of the Ten Peaks**
Banff National Park

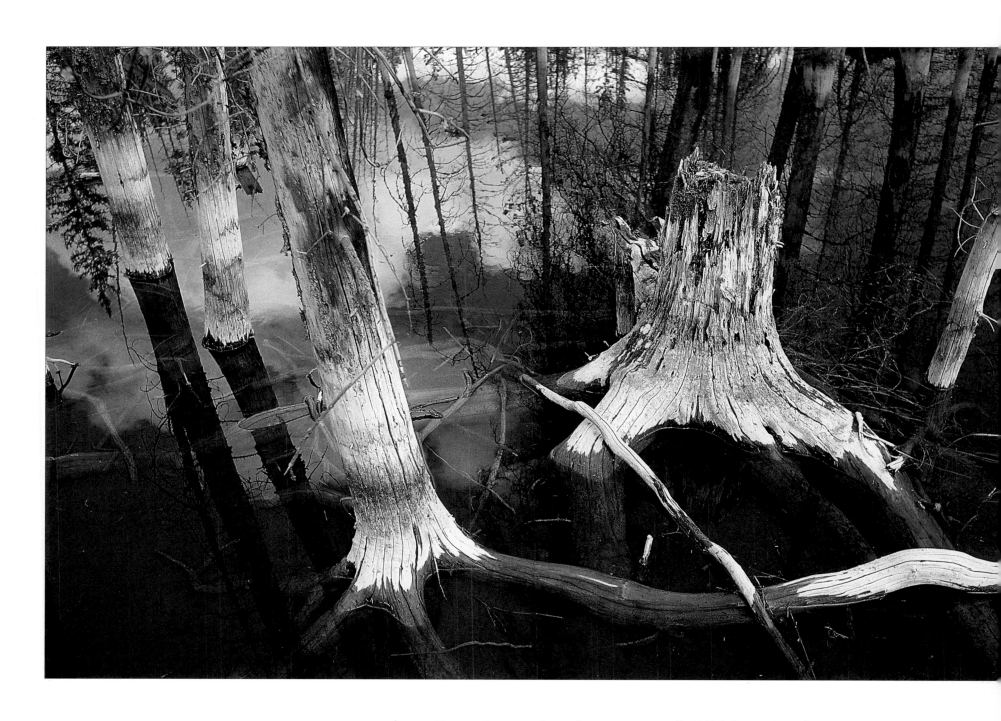

above: **Tree stumps in a beaver pond, Whiskey Creek**
Banff National Park

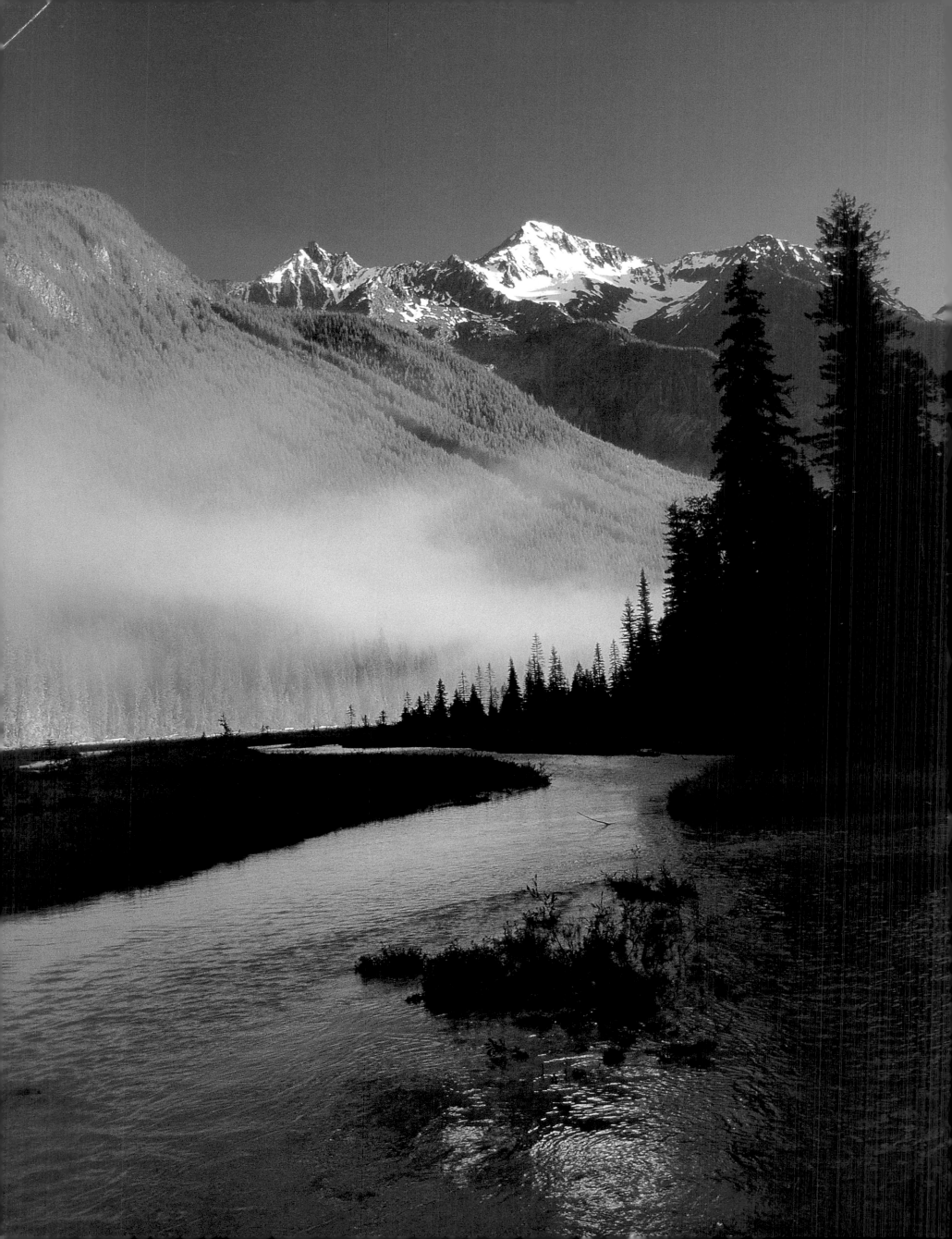

above: **Kinbasket Lake**
near Golden, British Columbia

opposite: **Morning mists on the Blaeberry River**
near Golden, British Columbia

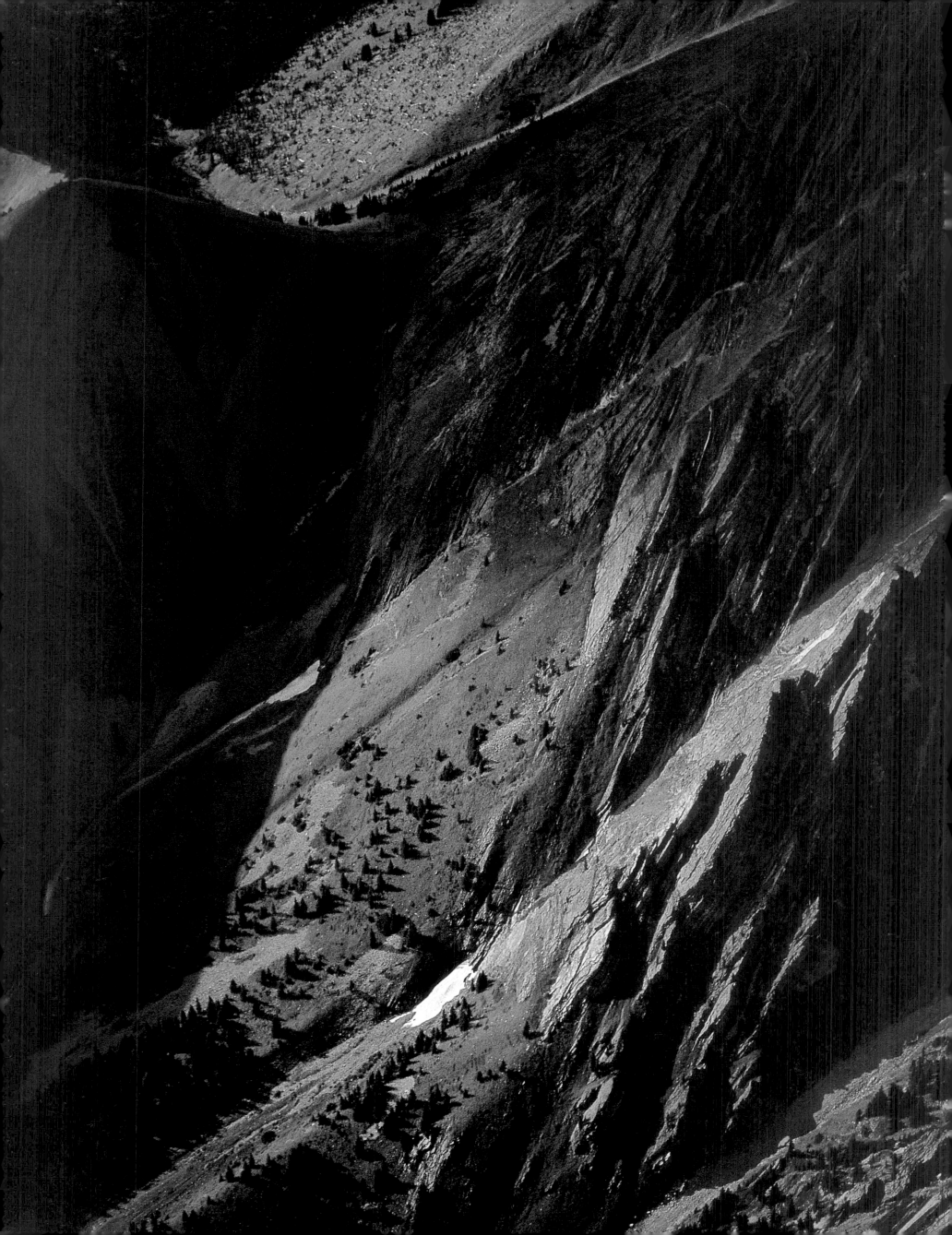

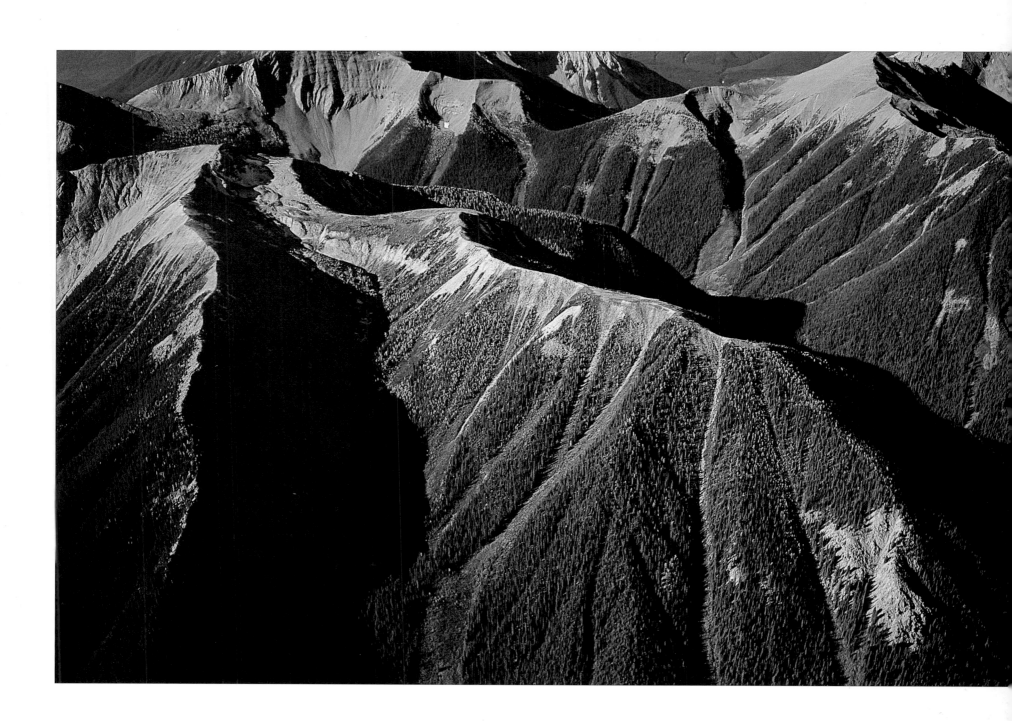

above: **Mountains and ridges**
Kootenay National Park

opposite: **The Spray Valley**
Banff National Park

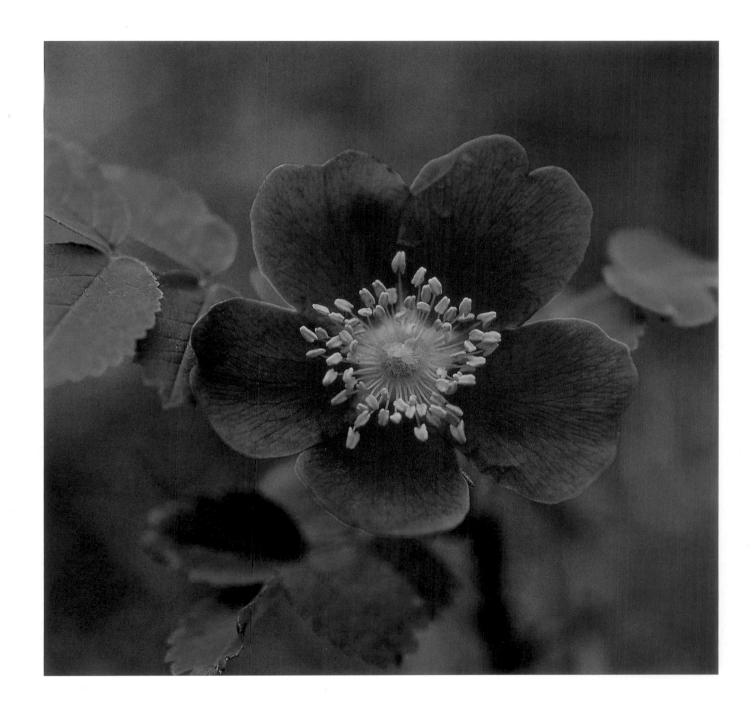

above: **Wild rose**
Kananakis Country

opposite: **Lake Louise**
Banff National Park

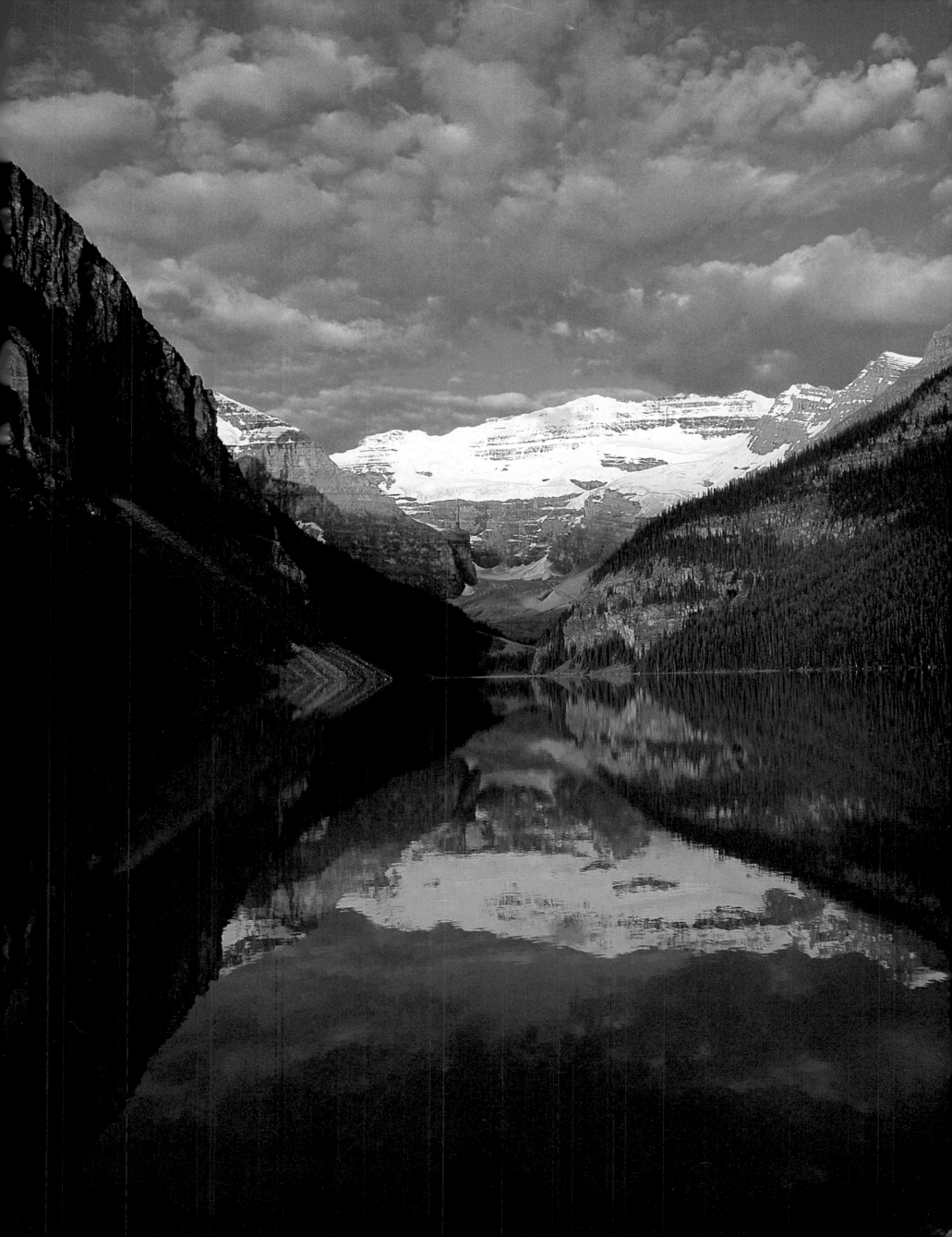

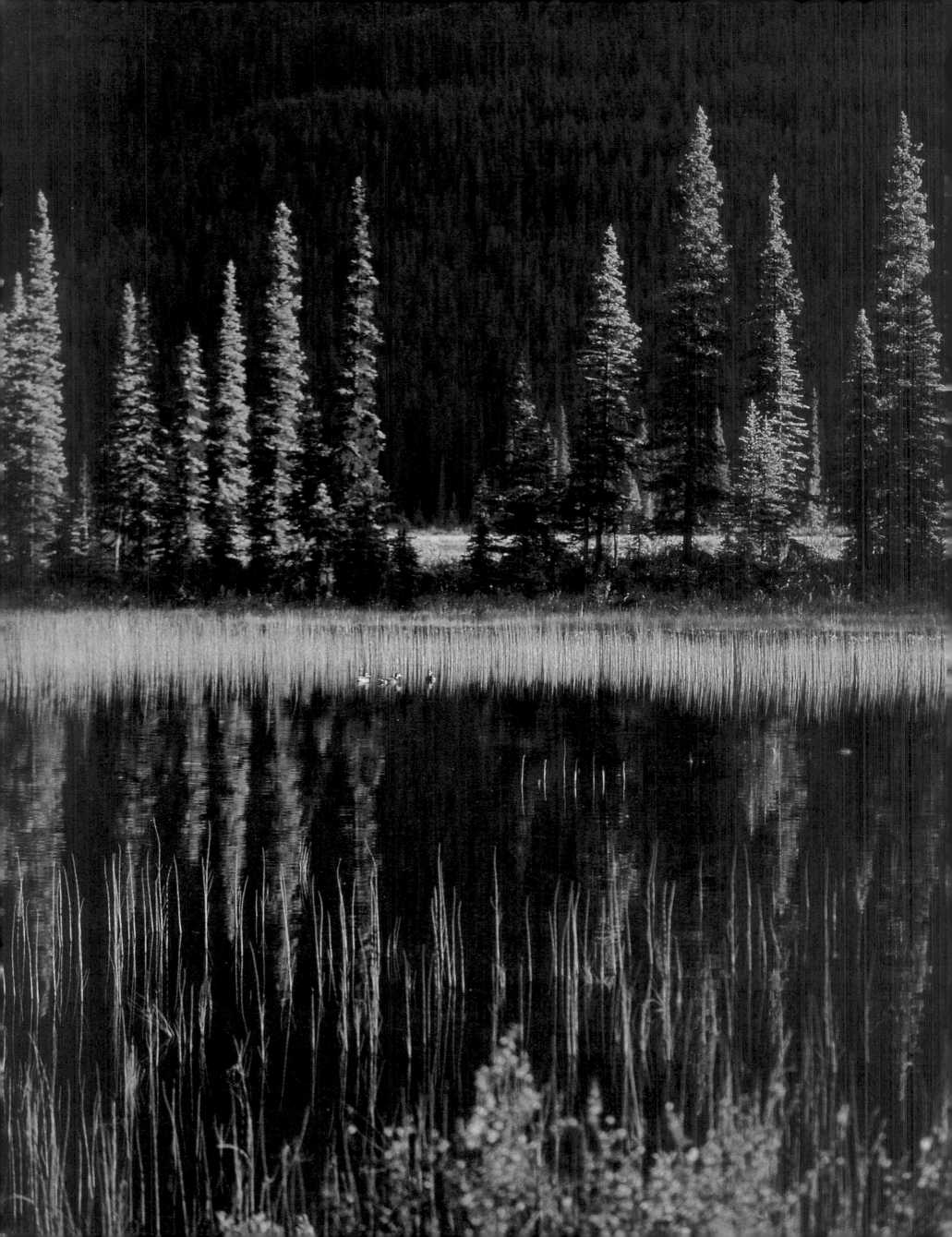

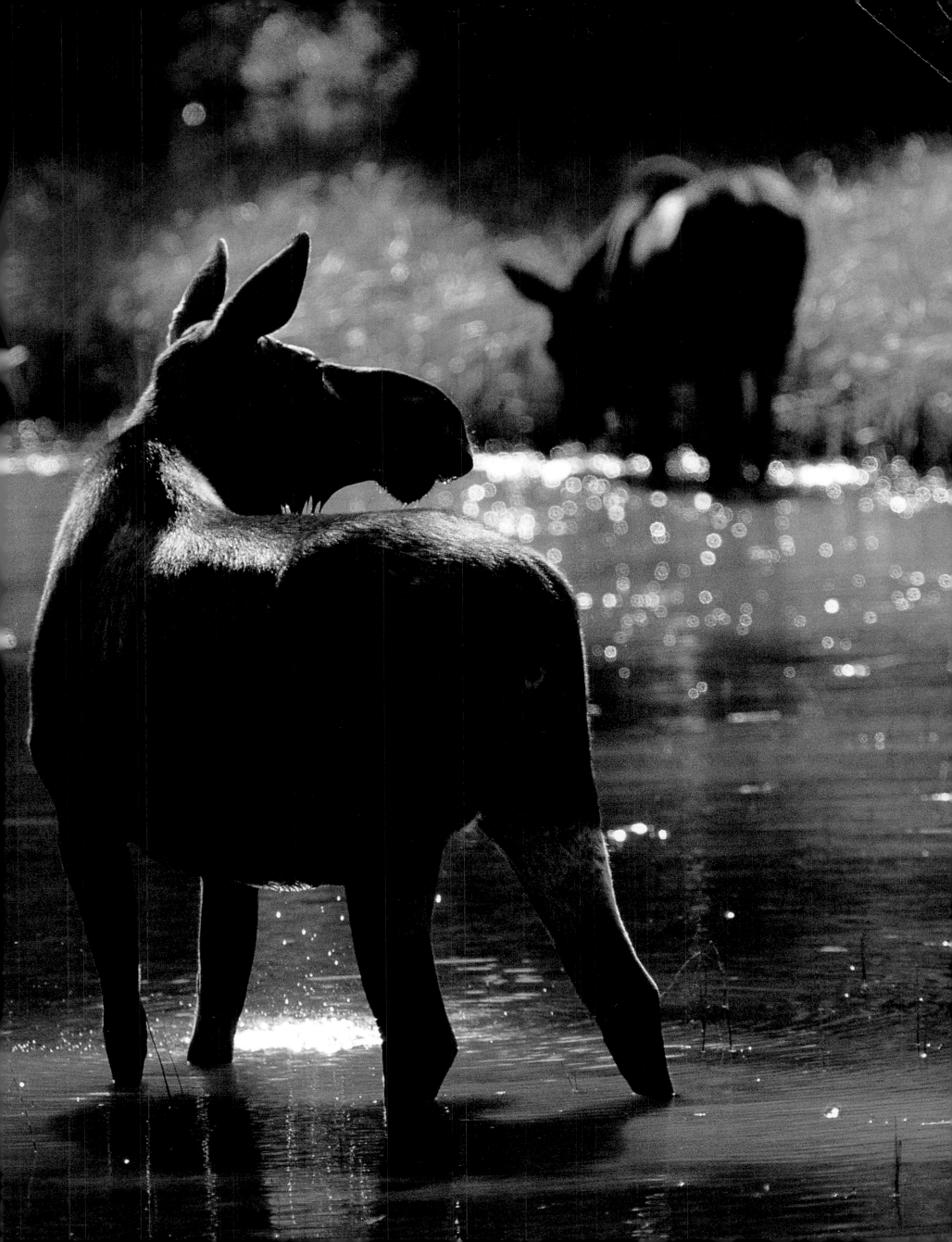

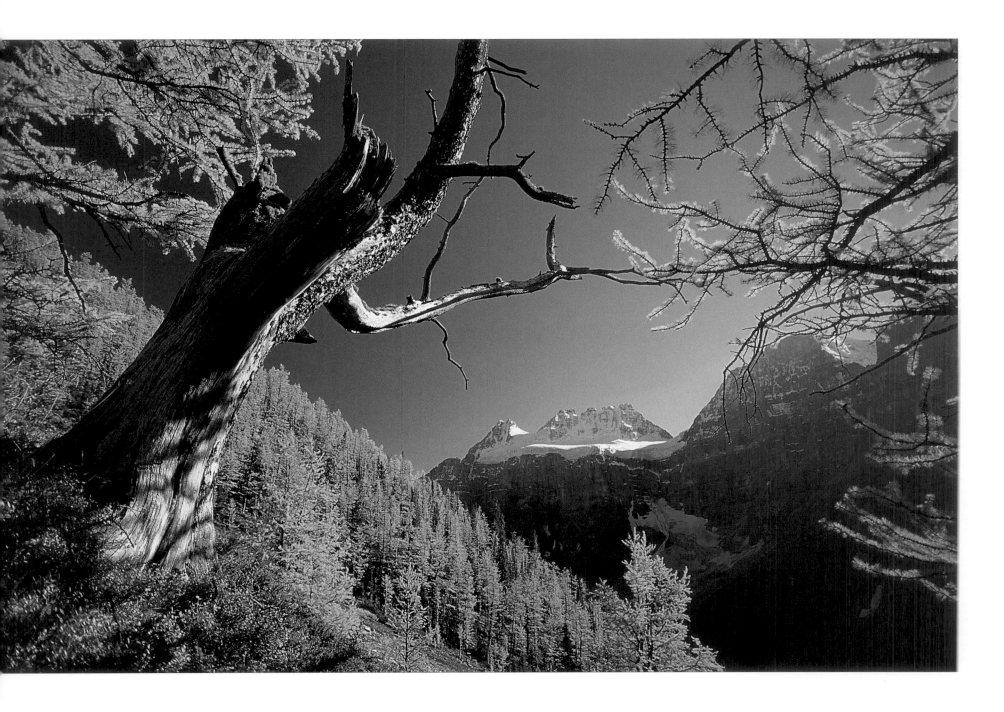

above: **Subalpine larches and Mt. Fay, Consolation Valley**
Banff National Park

previous page left: **Wetlands, Saskatchewan Valley**
Banff National Park

previous page right: **Moose**
Jasper National Park

AUTUMN

Colour film must have been invented to photograph autumn in the Canadian Rockies. The palette is vividly complete: start with the basic blues, whites, greys and greens of the alpine world, then add the purple hues of late-flowering valley asters. Complement this with the fiery reds of the high-country shrub meadows, mix in the lemon yellow and gold of valley aspens and summit larches, and finish off the scene with a fine dusting of the season's first snow.

In fall, even the ecological and landscape relationships seem to be colour-keyed, making for easy identification. The living biodiversity of the Rockies is revealed, for instance, in the varying hues of the different deciduous species growing on a flood-plain, in the washes of red shrublands and spruce edges, as well as in the lines of golden subalpine larches clinging to the rocky timberline.

There is something spellbinding about walking through a stand of Lyall's larch in mid-September when the needles turn from green to cadmium yellow and then develop into a full deep gold. When you time your walk just right, you will experience all of these colours at the same time. Wait a week or so and all the yellows mature together, and the entire stand of larches colours the atmosphere with a rich

autumn gold. Larch trees are deciduous conifers. They shed their needles each year in the fall and the tree becomes dormant. Lyall's larches are frequently several hundred years old, and this gives the larch forests a certain aura of antique charm.

Some say that the autumn is their favourite season. The cool air chases away the nasty summer insects; the muted, sometimes smoke-filled air of late August gives way to sharp, clear skies in September. And there is always that week or so late in

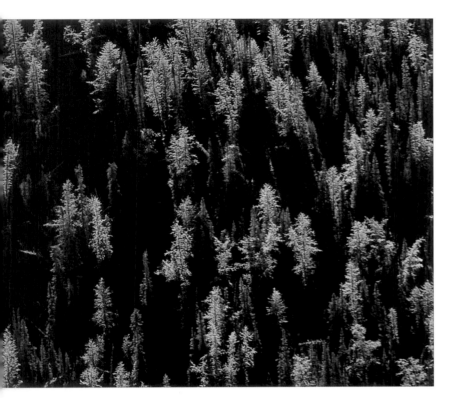

September when the weather turns warm again and everyone hopes that maybe this year winter will be just a little further away than it really is.

In the fall, one of the most conspicuous of the large animals in the Canadian Rockies is the bull elk. They look majestic with their freshly-grown antlers and they sound equally magnificent with their breeding-season bugling. During the early autumn their call can be heard throughout the entire mountain area, as they stake their claim to the mating rights of the cow elk clustered nearby. Listening closely, one can also hear the clashing of the antlers as the bull elk battle for supremacy. These amazing animals are one of a photographer's favourite subjects. Seemingly tame when they stand by themselves, they become quite the opposite when approached too closely. These elk (also known as wapiti) were reintroduced from Yellowstone National Park in Wyoming in 1917 and 1920.

above: **Subalpine larch and spruce forest, Healey Creek**
Banff National Park

Bighorn sheep also rut actively in the fall. The rams battle each other to determine which one will mate with the harem of ewes. They duel by charging headlong at each other, and although a strong bone structure beneath their horns usually prevents serious injury, there have been cases when two rams have battled to the death. The dominant ram is frequently put to the test; the position may change many times. After the fall rut, the flock travels to the higher slopes where the winds keep the snow-build down to a minimum, allowing the bighorn sheep access to the grasses they feed on during the long winter months.

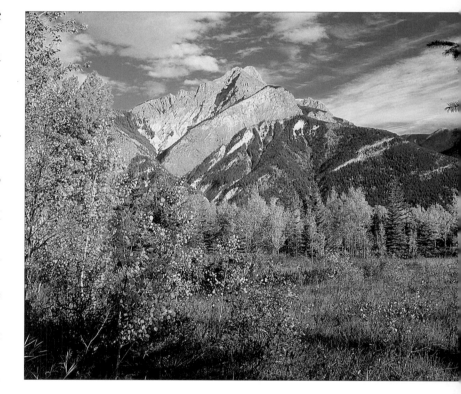

The trembling aspen is one of the most striking trees of the autumn Rockies (see, for example, pp. 130-31). The leaves of aspen forests turn bright lemon yellow, colouring entire mountainsides with their brilliance. The trembling aspen gets its name from the activity and noise of its leaves. They are shaped in such a way that they flutter easily with the slightest wind. A grove of aspens is actually a multi-stemmed clone rising from a single, living root system. They can be thousands of years old, and must be, since conditions for their new establishment by seed are rare, and it is even rarer for a seedling to establish a new grove. Long-term aspen survival depends on fire, which kills the conifers but not the fire-resistant aspens. Fire actually helps to recharge their root systems, causing fresh suckers to sprout on the perimeter.

above: **Blaeberry Valley**
near Golden, British Columbia

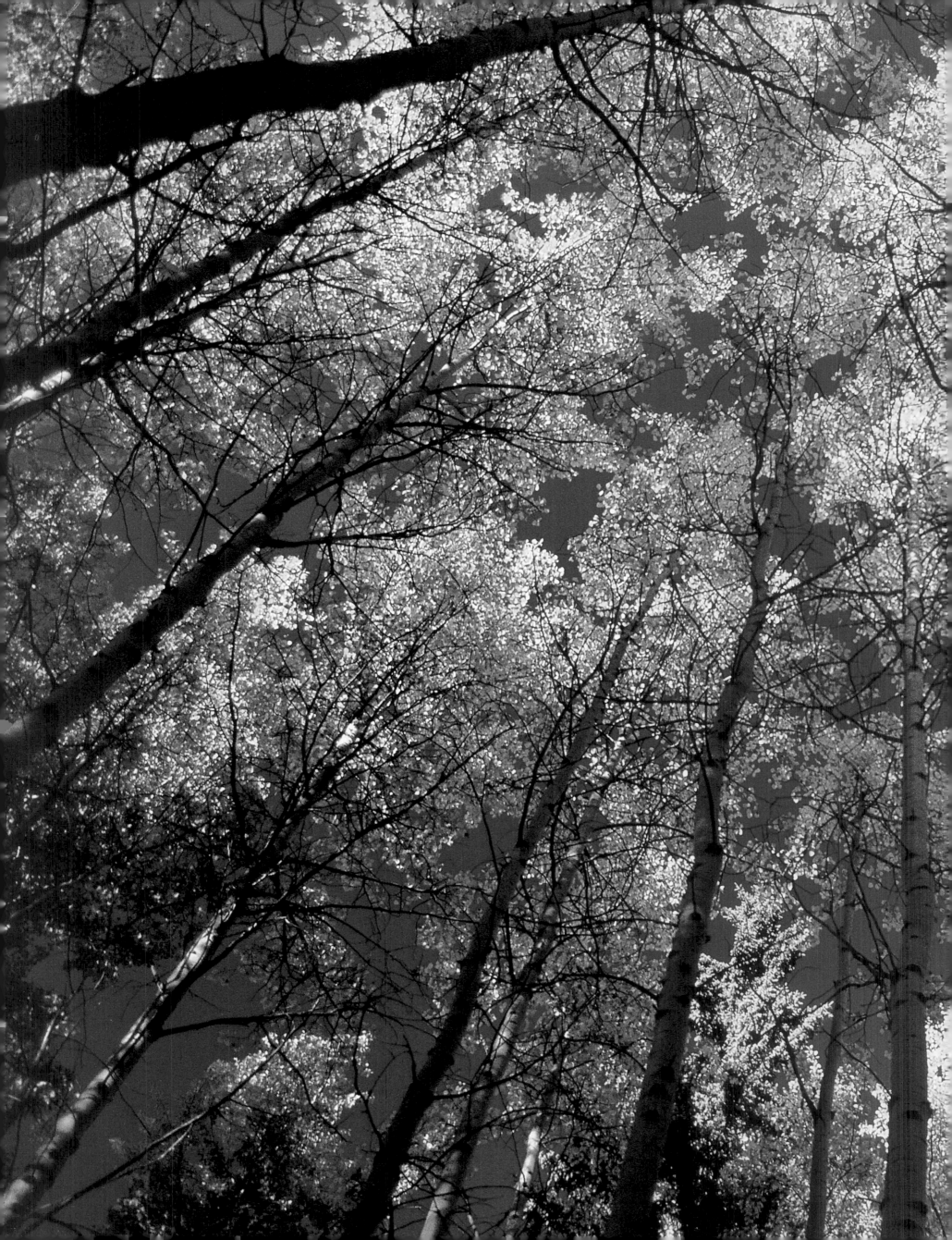

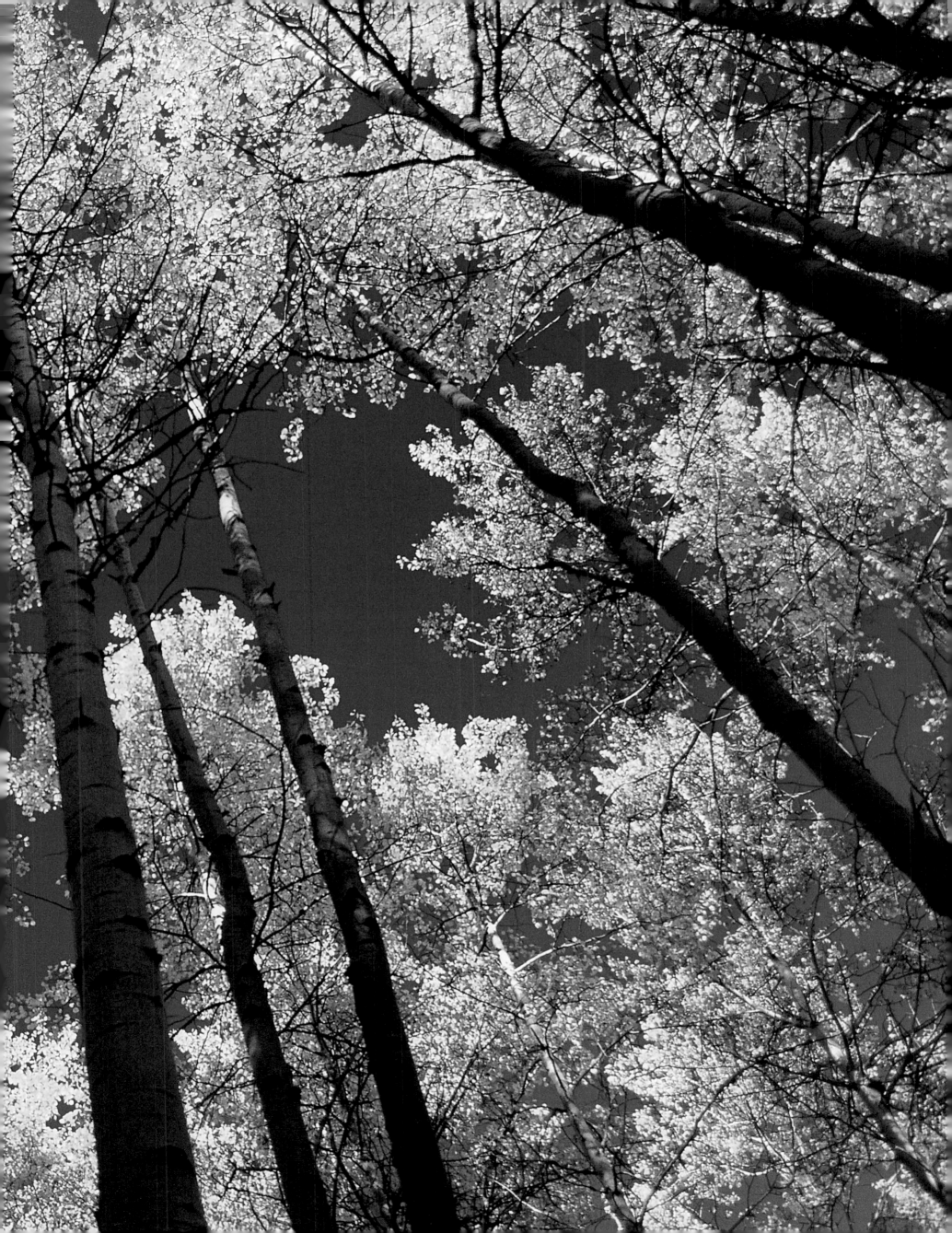

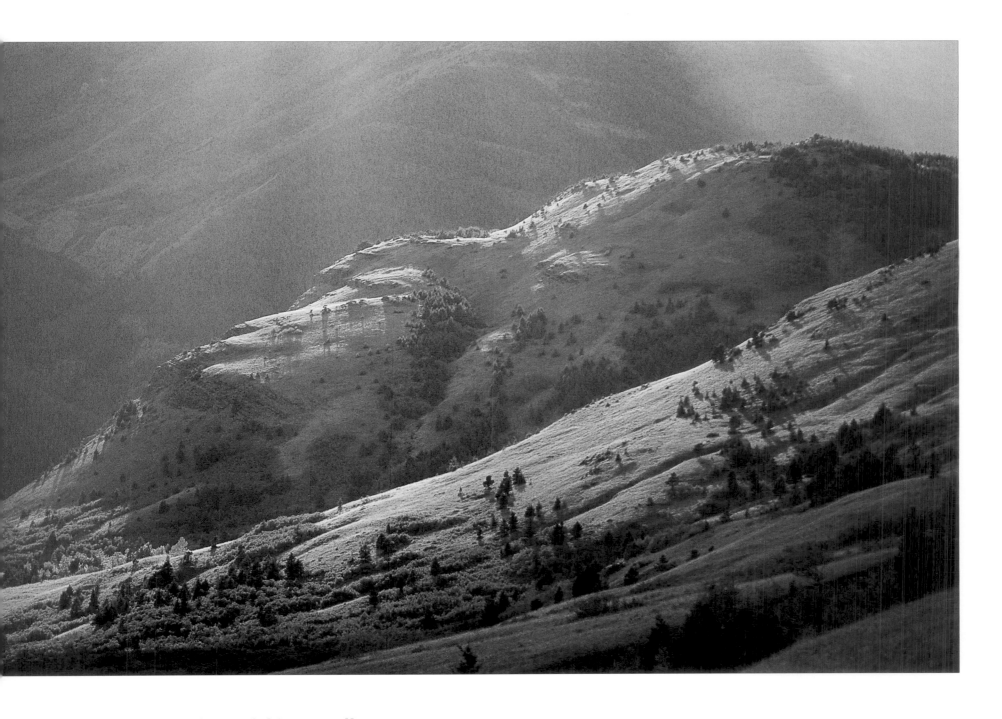

above: **Blakiston Valley**
Waterton Lakes National Park

previous pages: **Autumn aspens**
Banff National Park

above: **Autumn colours**
Waterton Lakes National Park

next pages: **Larch Valley and Wenkchemna Peak**
Banff National Park

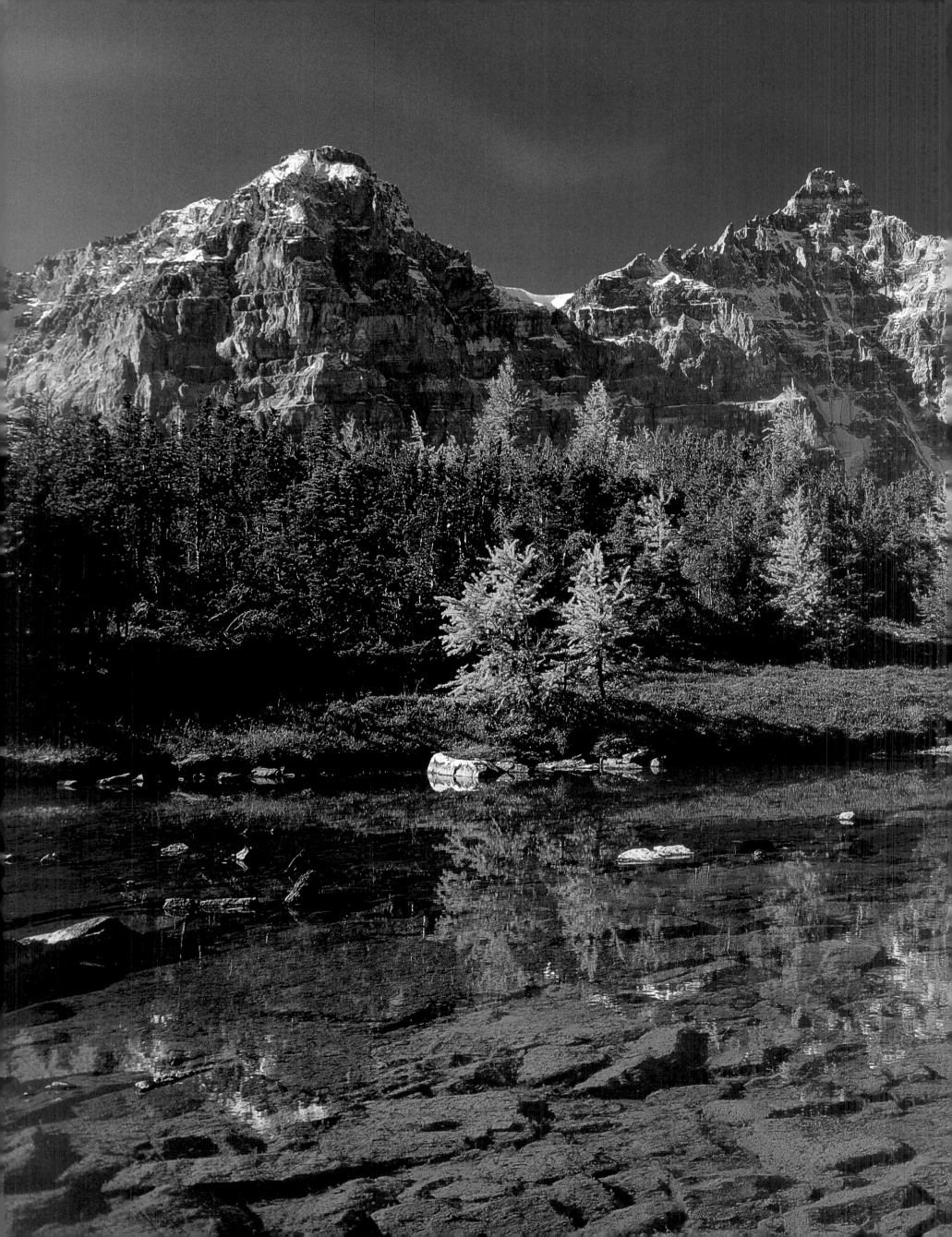

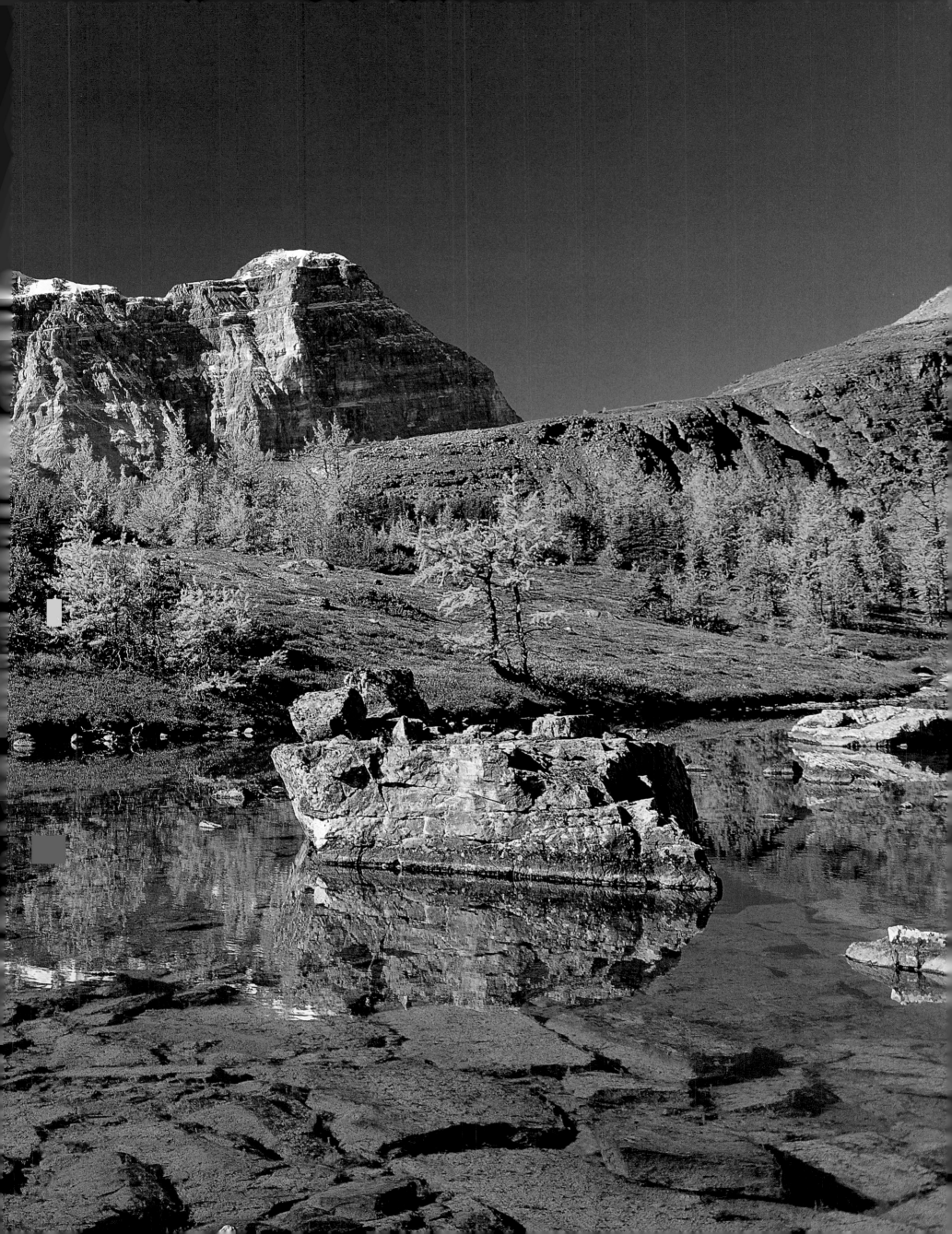

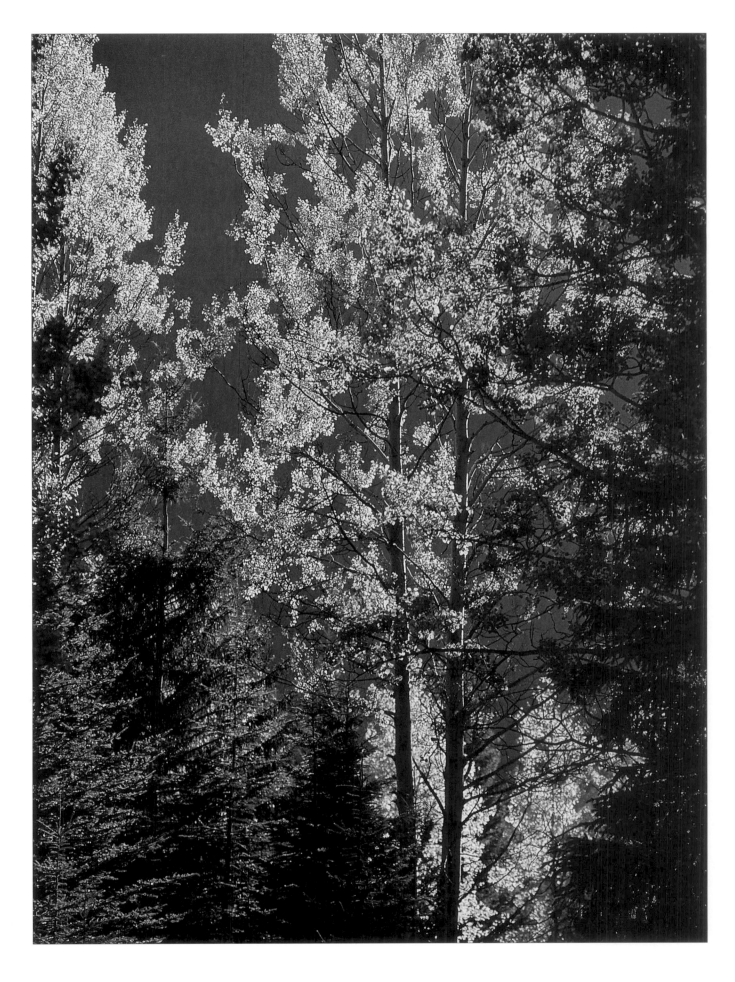

above: **Autumn aspens and spruce trees**
Banff National Park

opposite: **Marsh, Blaeberry Valley**
near Golden, British Columbia

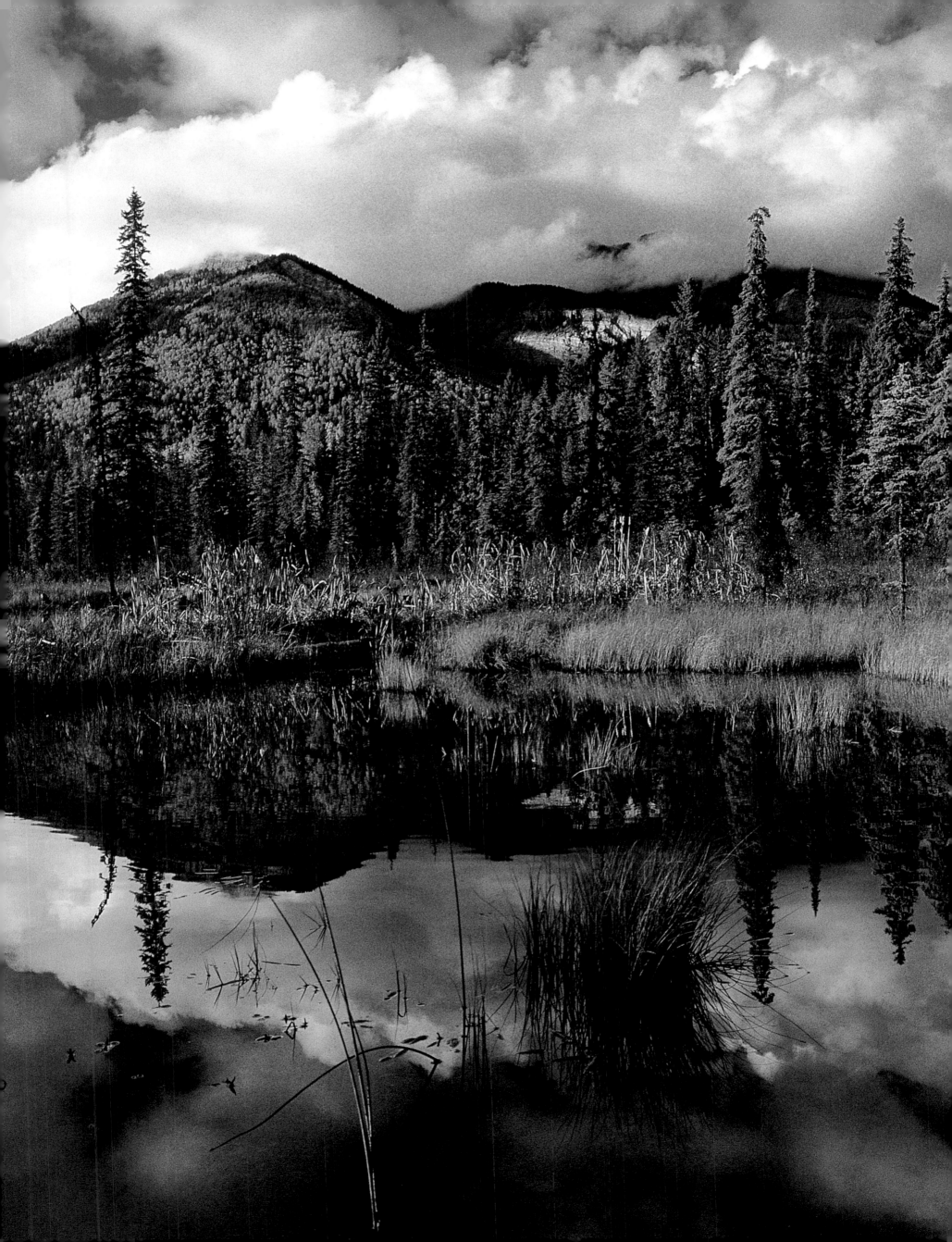

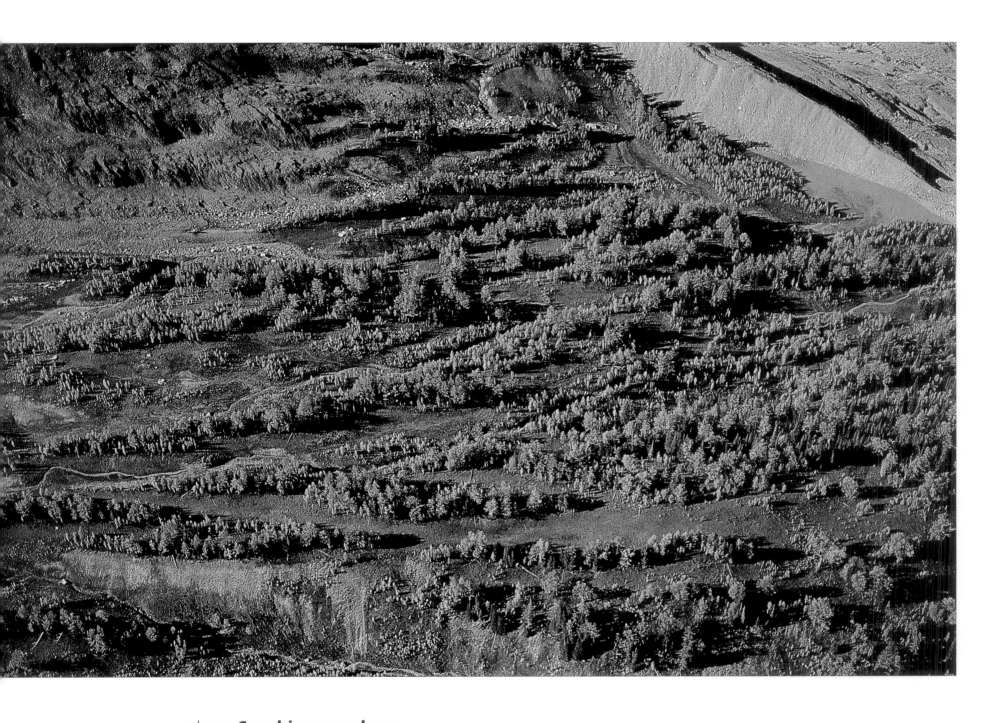

above: **Sunshine meadows**
Banff National Park

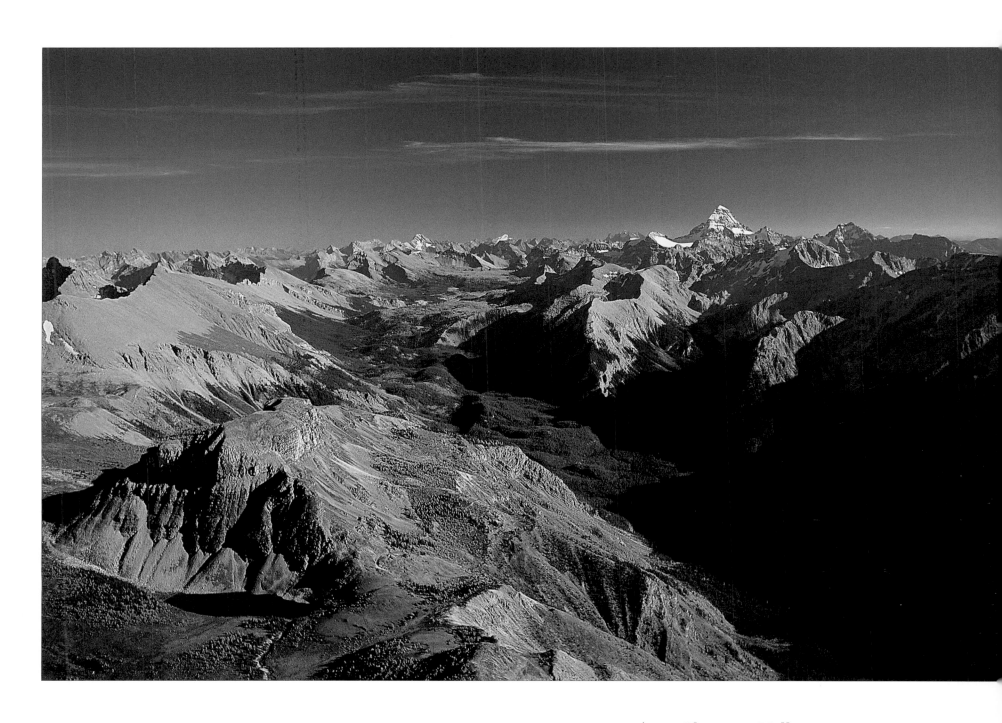

above: **Simpson Valley**
Mt. Assiniboine Provincial Park

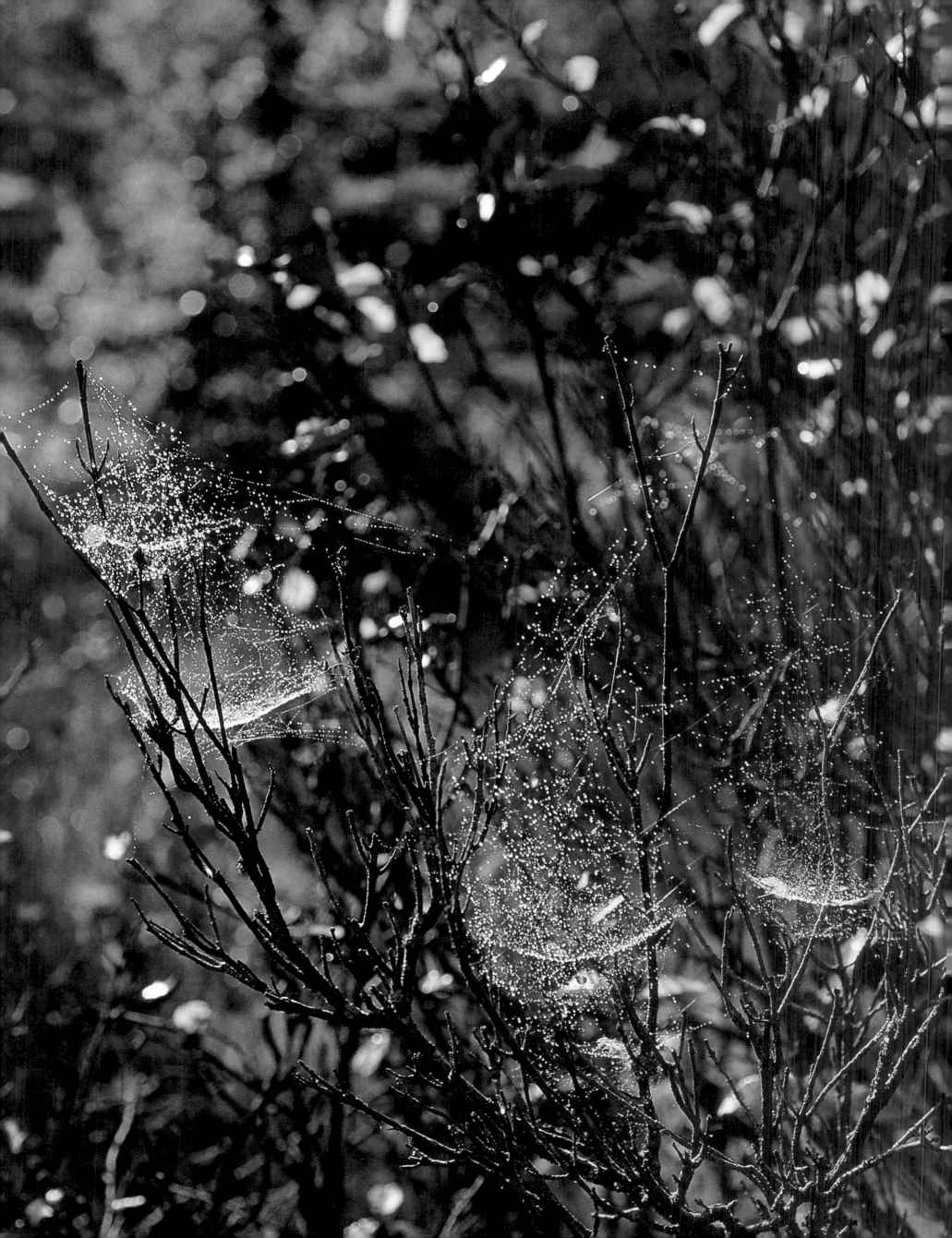

above: **Indian paintbrush**
British Columbia

opposite: **Spider webs and morning dew**
Bush River, British Columbia

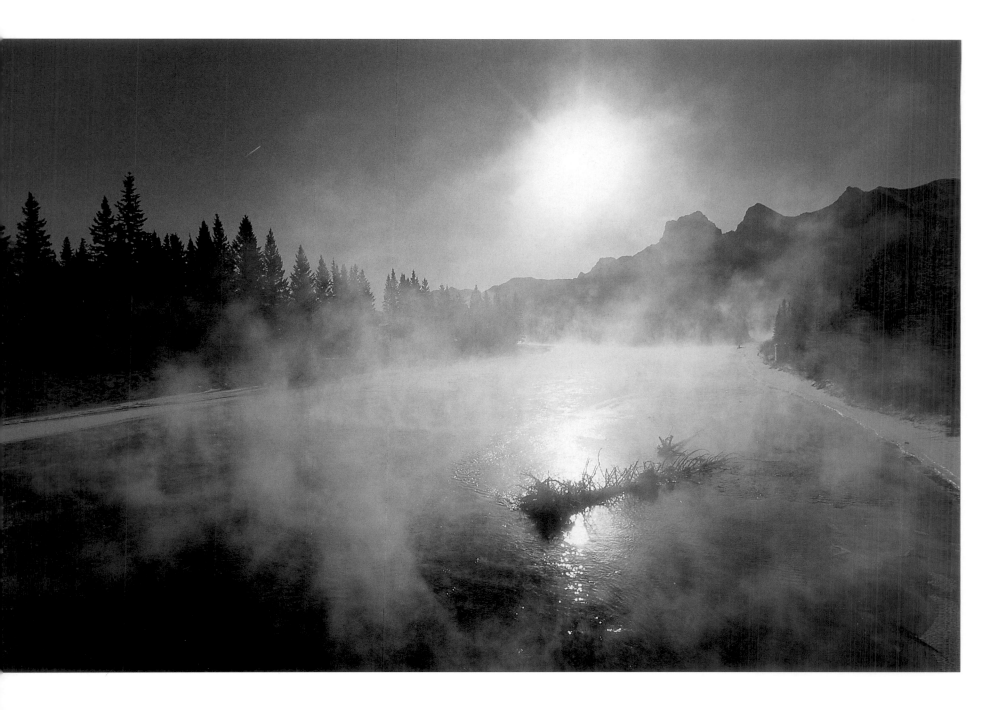

above: **The Bow River and The Three Sisters Mountain**
near Canmore, Alberta

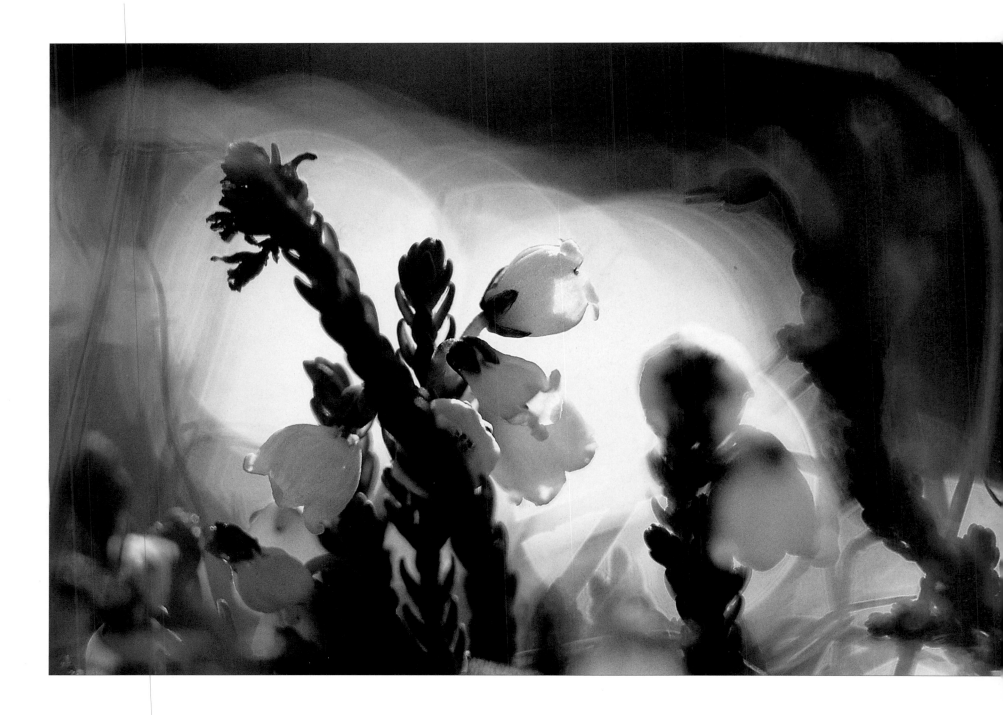

above: **White mountain heather**
Jasper National Park

next page left: **Tipperary Lake**
Height of the Rockies Wilderness, British Columbia

next page right: **Mitchell Range**
Kootenay National Park

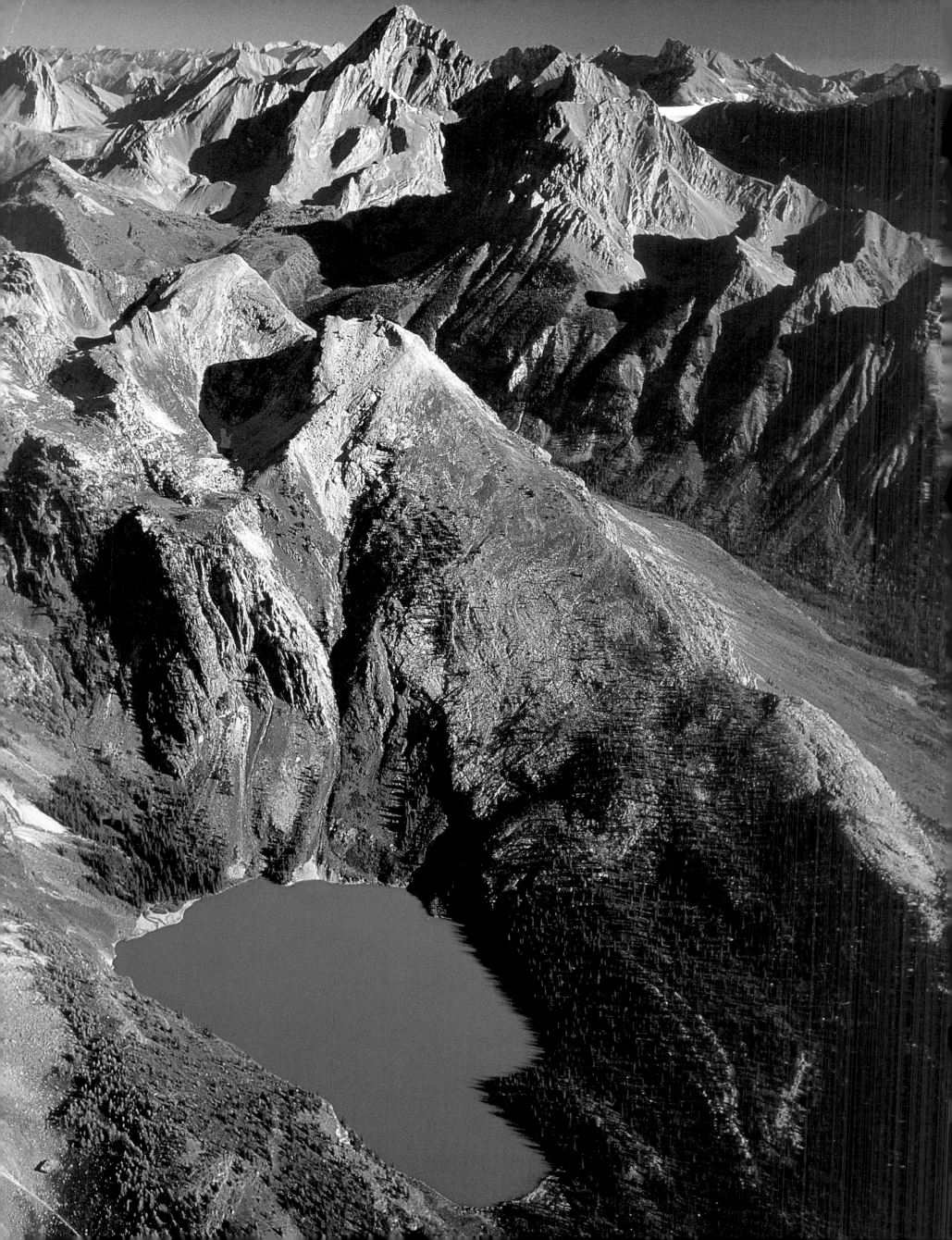

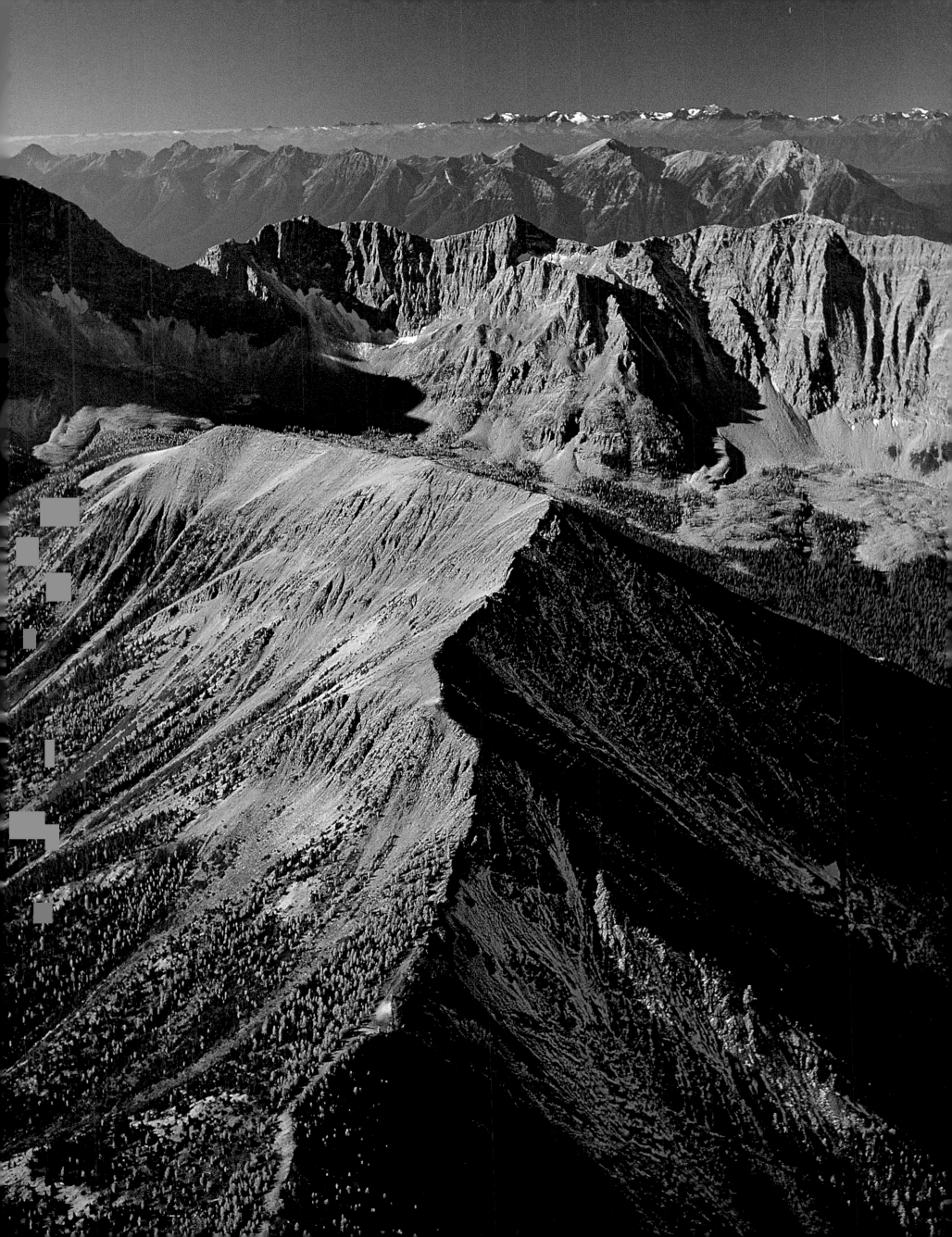

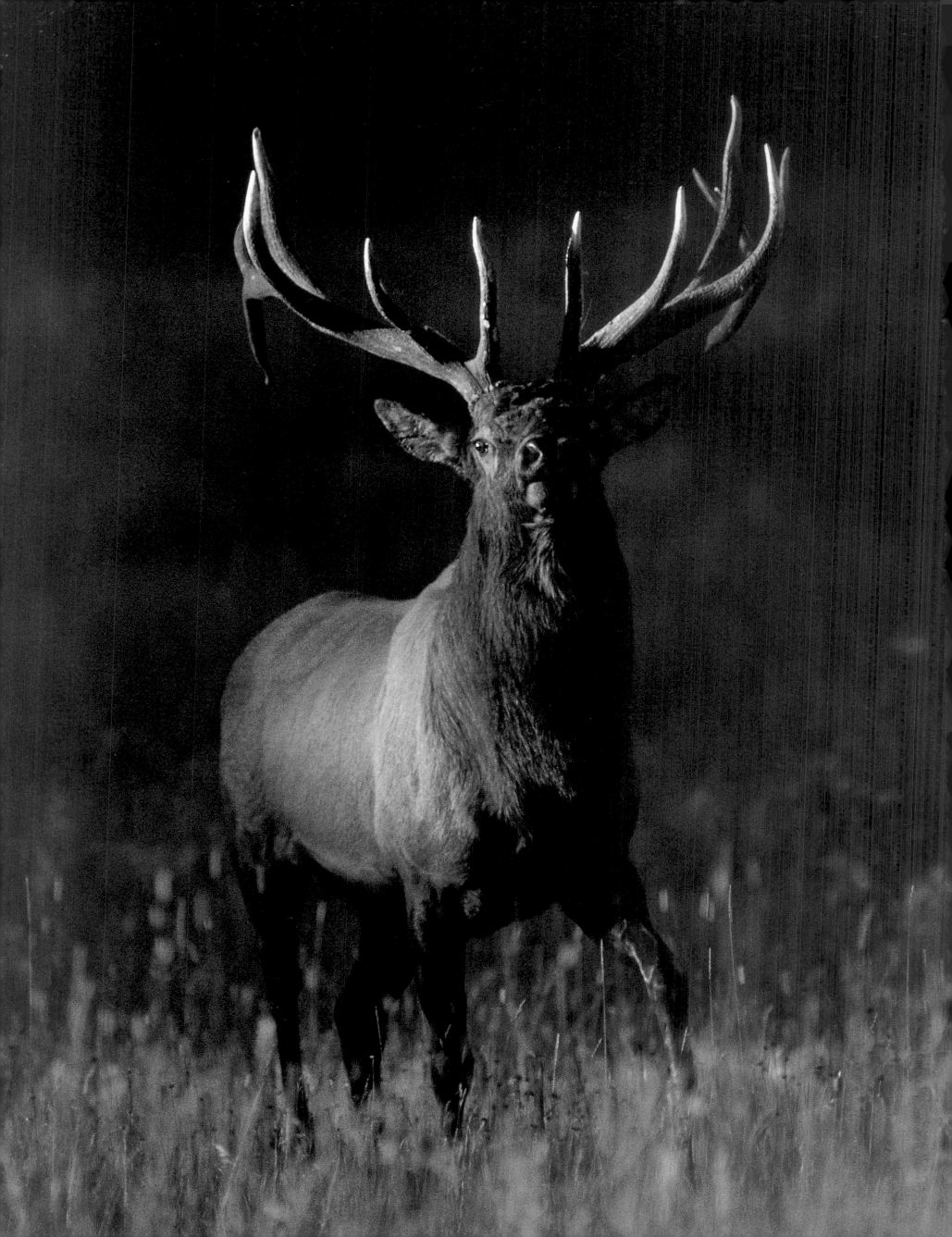

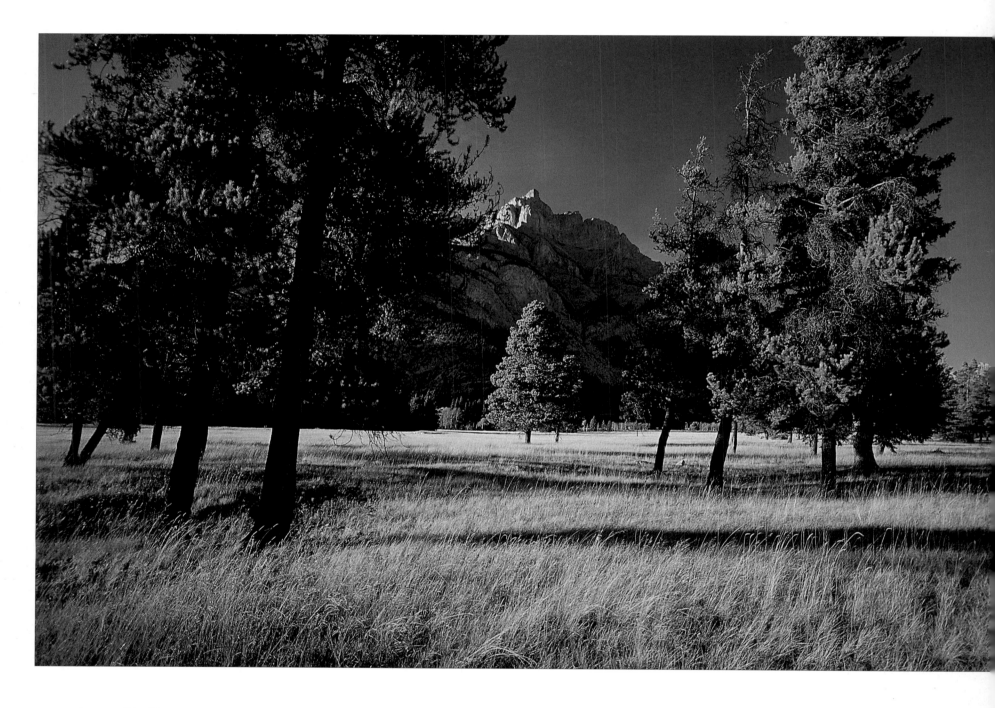

opposite: **Bull elk**
Banff National Park

above: **Cascade Mountain**
Banff National Park

next pages: **Barrier Lake**
Kananaskis Country

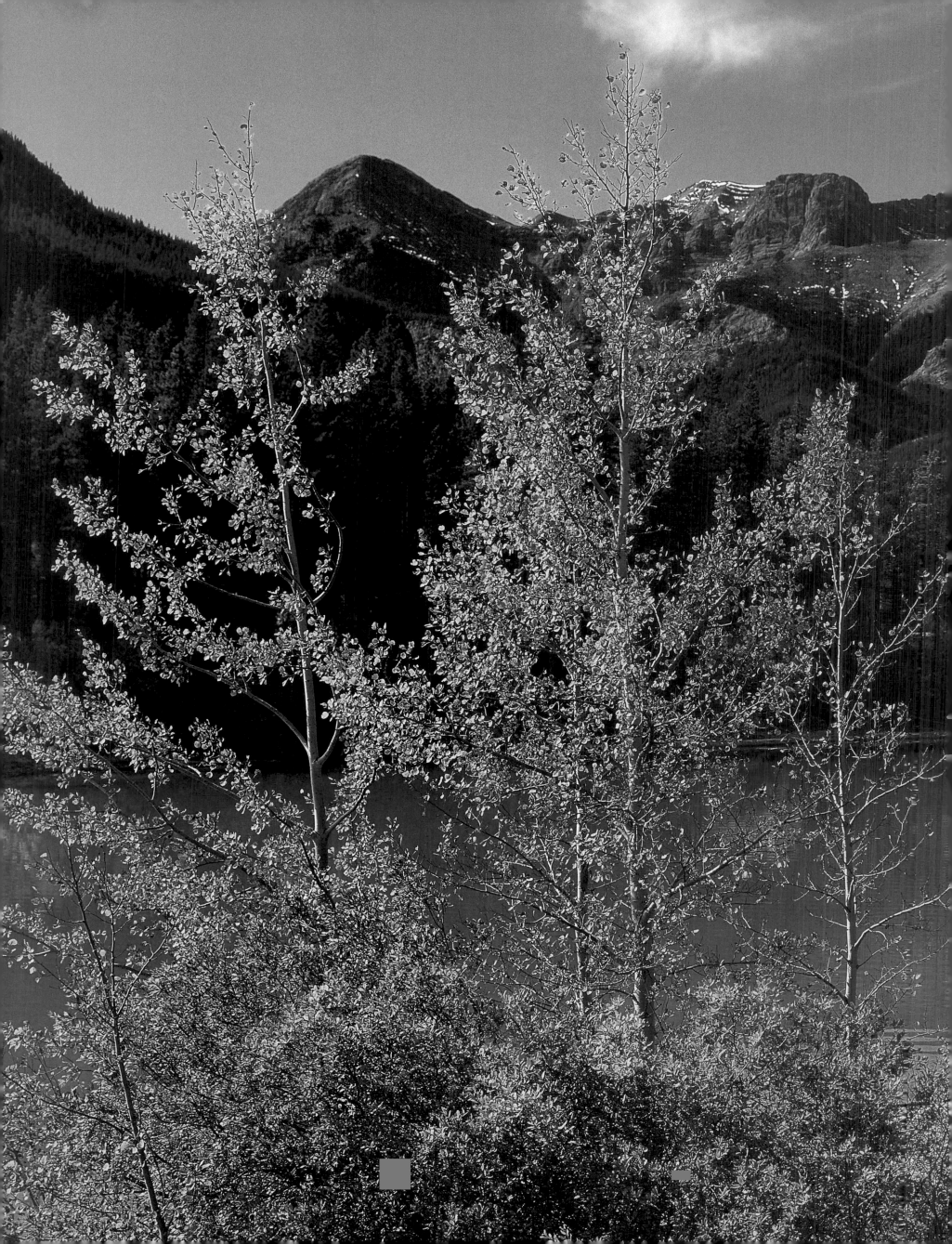

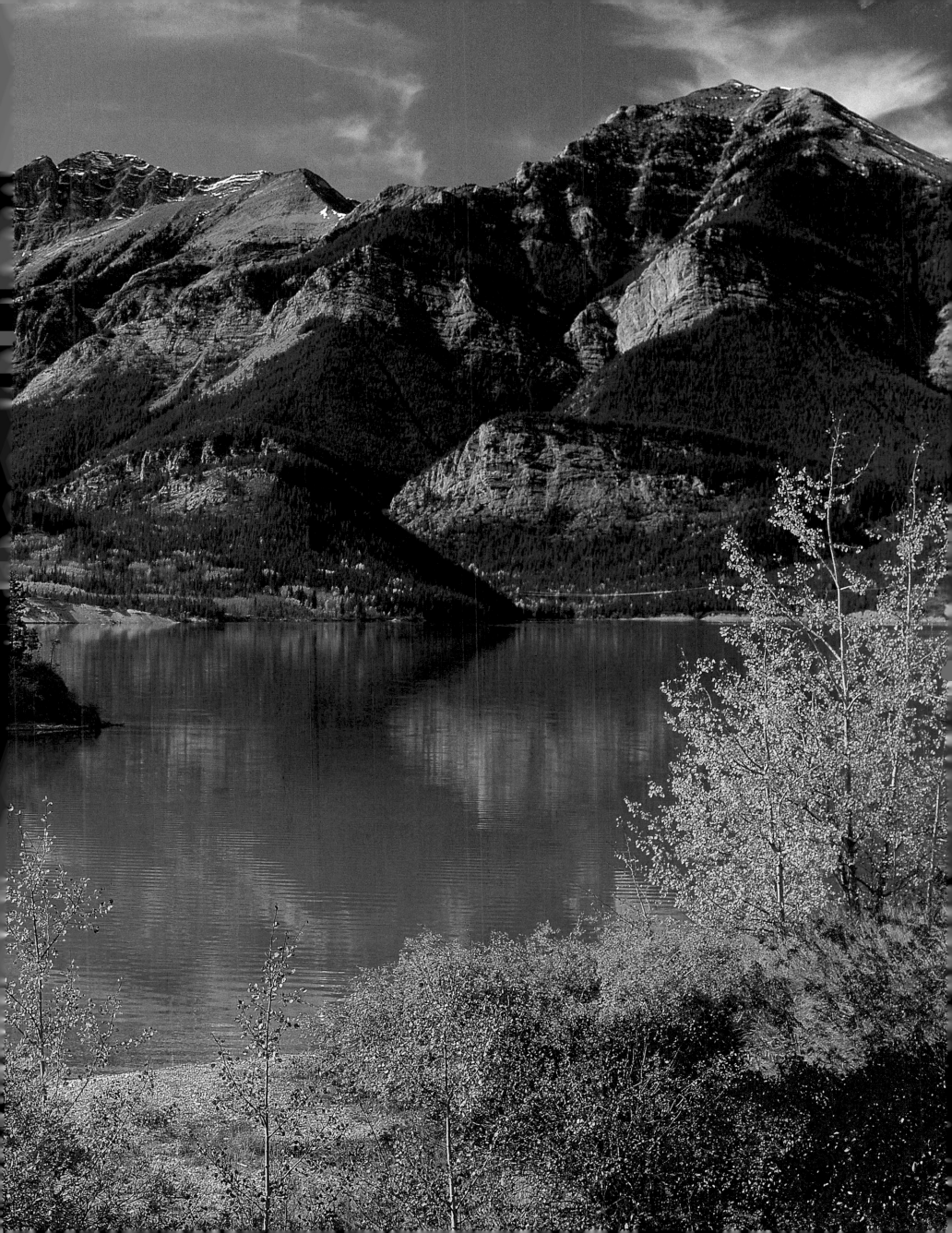

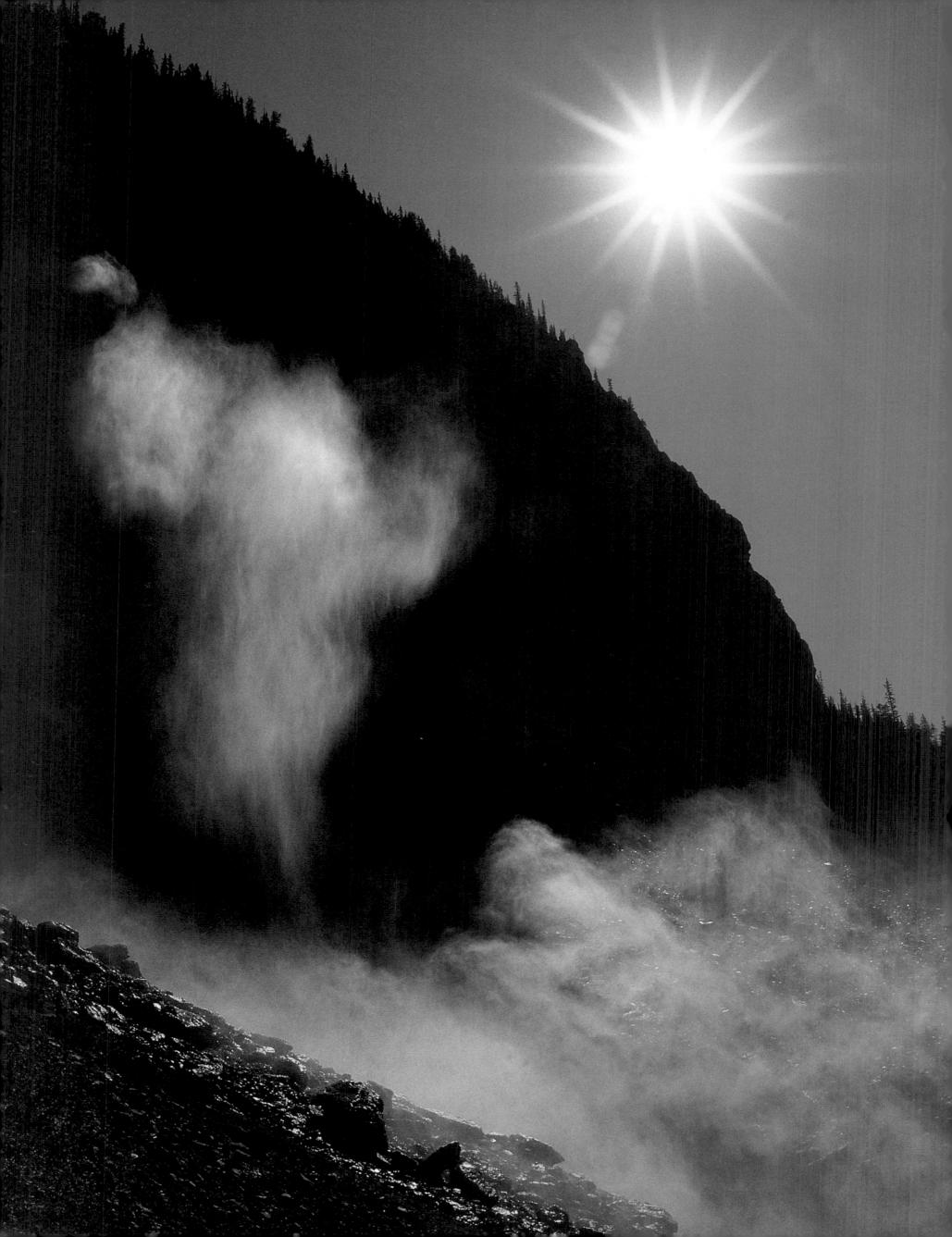

LIGHT

One of my personal photographic objectives is to capture images of familiar places in an unfamiliar way. In the world-famous national parks of the Canadian Rockies, where there has been more than a century of intense photographic activity, this represents an inspiring challenge. Just imagine, if you can, how many times Lake Louise or Mt. Rundle and the Vermilion Lakes have been photographed.

In some cases, pursuing this objective involves a search for new angles or alternate views that were perhaps overlooked or have been altered with the changing forest. In other cases, new lenses and films have created new opportunities. A whole new perspective is added through aerial photography. However, the single most important way for me to attain my objective is to be sensitive to the ever-changing, ever-powerful activity and quality of light. This is especially true for those famous and much-photographed places. In the end, it doesn't really matter how many times Lake Louise, Moraine Lake or the Vermilion Lakes have been photographed before, because the light makes the landscape unique every time.

I am fortunate to live in the Canadian Rockies, because mountain photography requires that the photographer be ever-present. One must be able to be on the scene

opposite: **Takakkaw Falls**
Yoho National Park

when the lighting dictates. Persistence is crucial in pursuing the vagaries of mountain light. It can take many days and many tries to capture a different view of a familiar scene. My adage is, "If at first you don't succeed, it helps to live nearby."

The experience of watching the light play in the valleys and on the peaks through storms and seasons over many years has made all the difference in my quest for new lighting effects. With every visit to a site, new ideas emerge. Some of my

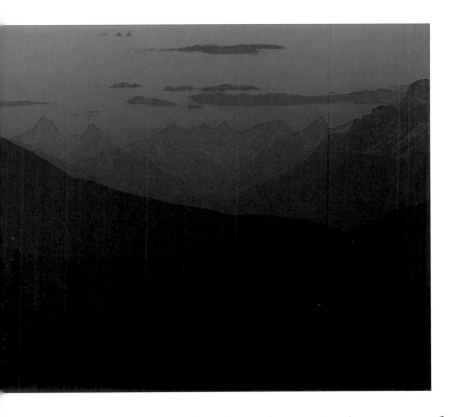

favourite photographs have necessitated multiple trips to finally obtain an image born of such a process. As an added bonus, many of these were taken either very early or very late in the day, when the most famous and therefore the most popular and crowded places are quieter and closer to their natural essence.

Sometimes these pre-visualised images emerge as anticipated, but often the Rockies add elements simply too good to be true. For instance, I recall the time that a single trout artfully dimpled the mirror-still surface of a mountain lake, adding just the right compositional element to the scene. Another time, two ravens flew into the composition, perched on the branches of a blackened tree, and added the perfect silhouette to complete the photograph (see page 166). Every now and then, perfectly shaped clouds will fill the sky just in time to catch the dawn's most intense colours, only to dissipate as soon as the sunrise abates.

above: **Sunset over Mistaya Valley**
Banff National Park

Occasionally, the light suddenly dulls, or the wind howls across a previously calm lake, and the dream shot vanishes. However, due to the inherent beauty of this landscape, camera lenses should rarely be capped. Instead of the planned photograph, one should look for different images to be discovered and captured. My first rule of nature photography is that there are beautiful images everywhere and every day; it is up to the photographer to find them.

Perhaps, on a rainy day, while you are having lunch indoors with the camera set aside, the clouds will suddenly break and the most brilliant rainbow you have ever seen will glow through the mists against dark monumental cliffs. Or perhaps, after returning from a long day searching unsuccessfully for wilderness wildlife on the Icefields Parkway between Banff and Jasper National Parks, you'll see a wolf standing in the forest right beside the "Welcome to Banff" sign.

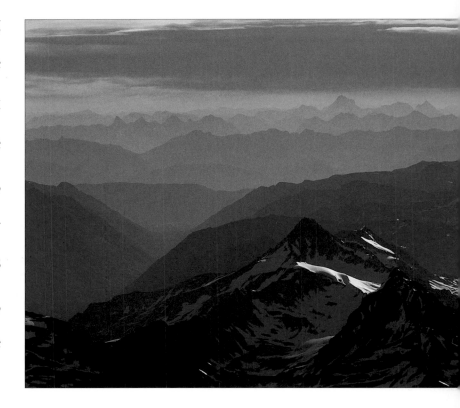

In fact, many memorable wildlife sightings are made while quietly standing beside a tripod, watching the light play on the landscape. A fixed observation point lets you become part of the scenery, and, with time, the birds and animals ignore you and carry on with their everyday lives. You are then treated to a glimpse of life reserved for those who have the time and patience to quietly observe the world around them.

above: **Sunset over the Front Range**
Siffleur Wilderness, Alberta

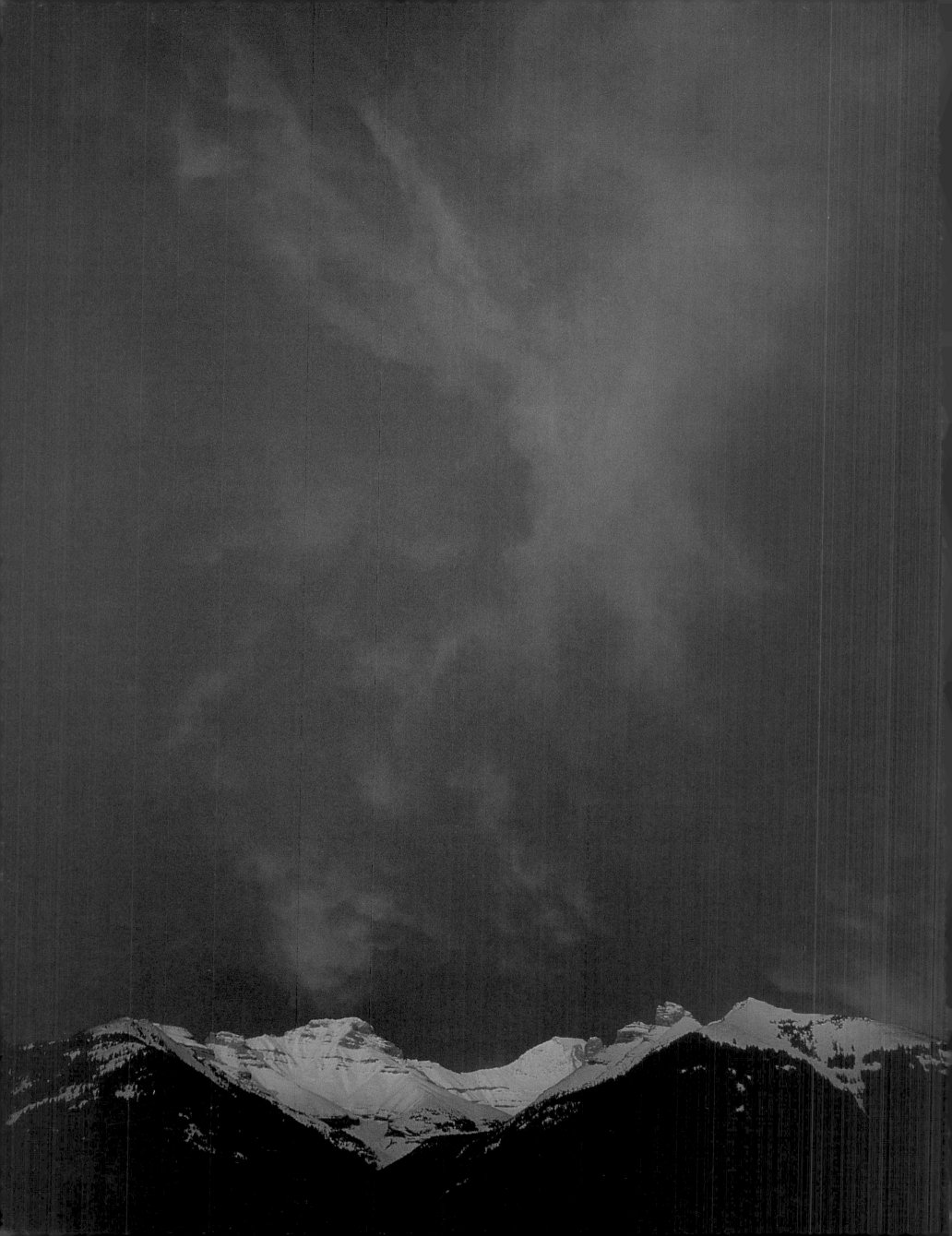

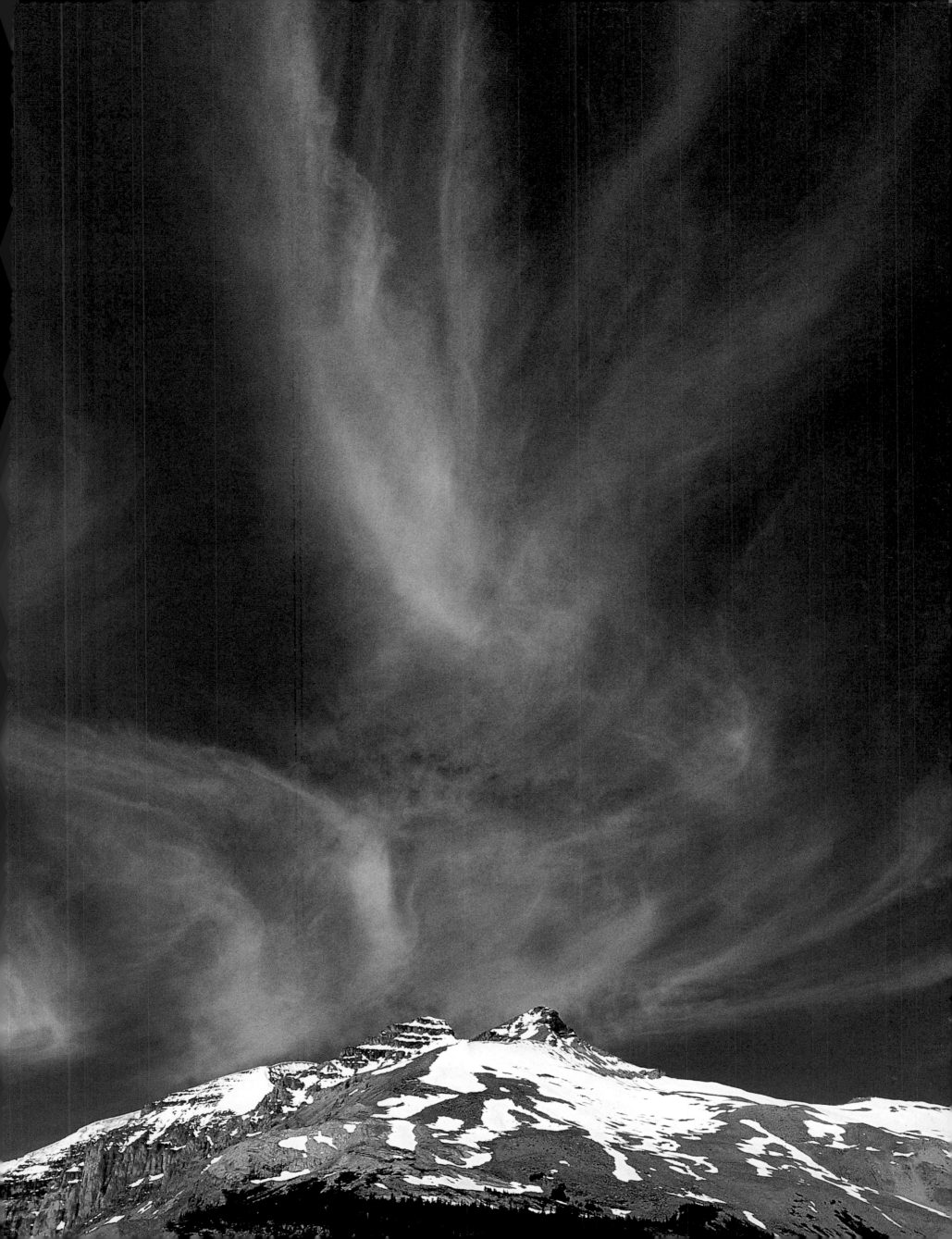

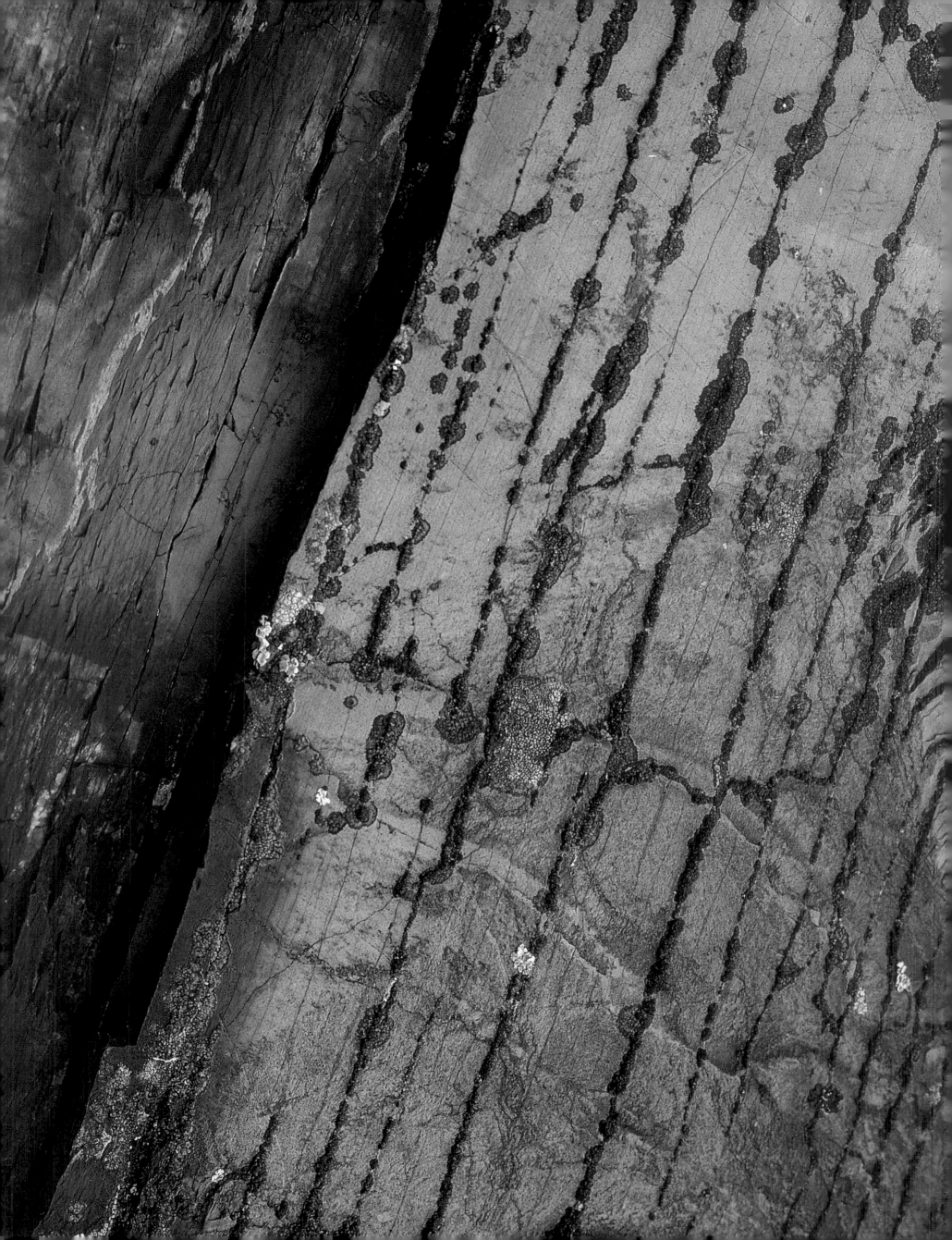

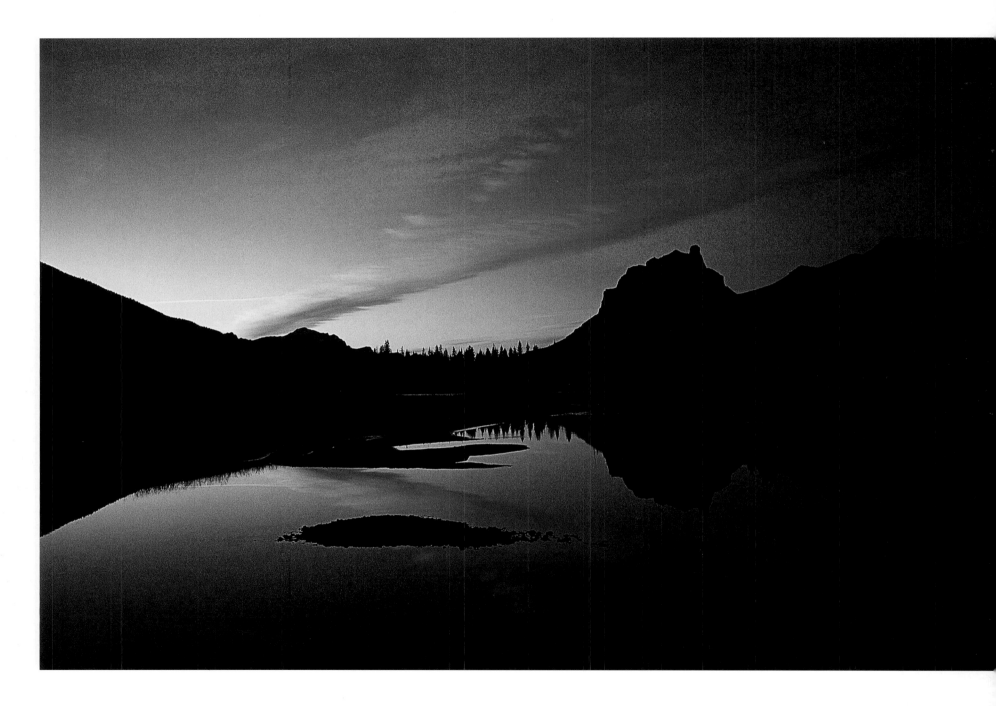

opposite: **Lichen on sedimentary rock**
British Columbia

above: **Castle Mountain**
Banff National Park

previous page left: **Fairholme Range**
Banff National Park

previous page right: **Columbia Icefield**
Jasper National Park

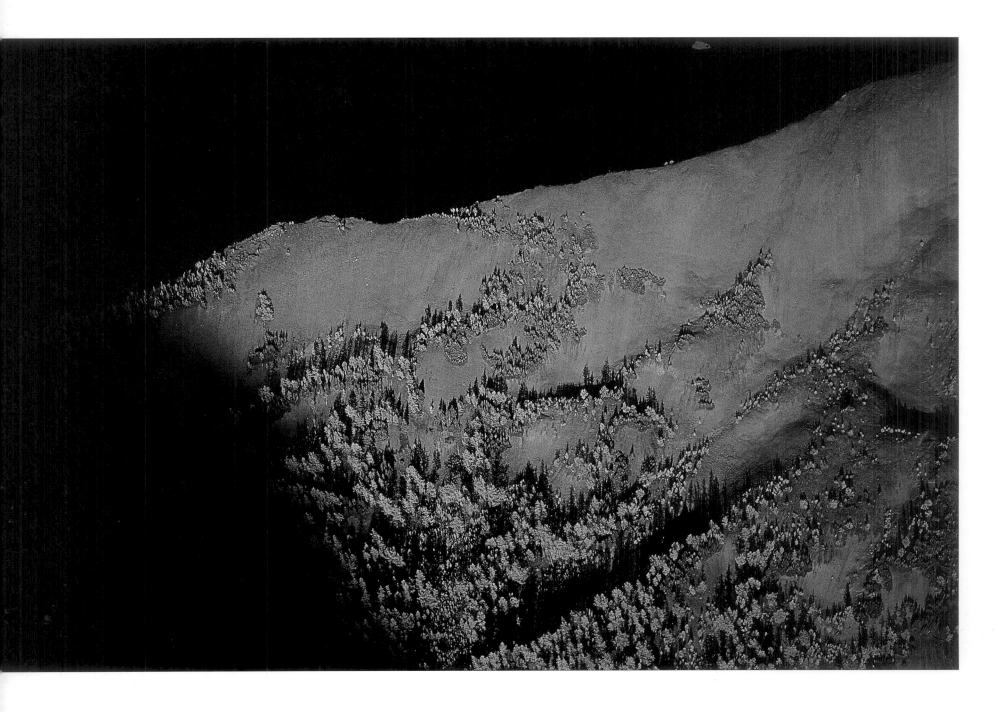

above: **Sunshine meadows**
Banff National Park

opposite: **Takakkaw Falls**
Yoho National Park

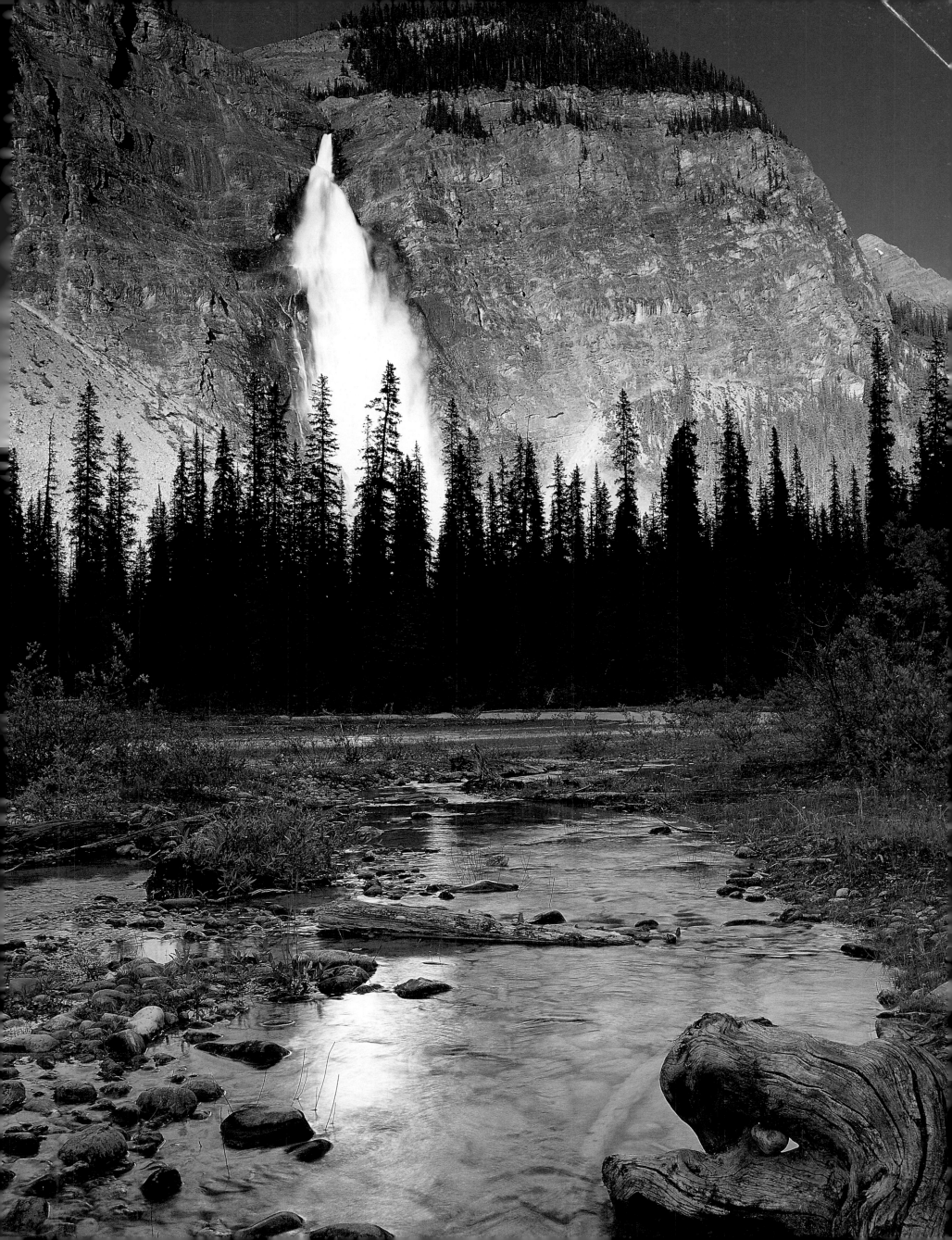

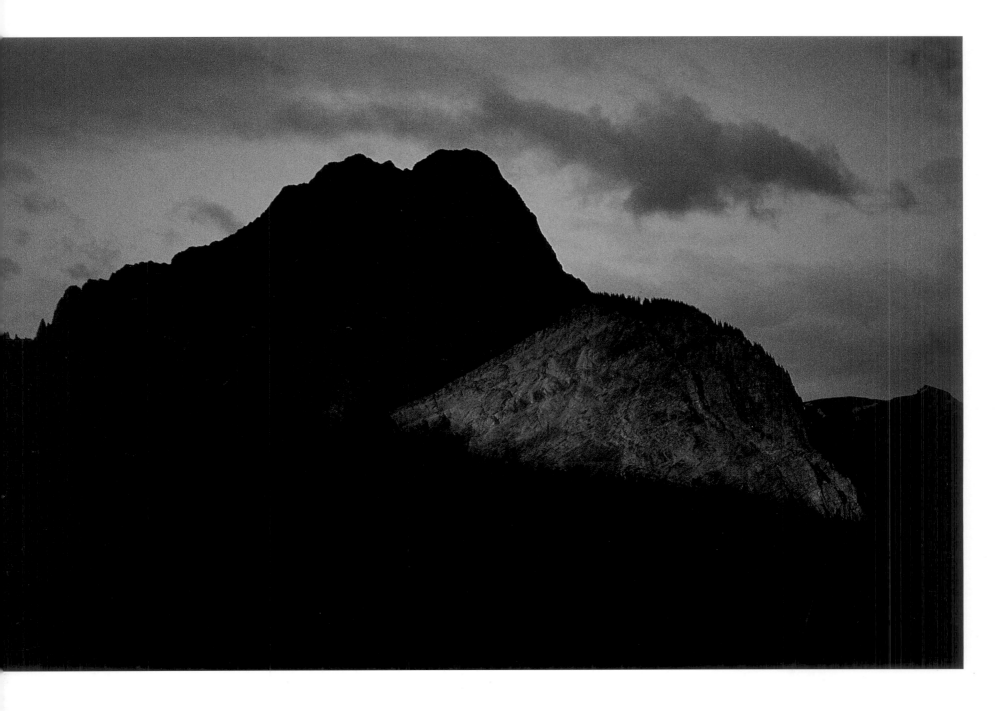

above: **Goat Mountain**
near Golden, British Columbia

opposite: **Sunset on a beaver pond, Blaeberry Valley**
near Golden, British Columbia

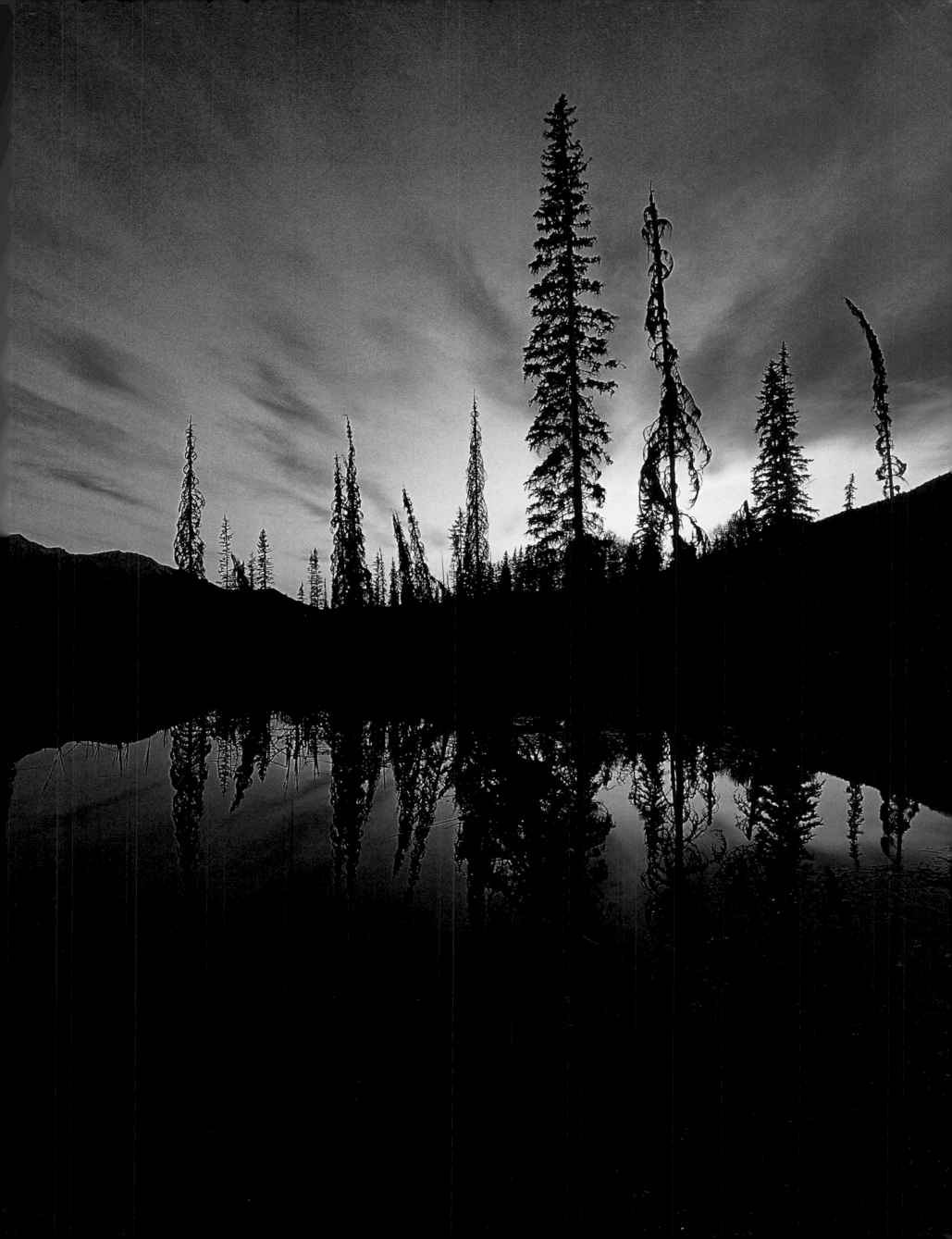

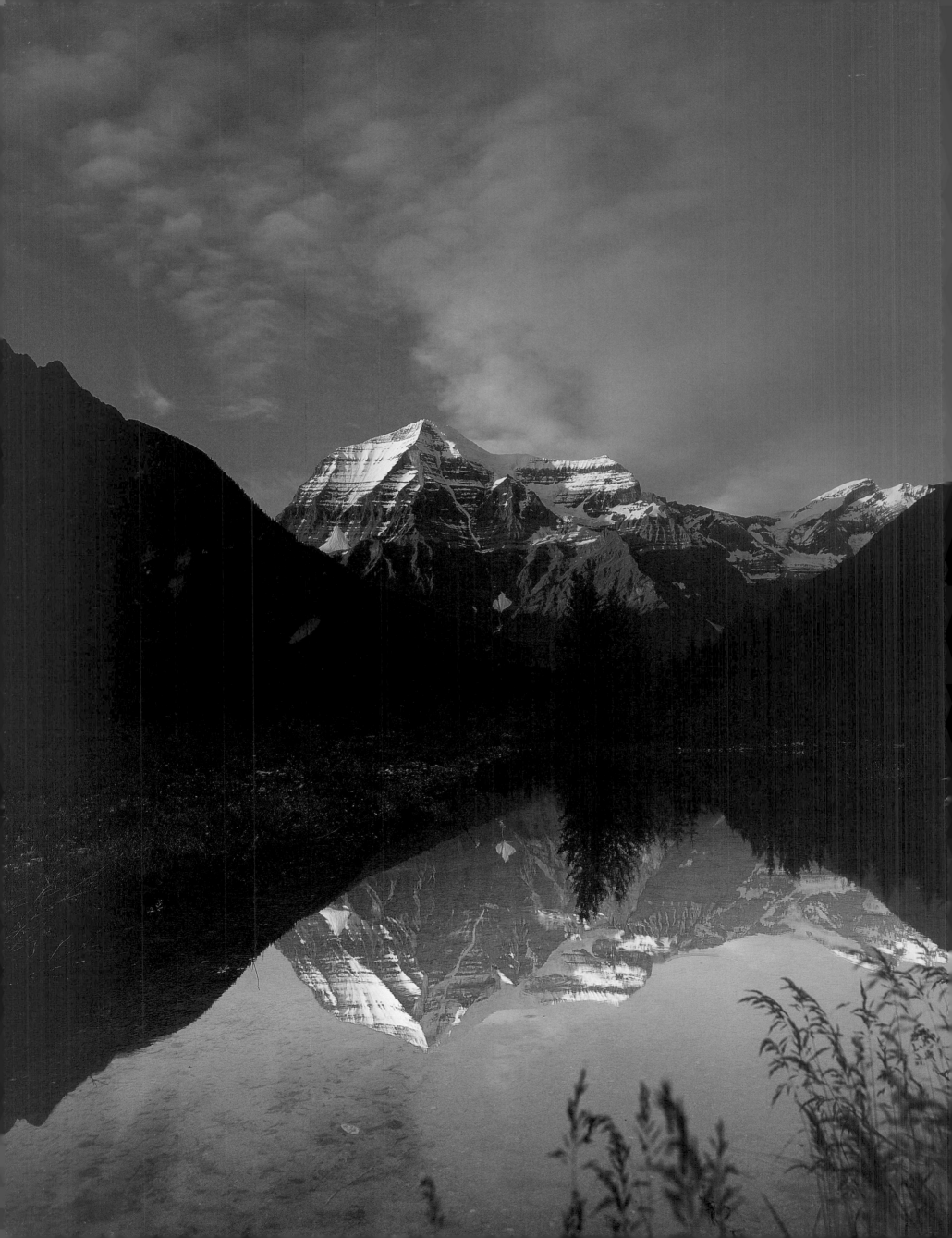

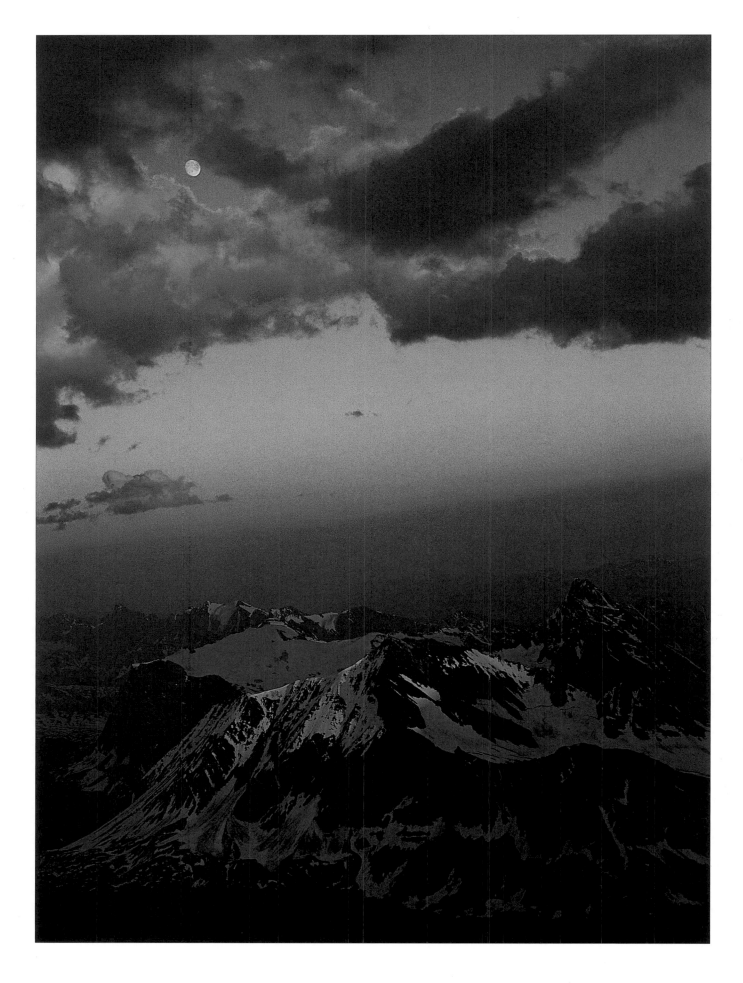

opposite: **Mt. Robson**

Mt. Robson Provincial Park

above: **Sharp Mountain**

Kootenay National Park

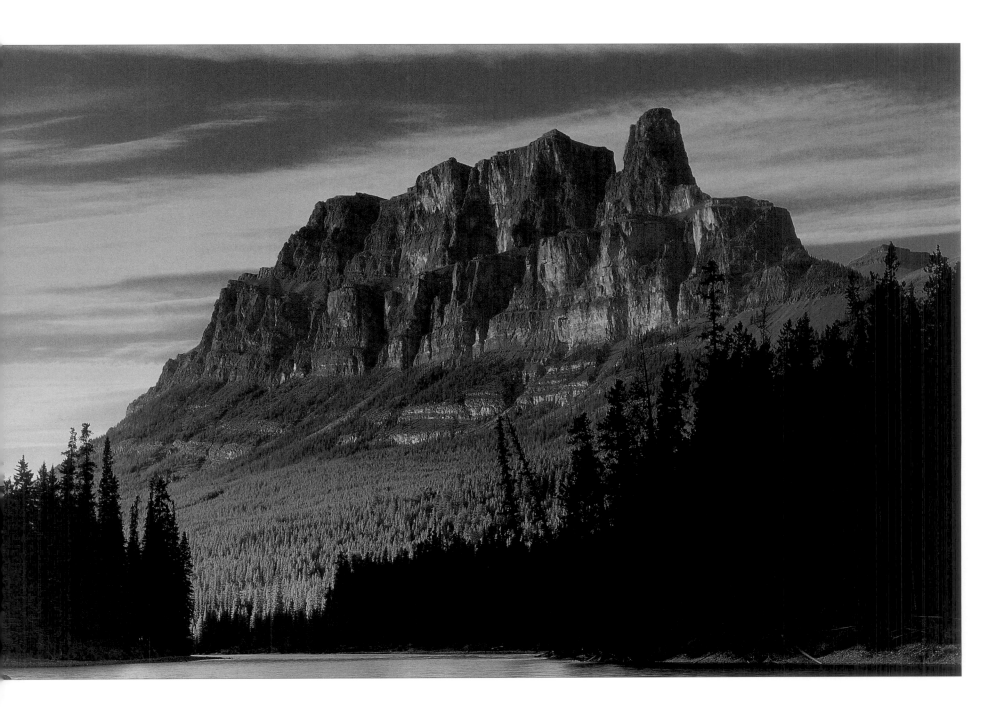

above: **Castle Mountain**
Banff National Park

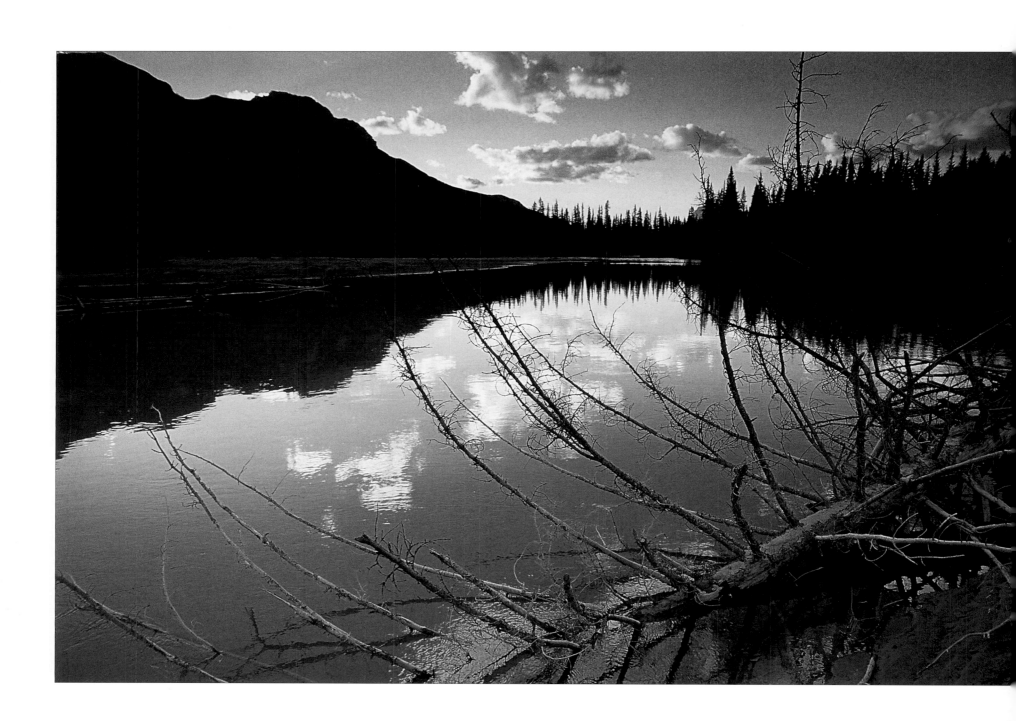

above: **The Bow River**
Banff National Park

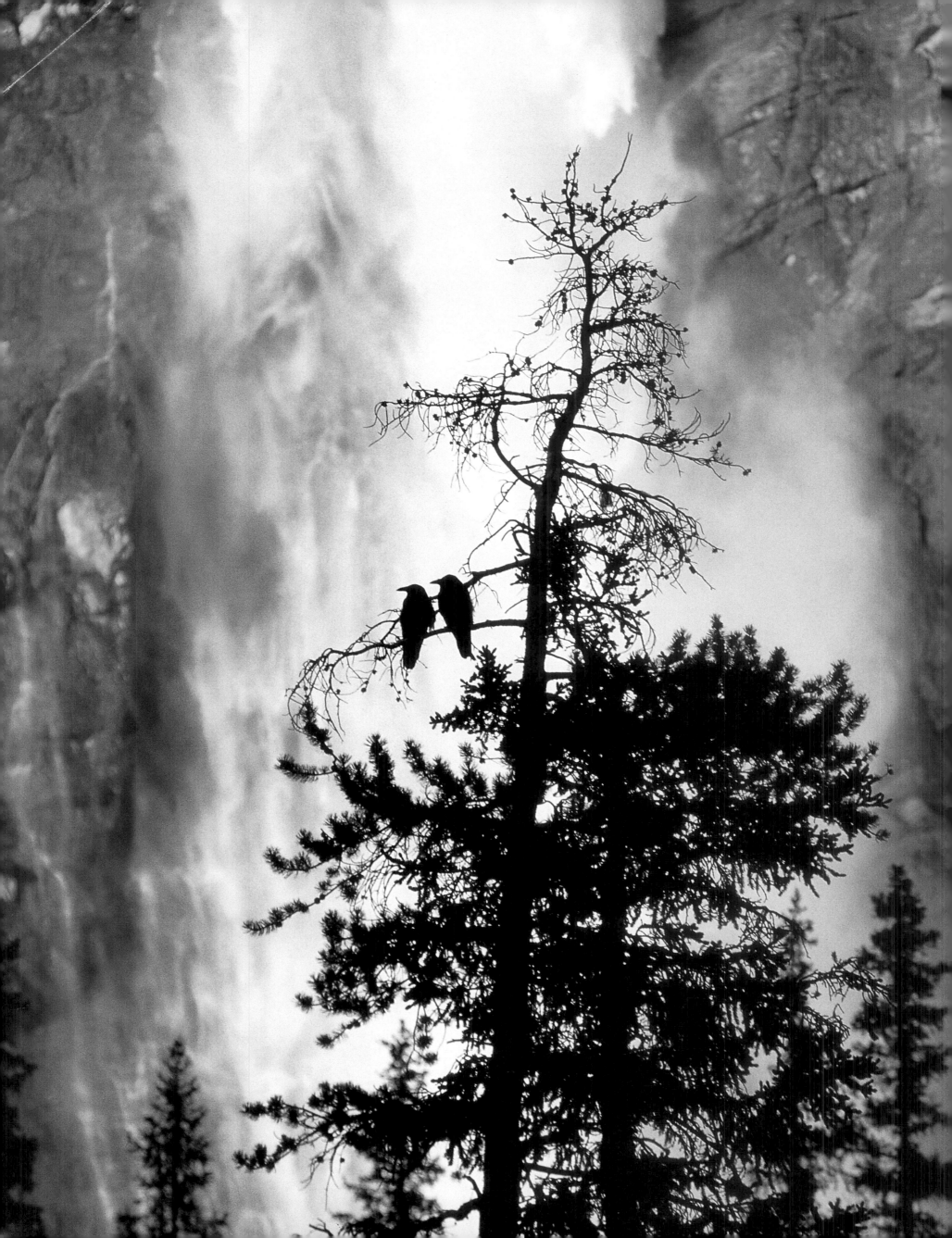

PHOTOGRAPHY

lthough I was a naturalist before I became a photographer, the two activities have always seemed to be perfectly complementary. The wonders of nature that I witness simply beg to be recorded. As the saying goes, "A picture is worth a thousand words," and the right photograph, capturing a defining moment or a revealing relationship, can express what words cannot. Moreover, because the camera lens is an objective documenter of reality, photography records elements that are often overlooked by the human eye alone. Sometimes the most interesting aspects of a photograph are discovered only after the film is processed. In fact, different viewers frequently discover elements in a nature photograph that the photographer did not intend to include, or did not even see.

Photography can enhance our awareness of nature. Conversely, an awareness of the details of ecological diversity enhances nature photography. The photographic mind and eye become attuned to see, seek, and anticipate the full palette that nature offers. Each different plant, animal, forest, and rock formation is unique, and exhibits a particular image, texture, colour, and mood that changes according to the light by hour, day, and season. There are beautiful photographs to be discovered everywhere

opposite: **Ravens at Takakkaw Falls**
Yoho National Park

in nature, from micro to macro, any time there is light enough to see.

Sometimes there is too much going on at once—a surfeit of subject matter for both naturalist and photographer. For example, after a long patient wait, a bugling bull elk may suddenly step out of the shadows, just as a rare bird flies overhead, a wolf trots into view, or spectacular light perfectly illuminates a distant peak. Luckily, this marvellous problem of breathtaking sensory overload is a risk that visitors to this whole ecosystem must accept.

Just as the photographer sees the light constantly changing, the naturalist sees the same constant change in the ecosystem. The human-caused changes occurring outside national parks are so rapid and dramatic that, in contrast, the parks' ecosystem may appear preserved. Nothing endures but change, however, even in national parks. Every photograph is a historic record of a unique moment that will never occur again.

These photographs were all taken in the past two decades. During this time, glaciers have receded, cliffs have crumbled, rivers have changed course, forests have grown in or burned, the wolf and elk populations have boomed and declined, and the grizzly bear population has grown. The images in this book add to the photographic record of this ecosystem that dates back over 100 years. For example, a comparison of contemporary images of the densely forested Bow Valley in Banff

above: **Rocky mountain bighorn ram**
Banff National Park

National Park with the wide open shrublands and grasslands that existed in this area a century ago (and throughout most of its known prehistory) reveals the larger landscape changes that have taken place.

In national parks, change is now driven as much by natural processes as is possible in the 21st century. They are the most intact landscapes and ecosystems we have left. But they are also a product of their history, are still part of the world around them, and therefore they will always change.

Photography makes you acutely aware of change. Scenic viewpoints become overgrown with pines, picturesque snags topple over, glaciers retreat, and opportunities for wildlife photography vary with wildlife populations. In the clear skies of the Canadian Rockies I have photographed the effects of global change, such as that caused by volcanoes in the South Pacific and dust storms in China. A flight over the Rockies reveals smokier distant horizons and increasing human activity around all the fringes. As vast and wild as the Canadian Rockies are, they are a still a small part of a crowded planet. Their wild nature is becoming an even more rare and precious heritage.

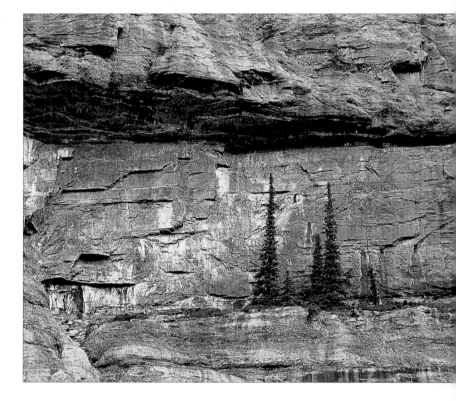

above: **The Weeping Wall**
Banff National Park

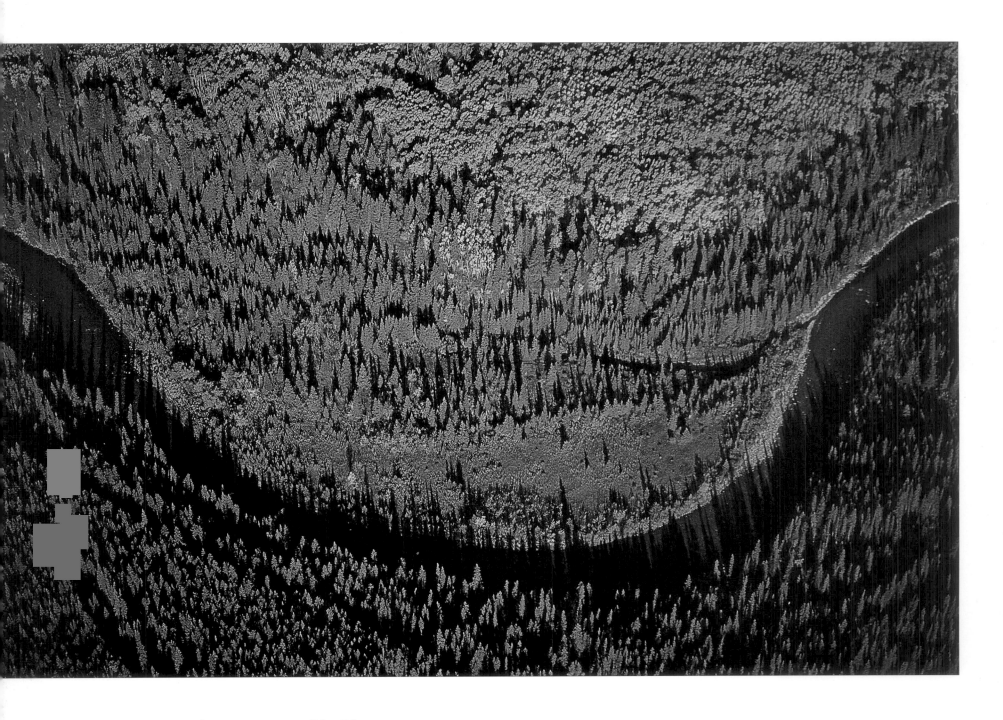

above: **Kananaskis River**
Kananaskis Country

opposite: **Barrier Lake**
Kananaskis Country

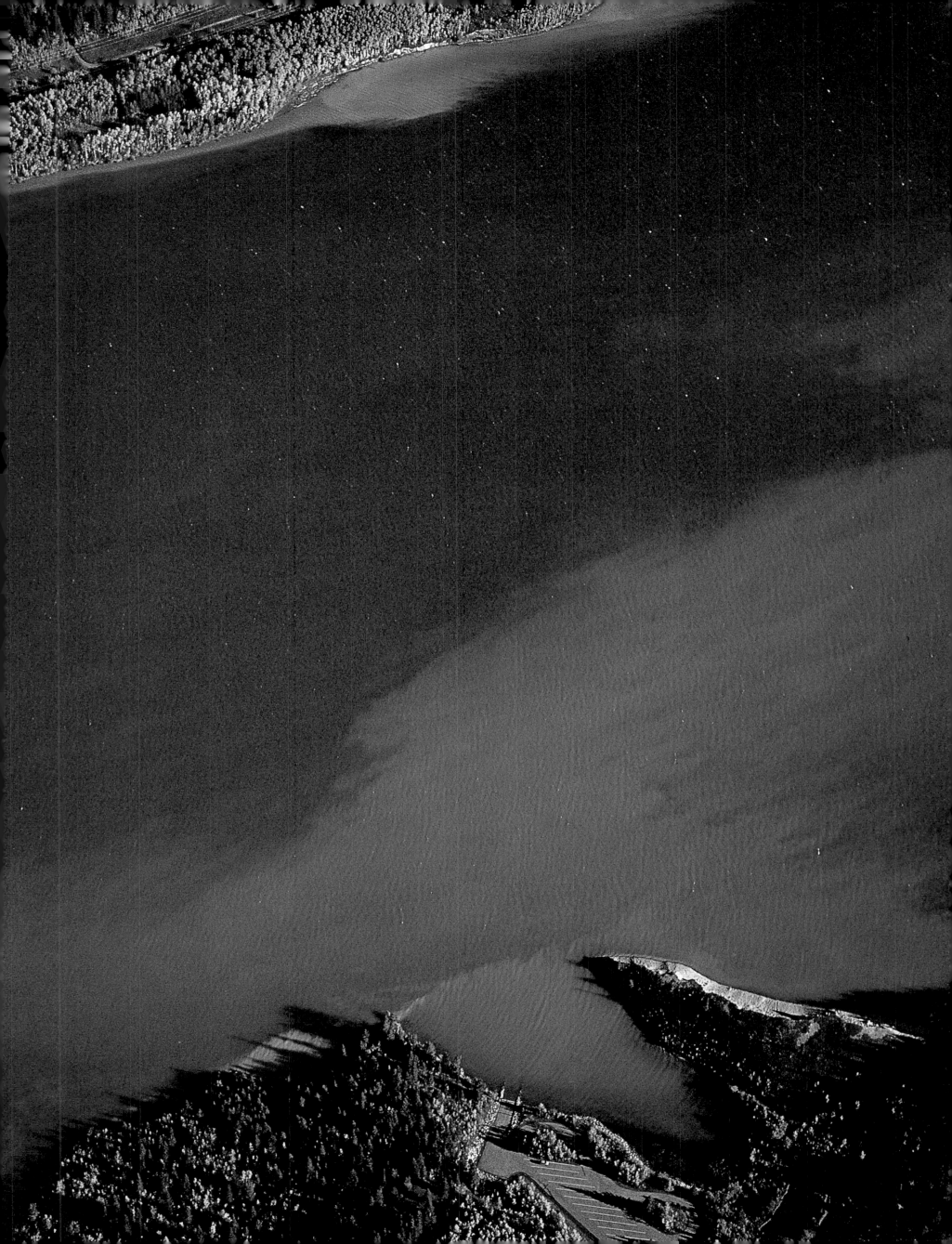

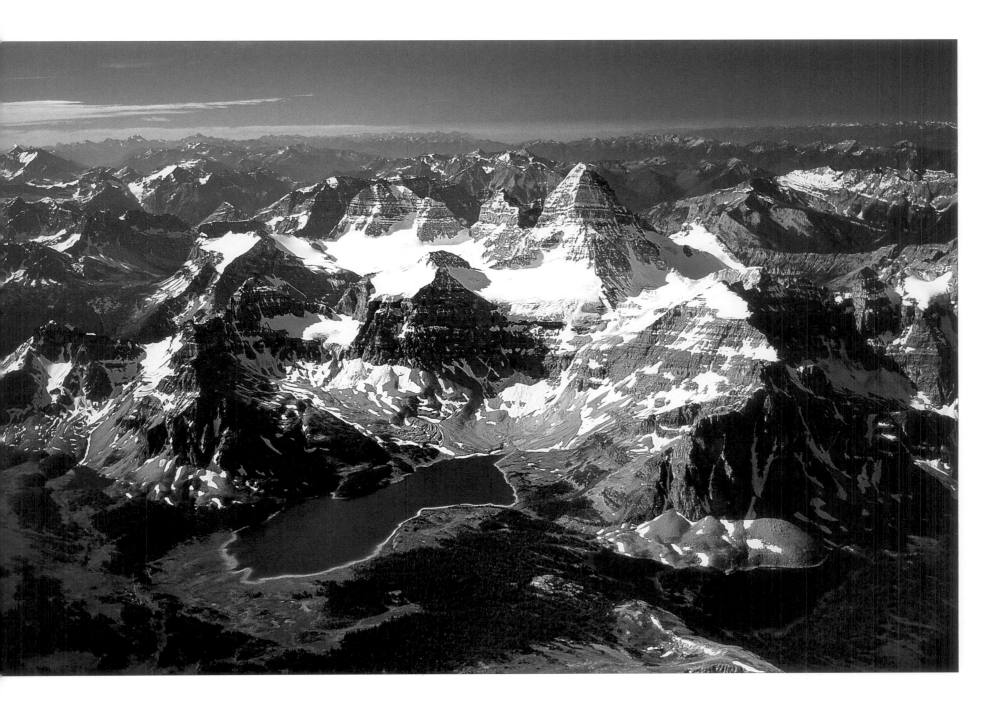

above: **Lake Magog and Mt. Assiniboine**
Mt. Assiniboine Provincial Park

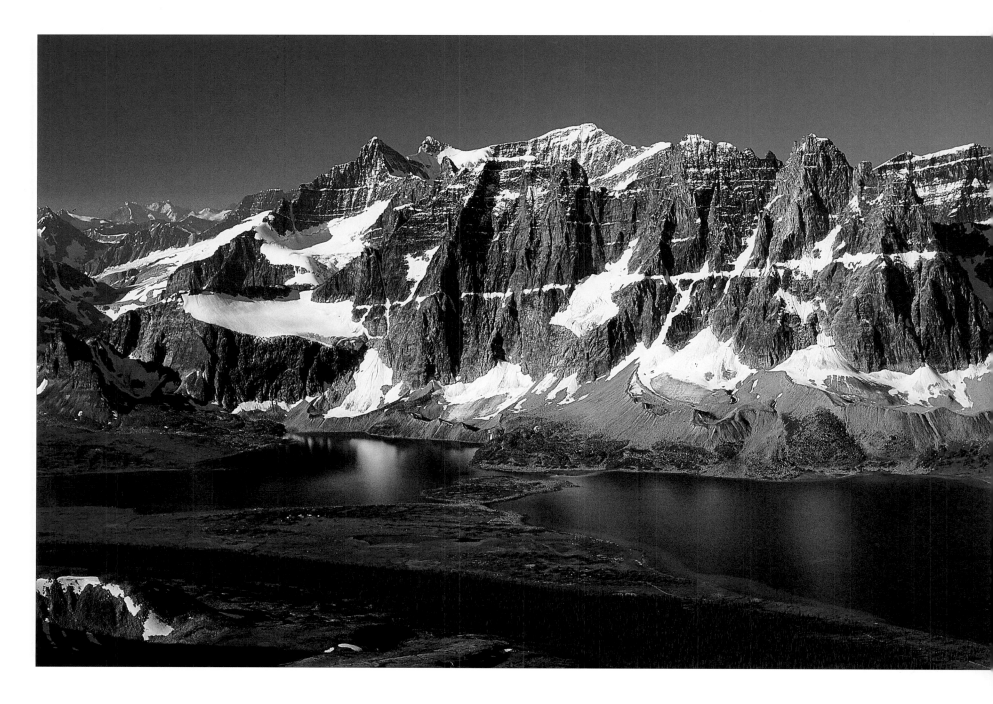

above: **Tonquin Valley and the Ramparts**
Jasper National Park

opposite: **Wind-shaped alpine fir, Blakiston Valley**
Waterton Lakes National Park

above: **Red Rock Canyon**
Waterton Lakes National Park

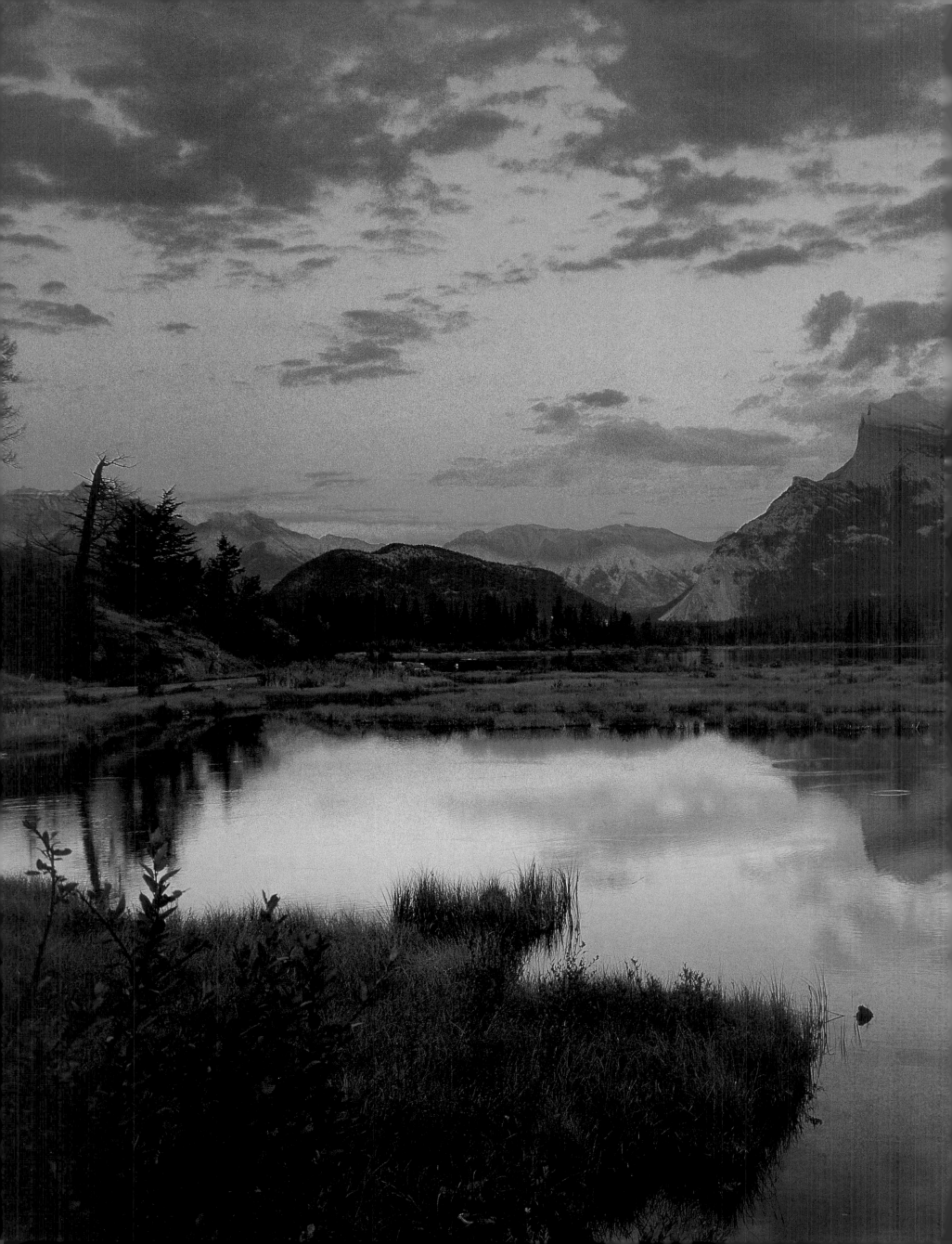

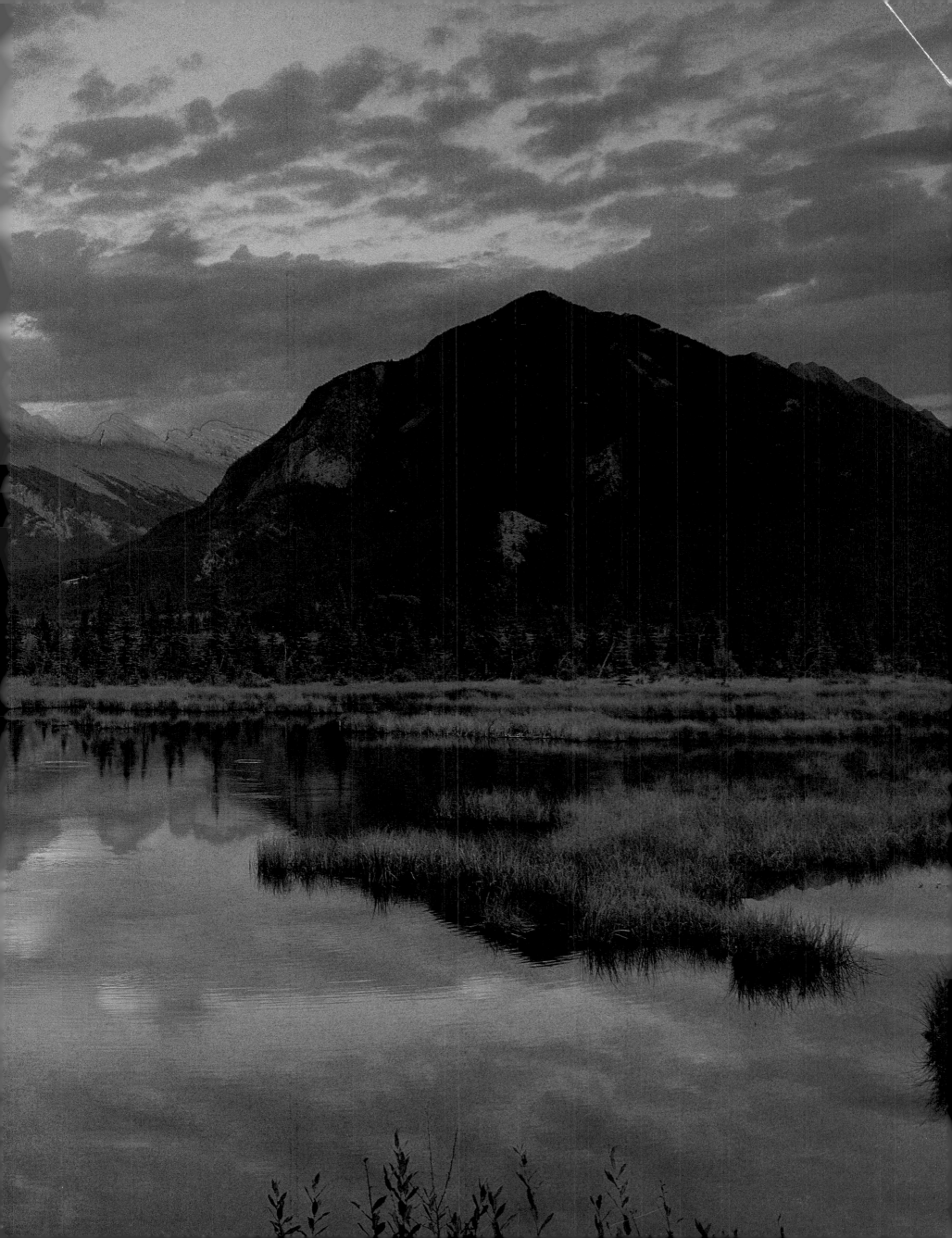

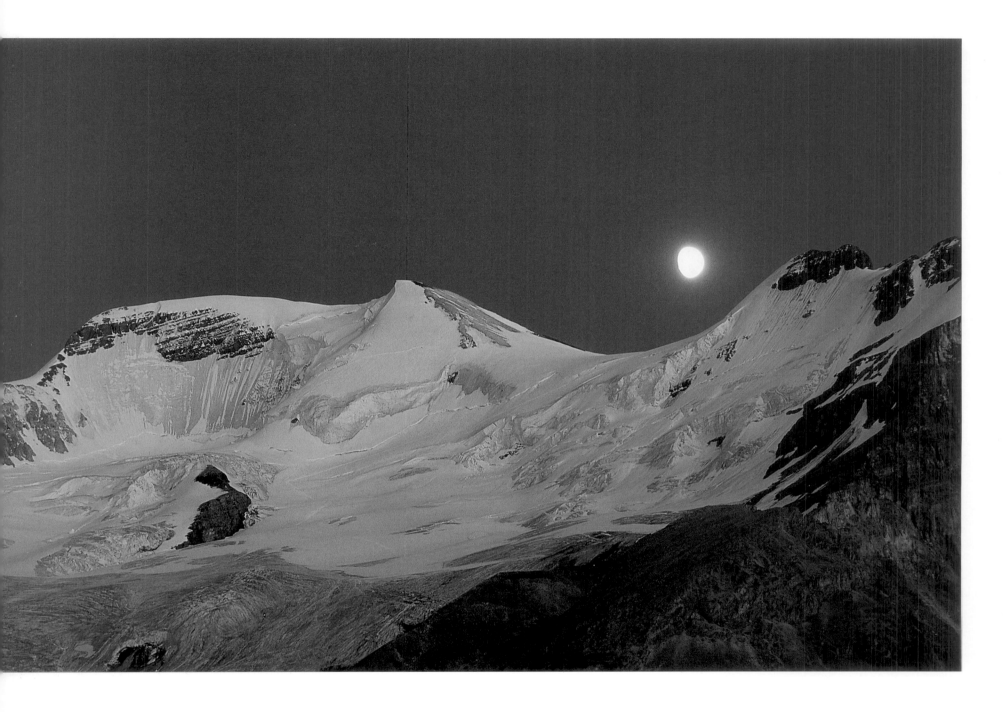

above: **Moonrise over Mt. Athabasca**
Jasper National Park

previous pages: **Sunset on Mt. Rundle and the Vermilion Lakes**
Banff National Park

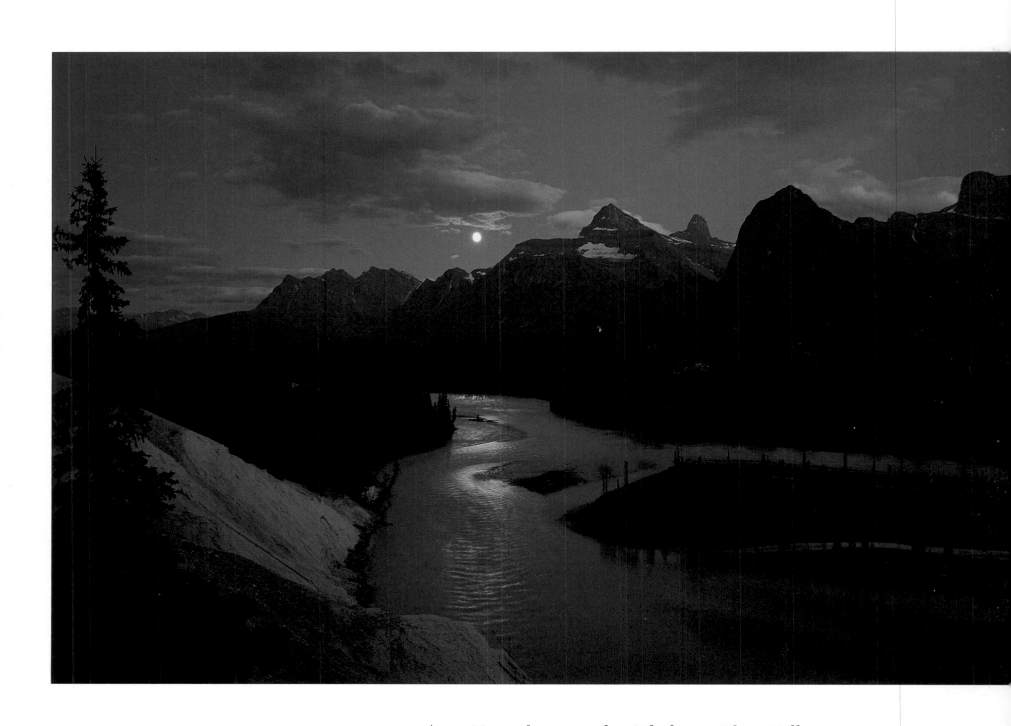

above: **Moonrise over the Athabasca River Valley**
Jasper National Park

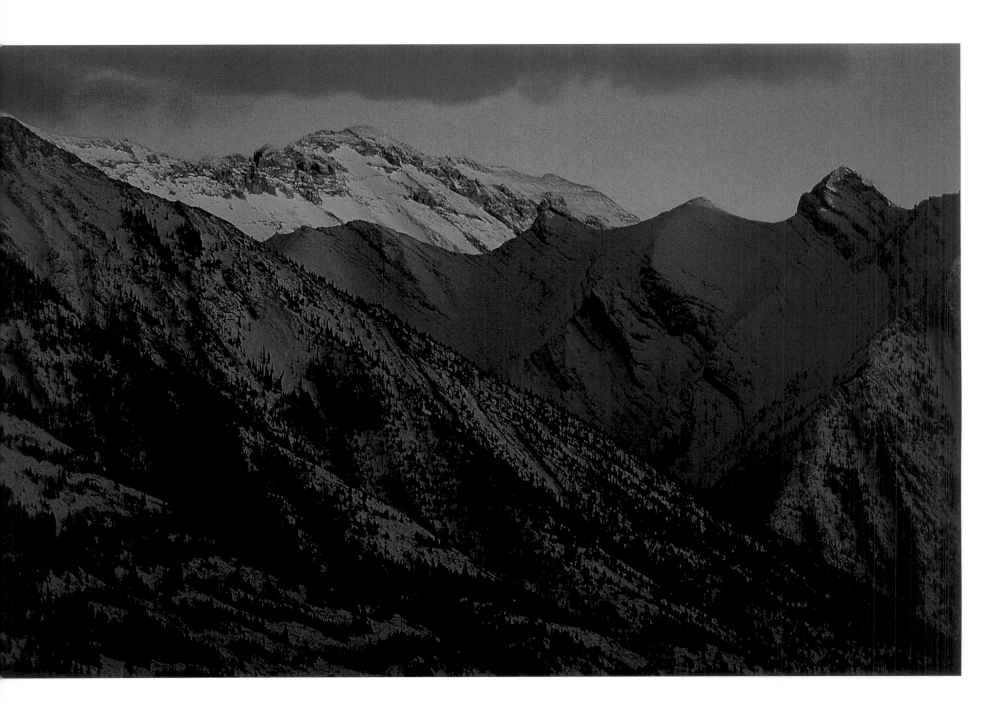

above: **The Fairholme Range**
Banff National Park

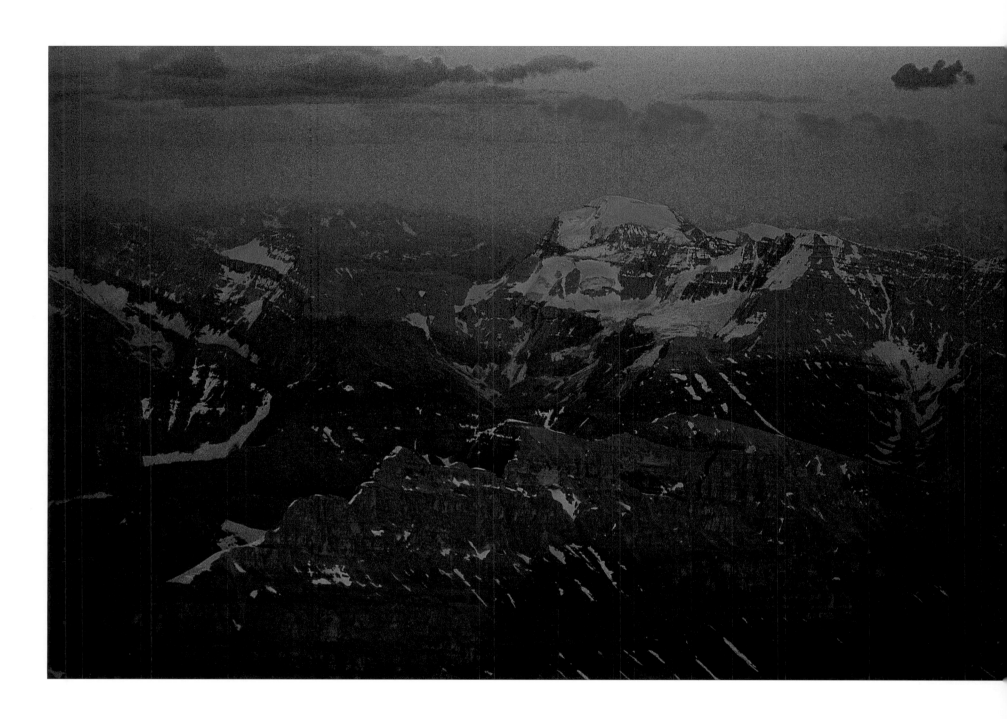

above: **Mt. Ball**
Banff National Park

next pages: **North Saskatchewan River Valley**
Banff National Park

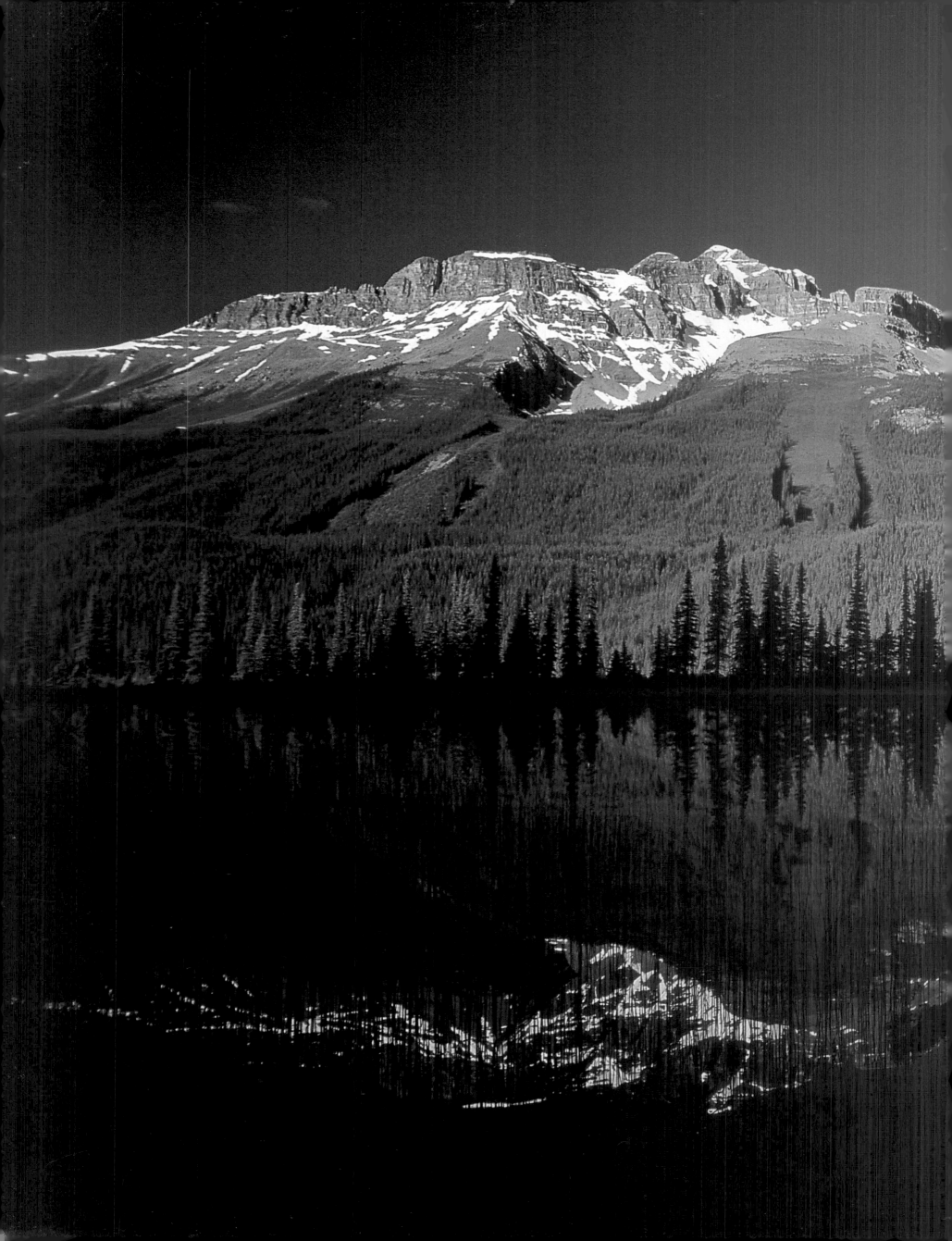

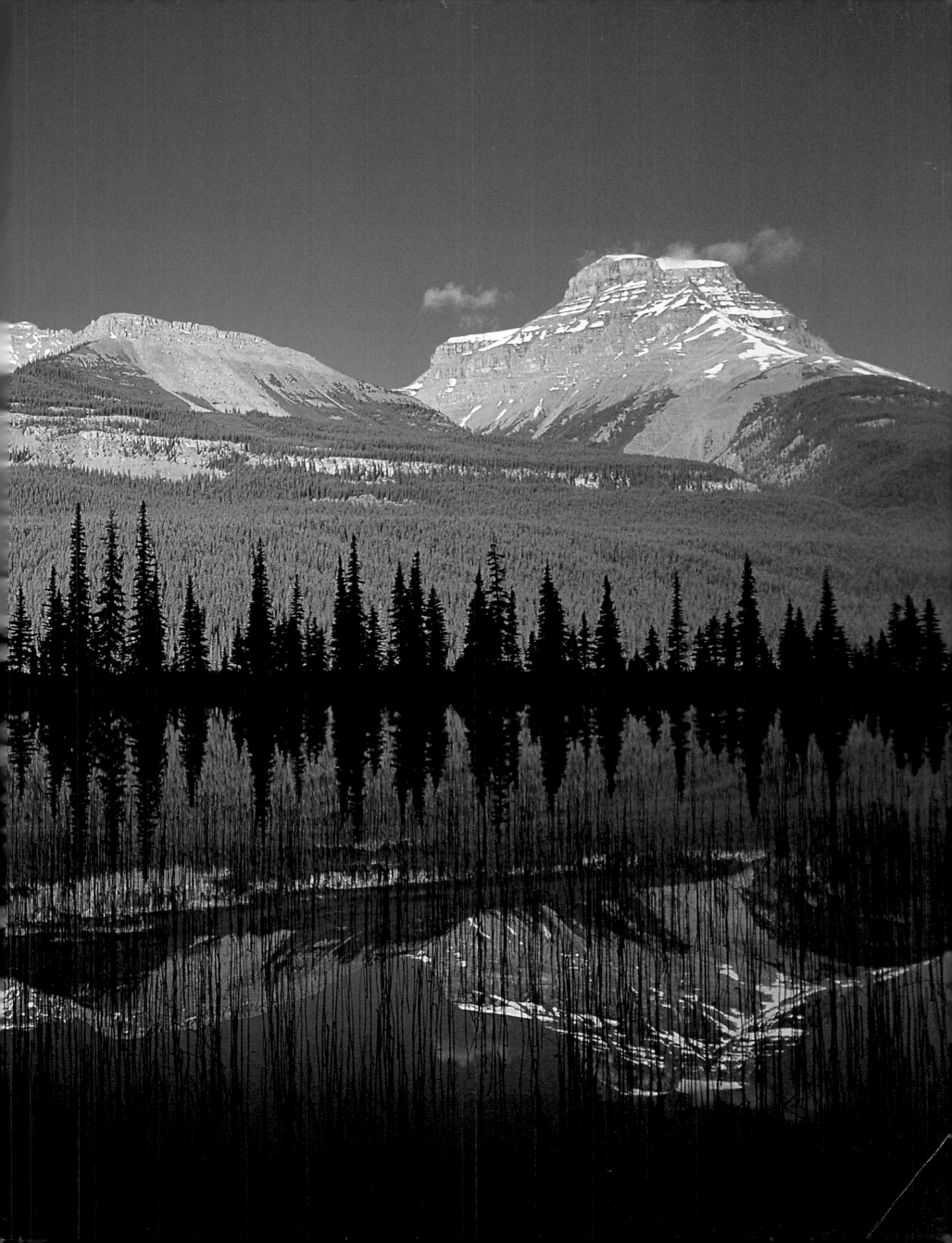

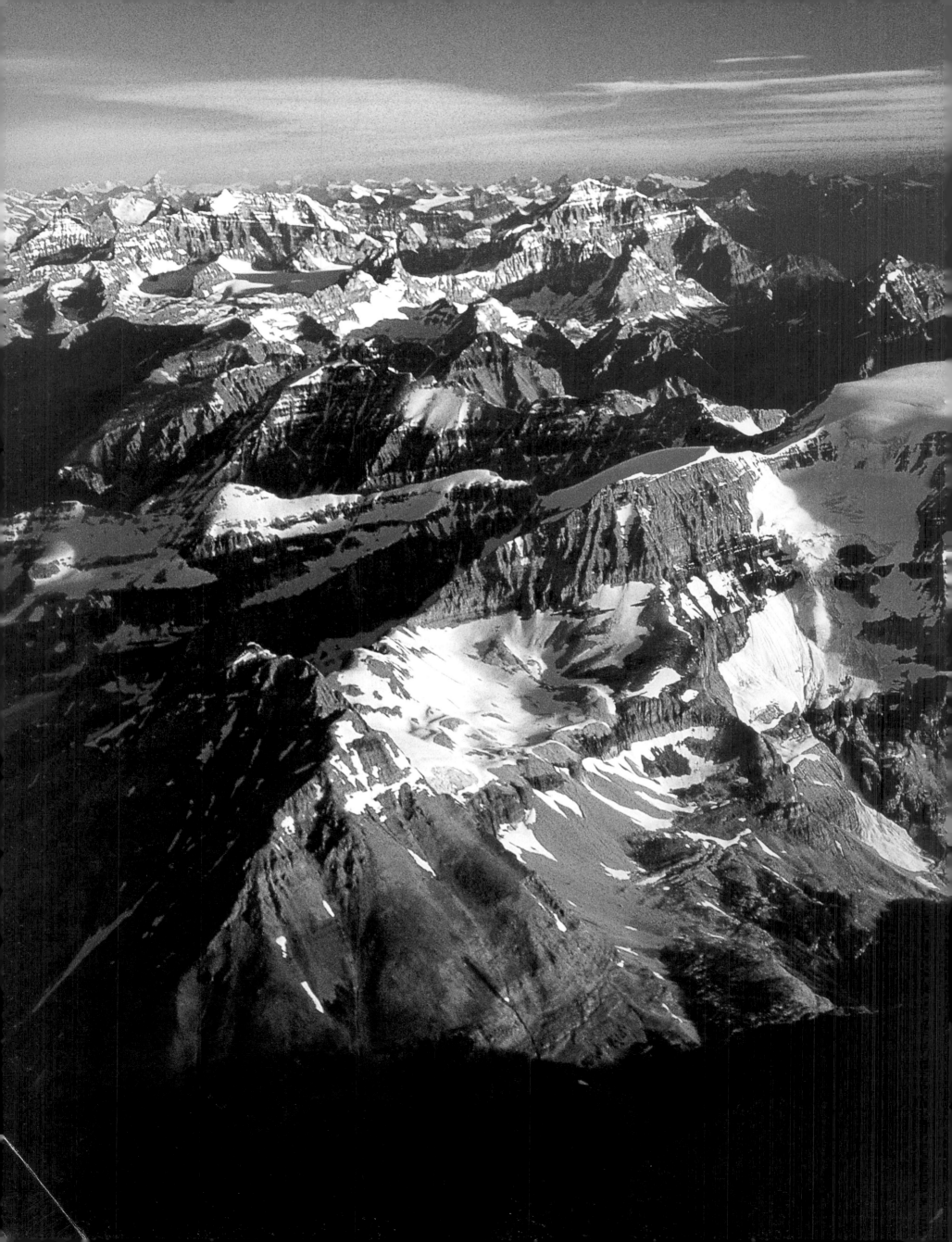

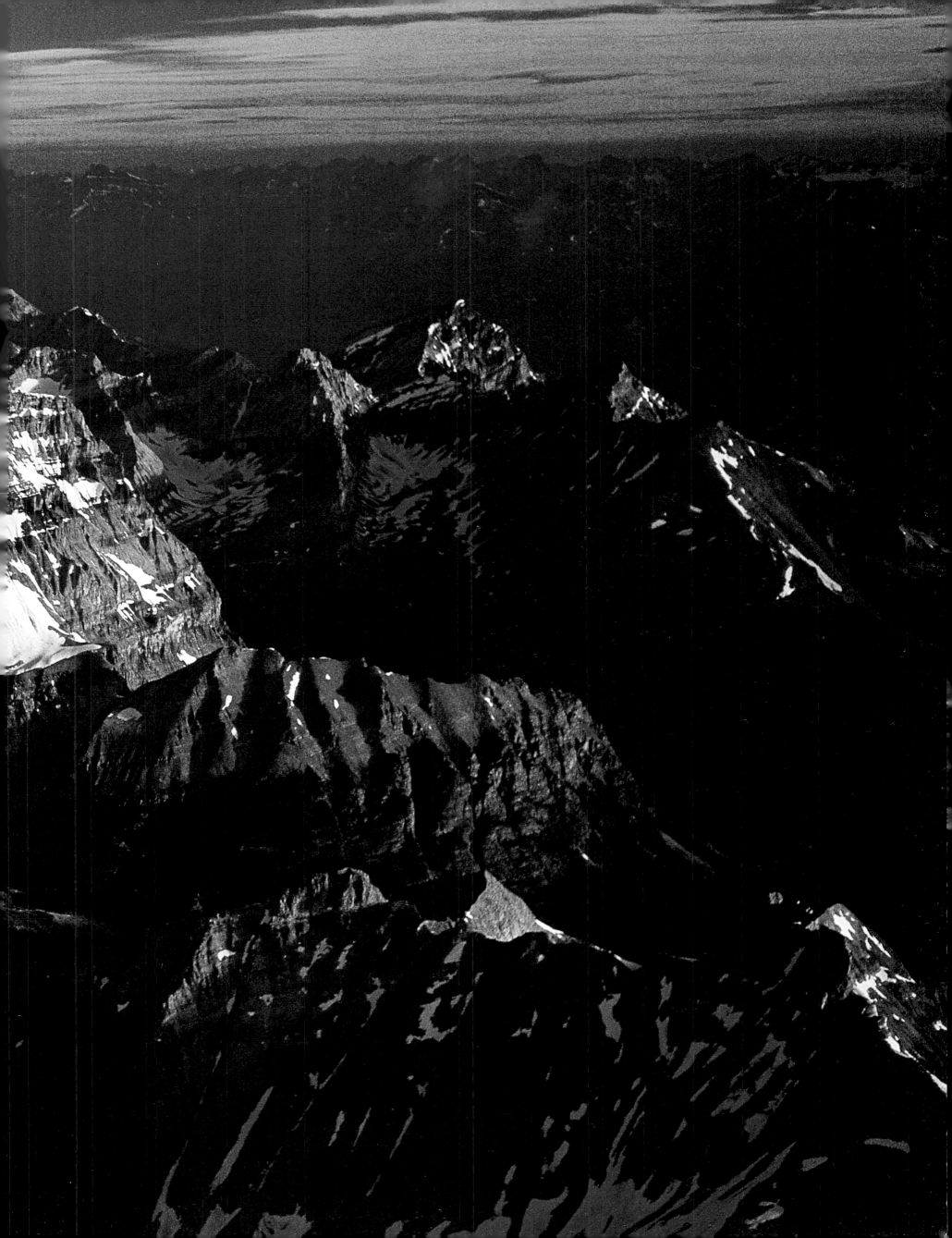

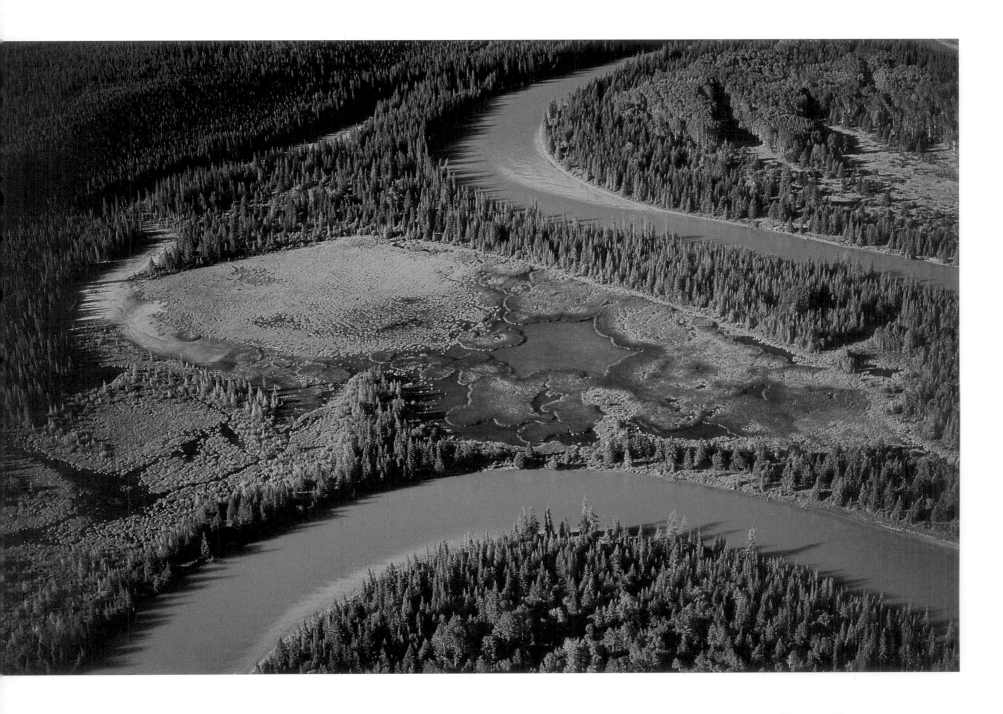

above: **Bow River at the Vermilion Lakes**
Banff National Park

previous pages: **Mt. Ball and the Main Range**
Banff National Park

next pages: **Pilot Mountain**
Banff National Park

opposite: **Paradise Valley**
Banff National Park

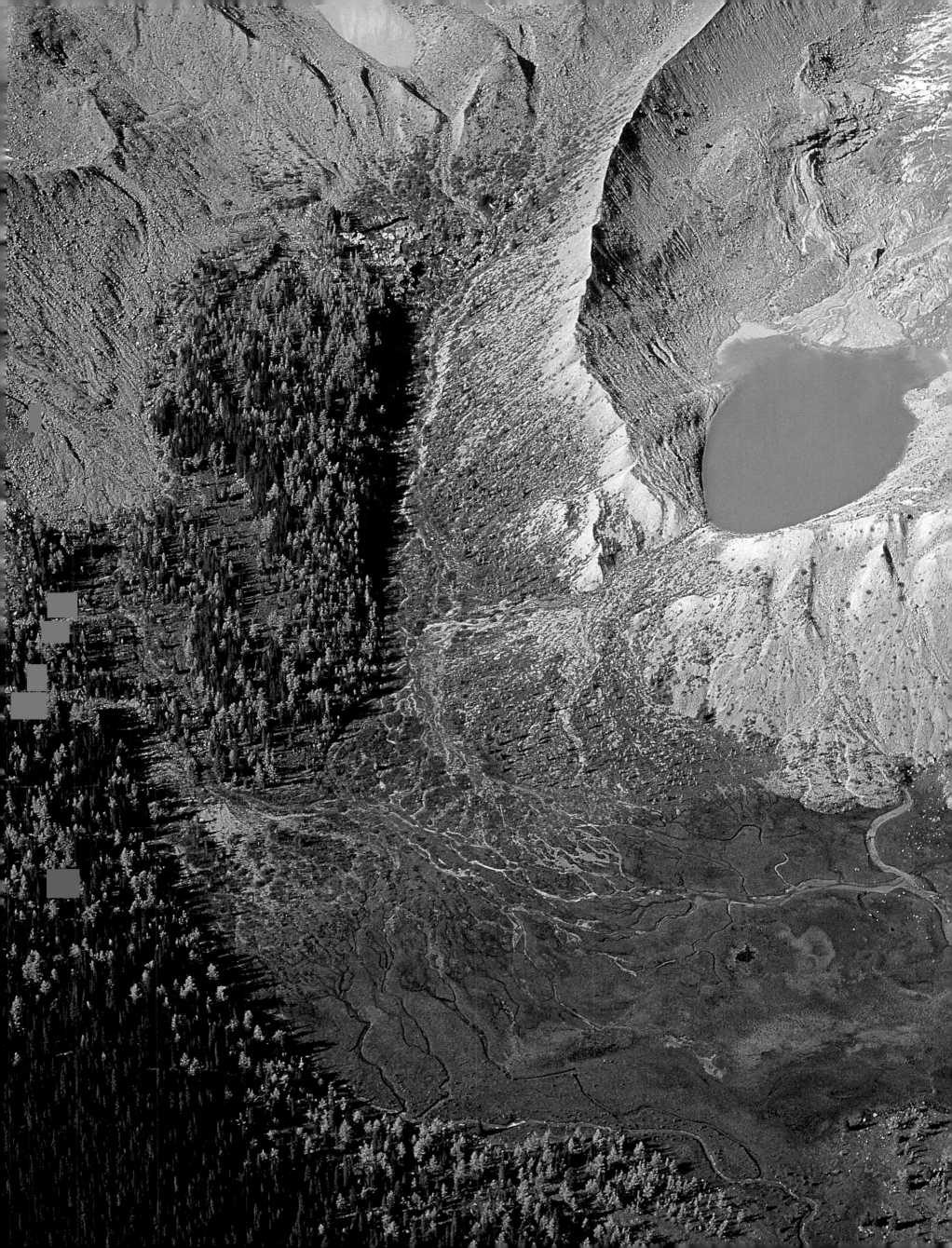

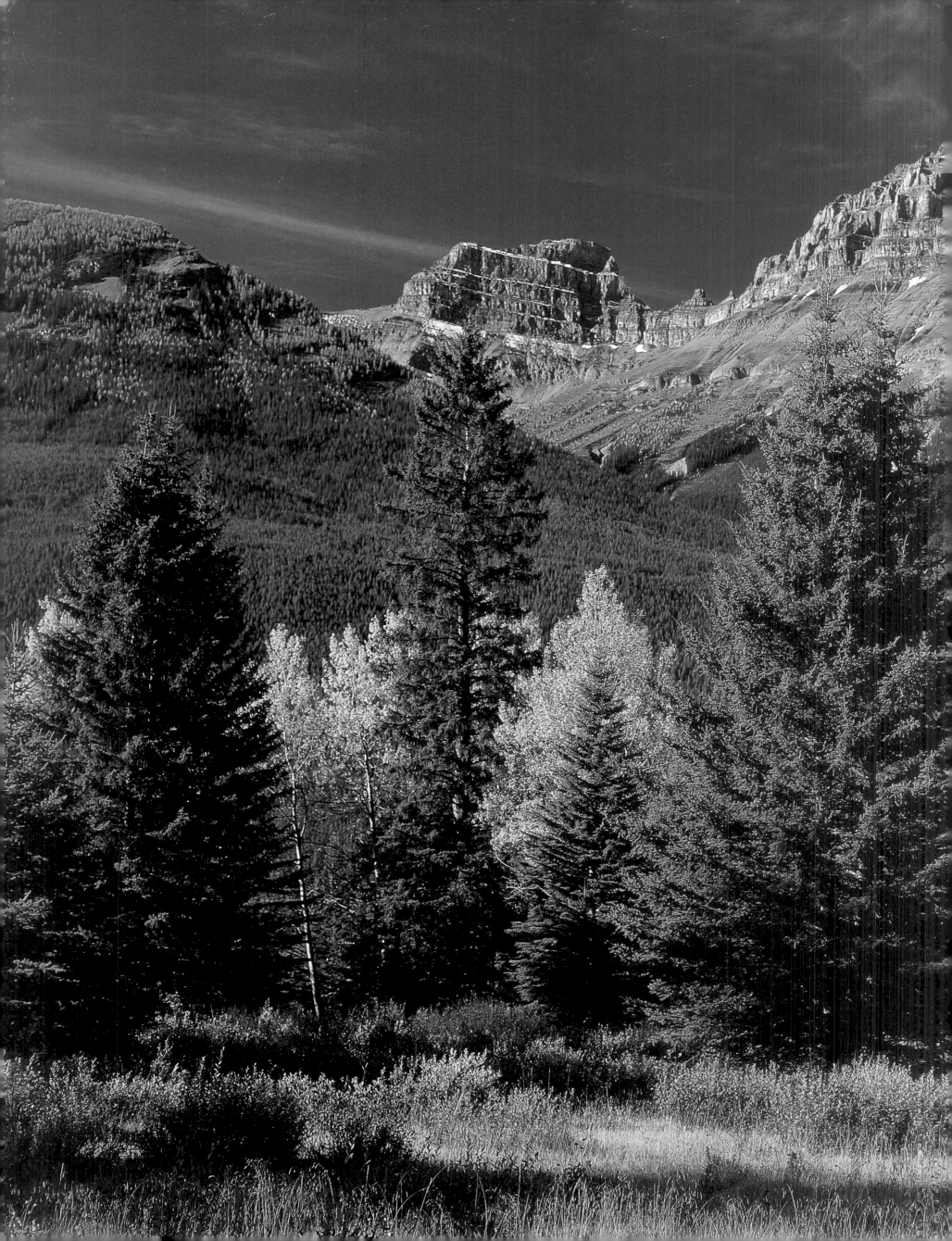

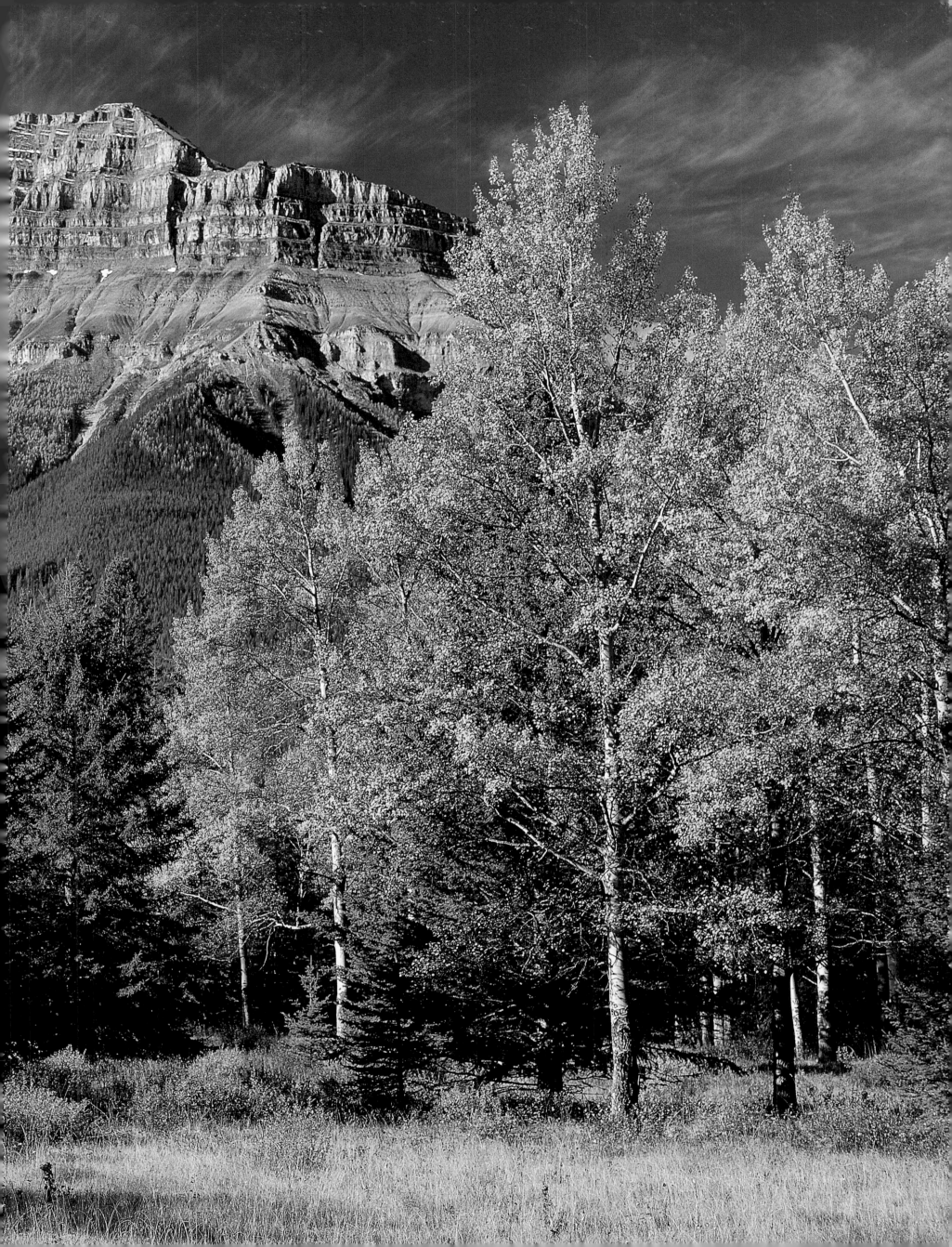

above: **Douglas Leighton**
© Bonner Photography

THE AUTHOR

Douglas Leighton was born and raised in the Canadian Rockies. From early childhood, his world has thus been shaped and informed by a daily association with his alpine surroundings. It is no wonder, then, that his photographs reflect his deep connection to the Canadian Rockies. Before settling on photography as his livelihood, Doug worked as a park naturalist in British Columbia. His early photographs as well as his initial research on nature provided him with the source material for his interpretive programs and fireside talks.

Doug's photographs have appeared in many books, including those published by the National Geographic Society, Audubon Books, and Time-Life Books, and in magazines such as *Canadian Geographic, Nature Canada, Equinox* and *Beautiful British Columbia*. His four coffee-table books published by Altitude Publishing—*The Canadian Rockies; Alberta, The Canadian West; Greater Vancouver;* and *British Columbia*—are the definitive volumes on these regions. They have all been reprinted many times, their combined sales making him western Canada's best-selling scenic photographer, and have been translated into many languages. Doug's books, which have won a number of international awards, are frequently used as special gifts by government and business leaders.

When he is not busy taking photographs, Doug is a serious birder. His documentations of bird distribution in the Canadian Rockies have made an important contribution to this field of study. He is currently working on a personal wildlife habitat project in the Canadian Rockies near Golden, British Columbia.

Doug lives in Banff with his wife, Myriam.

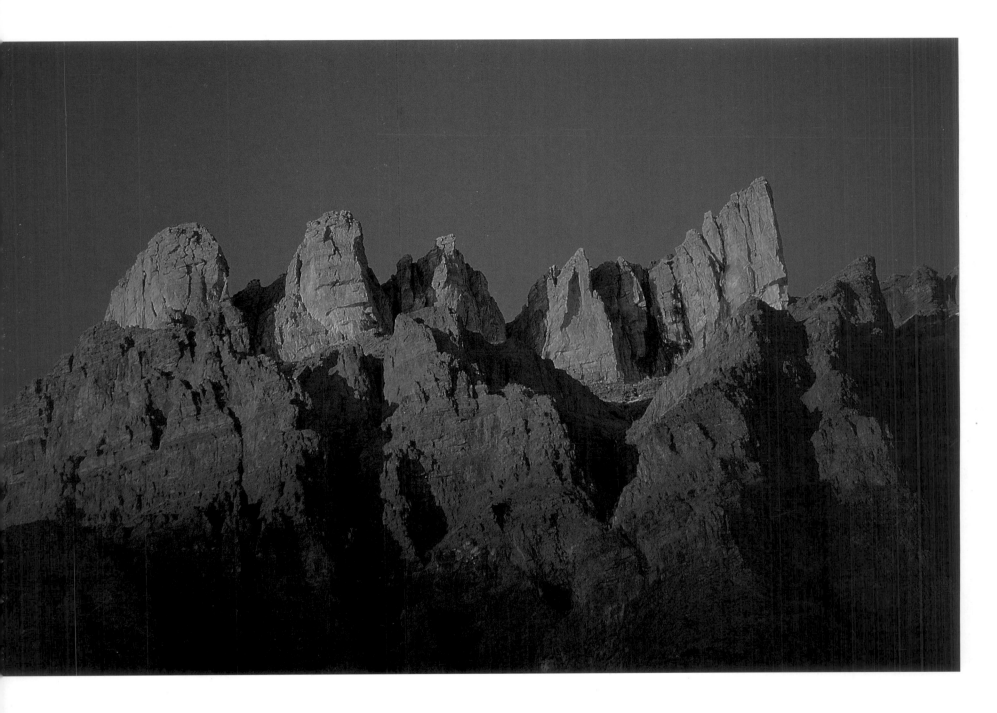

above: **Mt. Wilson**
Banff National Park